The Painter's Dictionary of Materials and Methods

The Painter's Dictionary of Materials and Methods

By Frederic Taubes

WATSON-GUPTILL PUBLICATIONS / NEW YORK

Copyright © 1971 by Watson-Guptill Publications,

First published in the United States by Watson-Guptill Publications,
a division of Billboard Publications, Inc.,
1515 Broadway, New York, N.Y. 10036

Library of Congress Catalog Card Number: 71-155-142
ISBN 0-8230-1335-9
ISBN 0-8230-1336-7 pbk.

Manufactured in U.S.A.

First Printing, 1971
Second Printing, 1974
Third Printing, 1976
Fourth Printing, 1979

Paperback Edition
First Printing, 1979

FOREWORD

The material gathered in this volume should give the painter a complete knowledge of his tools and of the technical processes of drawing and painting. The book is intended primarily for the painter, and the emphasis is, accordingly, on drawing and painting materials and techniques. Descriptions of printmaking, for example, are really intended as summaries, particularly for such complex techniques as color printing from wood blocks, copper plates, and stencils. Specialized manuals should be consulted for detailed directions on these subjects.

In compiling the text, my intention was to keep it free from descriptions of obsolete practices and the altogether worthless information that frequently appears in handbooks on artists' materials and methods. Many materials no longer in use are omitted or only briefly mentioned, and references to chemistry are limited to a bare minimum, so as to enable the practicing artist to acquire only such knowledge as will be of concrete value to him in the tasks of drawing and painting.

In writing a contemporary account such as this, I have kept in mind one important fact: In older manuals—from Cennino Cennini to our own day—countless recipes are offered, most of them esoteric. The reason for this is that many materials were not commercially available in the past; for lack of scientific research and adequate marketing, the painter was forever searching for "secret formulas." Today things have changed radically. The painter is no longer forced to be an alchemist. The manufacturer has relieved him of many chores that were once unavoidable. Like

the pharmacist, the painter does not have to compound prescriptions—most of them come right out of a bottle. Thus I have been able to condense a thousand pages of technical data into the small number in this volume.

To aid the reader in finding information quickly, all cross references have been italicized.

I would like to give a special word of thanks to my wife, Lili Taubes, for her help; particularly for her text in the *Enameling Mosaic* entries.

ACCELERATION OF OIL PAINT DRYING. Certain measures and/or ingredients can be used for this purpose. Exposure to heat—from the sun or from an artificial source such as a radiator or an electric heater—will speed up the drying process considerably. Moderate heat (heat that a person can endure without discomfort) is best. Prolonged exposure to excessive heat will cause the *Linoxyn* to become brittle. Paint will dry appreciably faster when certain ingredients—specifically such metallic-salt compounds as *Cobalt Dryer*, *Manganese Dryer*, and *Lead Dryer*— are added. Known as *Dryers* or *Siccatives*, these additives are obtainable in liquid form.

Cobalt dryer is recommended for use in oil painting, in a quantity of up to .5% of the amount of paint to which it is added. In practical use, this amounts to one drop of the siccative added to a teaspoonful of the paint thinner or painting medium used or one drop to about one inch of the paint as it comes from the tube. In underpainting, when every color is mixed with white, the dryer should be added to the white alone; in overpainting, one or two drops of the dryer should be added to a teaspoonful of the medium. A dryer should never be added to paint that will be thickly applied or the paint will form a strong film on the surface and drying under the film will actually be considerably retarded.

The two other common dryers, oxides of lead and manganese, are used only in industrial paints. These cause *Embrittlement of Oil Paint*, *Yellowing of Oil Paint*, and *Darkening of Paint Film*, in artists' colors.

7

Some colors, such as raw *Umber* and *Burnt Umber* and *Manganese Blue,* can also be used with excellent effects to speed the drying of paint mixtures. A small quantity of umber (not enough to affect the colors) can be added to a color or mixture of colors, or a thin glaze of umber, diluted to a thin consistency with painting medium, can be applied to the surface before painting. *Ivory Black,* one of the slowest dryers in the painter's palette, will dry more quickly if mixed with a little raw or burnt umber. Manganese blue can be added in the same way even to light, delicate colors without changing their appearance.

I refer here only to oil paint simply because other mediums—watercolor, acrylic, casein, gouache, egg tempera, fresco, and encaustic—dry rapidly, some almost at the moment of their application. *Oil Tempera,* however, is an exception; it behaves just like oil paint and can be treated in the same way when rapid drying is necessary.

ACETIC ACID is a colorless liquid found in vinegar. It is used as part of a formula for producing a finish on bronze, copper and brass. It has also been used as an egg preservative (1% or less of a 3% solution of acetic acid is added to the beaten egg), although this use is obsolete.

ACETONE is one of the strongest *Solvents* and among the most versatile because it mixes with water, oil, turpentine, and petroleum derivatives. Hence, acetone is a useful coupling agent for combining immiscible fluids. It must be understood that, because of its rapid evaporation, acetone cannot be used unmixed. Mixing the solvent with turpentine, alcohol, or a petroleum solvent is often required when cleaning old paintings. In the *Restoration of Paintings,* complex formulas must often be used to remove surface coatings of indeterminate nature.

Acetone is toxic (although less than many other volatile solvents) and should be used in a well ventilated area. Its low flash point also requires that it be kept away from flames and high heat.

ACID NUMBER represents the amount of a specific chemical needed to neutralize the *Free Fatty Acid* in a given quantity of

Linseed Oil or other vegetable drying oil. In refined linseed oil, the acid number may be as high as 3. In other oils in which pigments are ground, it can reach 10.

Linseed oil with a low acid number produces short or stiff paint, and is therefore unsuitable for grinding pigments. When oil is exposed to the air its acidity increases. Consequently, oil used for grinding should have a higher acid number, because its wetting power is improved.

Most painters are less interested in the actual acid number of the oil vehicle than in the general condition of the oil—whether it is acid or neutral. This can be ascertained by its odor: neutral oil has a sweet smell; the more free acid an oil contains, the more acrid its odor.

ACRA CRIMSON. See *Acra Reds.*

ACRA REDS are a trade name for the recently developed *Linear Quinacridone Pigments.* These are brilliant, extremely permanent synthetic organic colors used in *Oil Painting, Watercolor Painting,* and *Acrylic Painting.* In color value, the light hue of this red approximates *Cadmium Red* medium (see *Cadmium Colors*), without having its opacity. The darker variety, *Acra Crimson,* is bluer and deeper in color than *Alizarin Crimson.* These rather slow drying, quite transparent colors should be used chiefly for glazing, but because of their excellent tinting strength, they are also quite suitable for being mixed with any other color on the palette.

ACRYLIC EMULSION. See *Acrylic Polymer Emulsion.*

ACRYLIC FIXATIVE. A *Fixative* prepared from acrylic resin suspended in a highly volatile liquid. It replaces the older, shellac-based fixative. It is used on drawings made with charcoal, pencil, crayon, chalk, carbon, and any other medium that is inclined to smudge.

ACRYLIC GEL MEDIUM, a colorless, thickened version of *Acrylic Polymer Emulsion,* serves as a painting medium for making an emulsion suitable for impasto or for simply binding dry pigment. See *Acrylic Painting.*

9

ACRYLIC GESSO, made by binding *Titanium White* pigment with *Acrylic Polymer Emulsion,* was originally designed for preparing surfaces for *Acrylic Painting* but can be used as well for priming surfaces for oil painting. Compared with the traditional glue-size gesso, its advantages are greater hiding power (only two or three very thin applications are needed to provide sufficient priming); decreased absorbency of the primed surface to a point where no isolation of the gesso is required when painting on it with oil colors; elasticity, allowing the material to be applied to canvas (the traditional gesso can only be used on rigid panels); and resistancy to mold. When dry it is insoluble in water, but turpentine and hydrocarbon derivatives will dissolve it. See also *Gesso.*

ACRYLIC MEDIUM. Acrylic colors are normally thinned either with water or with a form of *Acrylic Polymer Emulsion,* called acrylic medium. This medium comes in two forms: gloss and matt. Both are thick, milky fluids when wet, but both dry water-clear. Both are water soluble when wet—and can be thinned with water to a more fluid consistency—but are insoluble once they are dry.

The gloss medium lends a distinct shine to the surface, while the matt medium dries to a satin—non-glossy—finish. A semi-matt surface may be produced by combining the two mediums.

Acrylic medium is intended primarily for use with acrylic colors, but it may also be added to watercolor, gouache, casein, or any other water-soluble paints, which will then dry insoluble.

ACRYLIC MODELING PASTE is a combination of *Acrylic Polymer Emulsion,* marble dust and other inert fillers. The material can serve for texturing a surface, or as a thickener to be added to acrylic colors for impasto effects (see *Acrylic Paints: Technique).* It is also sometimes used to create three-dimensional ornaments on frames.

In making *Collages,* the adhesive paste can be used as an understratum in which the artist can embed any conceivable materials suitable for this purpose.

When heaped up to considerable thickness, the modeling paste develops fissures on its top surface, due to rapid drying of the

mass. This can be easily remedied by covering up the shallow cracks with more paste. Once dry, the material can be drilled, sawed, and cut with a knife. Because of its lack of elasticity, the paste must be applied to a rigid support.

ACRYLIC PAINTING. See *Acrylic Paints.*

ACRYLIC PAINTS are normally a combination of *Pigment, Acrylic Polymer Emulsion,* and plasticizers or similar additives to give the pigment-emulsion dispersion the proper consistency for painting. With one exception—a petroleum or turpentine soluble acrylic—all commercially manufactured brands are water based. Acrylic paints are characterized by their resistance to yellowing, oxidation, brittleness, and other forms of deterioration; they remain unaffected when exposed to moisture, dryness, heat, and cold. These paints are extremely light refractive and have great *Hiding Power* and *Tinting Strength.* They dry rapidly with the evaporation of the water and are insoluble in water upon drying. They retain their adhesive property in spite of great dilution by water. They are impervious to *Mold.* Dry acrylic paints, however, remain soluble in *Turpentine, Petroleum Derivatives,* and *Coal Tar Derivatives.*

Colors. Here is a suggested list of permanent colors obtainable in jars or tubes at this writing. The sequence of the list follows the customary placement of the colors on the *Palette.*

Greens: *Phthalocyanine Green, Hooker's Green, Permanent Green, Chromium Oxide Green, Light Green Oxide.*

Blues: *Phthalocyanine Blue, Ultramarine Blue, Cobalt Blue, Cerulean Blue.*

White: *Titanium White.*

Yellows: *Yellow Oxide, Raw Siena, Hansa Yellow, Yellow Medium Azo, Yellow Orange Azo, Cadmium Yellow Light, Cadmium Yellow Medium, Cadmium Orange* (see *Cadmium Colors*).

Reds: *Red Oxide, Indo Orange Red, Cadmium Red Light, Cadmium Red Medium, Naphthol ITR Red.*

11

Browns: *Burnt Siena, Burnt Umber, Raw Umber.*

Black: *Mars Black* (see *Mars Colors*).

Violets: *Dioxazine Purple, Naphthol ITR Crimson.*

A limited list of colors adequate for painting in acrylics would include: Phthalocyanine Green, Chromium Oxide Green Opaque, Phthalocyanine Blue, Ultramarine Blue, Titanium White, Yellow Oxide, Raw Siena, Cadmium Yellow Light, Cadmium Yellow Medium, Cadmium Orange, Hansa Yellow, Burnt Siena, Burnt Umber, Mars Black, Dioxazine Purple, and Naphthol ITR Crimson. This list should suffice for every kind of representational painting. The frequent introduction of new colors seems chiefly to serve commercial rather than artistic ends.

Tools. Because of the liquid consistency of acrylic, many artists feel that *Soft Hair Brushes,* both flat and round, work best, although the stiffer *Bristle Brushes* (used for oil painting) are also suitable. For covering large surfaces (as in mural or nonobjective painting) a *Utility Brush* or *Nylon Brushes* can be used. A technique like that of the early tempera painters, utilizing cross-hatching, requires a round, perfectly pointed *Sable Brush.* When working with thick color, either with the paint as it comes from the tube—or with liquid colors that have been thickened with *Acrylic Modeling Paste* or *Acrylic Gel Medium*—a *Painting Knife* can be used to create impasto effects.

Because of the rapid drying time of acrylic paint, which becomes water-insoluble when the water evaporates, it is necessary to keep the brushes submerged in water during the working period. Once dry, the paint can be cleaned off the brushes with a *Paint Remover, Xylene, Acetone,* or a special solvent produced for this purpose by the acrylic paint manufacturers.

Supports. Because acrylic paints have great elasticity and strong adhesive properties, they can be applied to any desirable non-oily surface—*Paper, Canvas, Illustration Board,* Masonite, wood, plaster, etc.—without prior preparation such as sizing or priming. The only precaution required is not to use impasto on a highly absorbent surface, which would deprive the paint of its liquid binder.

Grounds. On most normal painting surfaces no ground is necessary. However, the manufacturers of acrylic paints do produce an *Acrylic Gesso* which is particularly suitable for this medium and needs no preliminary sizing. Packaged in cans and jars, the gesso is thick and if not used on canvas, it should be thinned with water and applied directly to the (rigid) support in successive coats to minimize brushmarks—unless the artist prefers a textured ground. If a really rough ground is desired, marble dust or a similar inert granular substance can be added to the gesso. Note that the traditional white lead oil ground (for oil painting) is unsuitable for acrylic.

Technique. The nature of acrylic paint differs radically from that of oil paints. Therefore, this new medium cannot be adapted to the exact processes we know in oil painting. Acrylic is not, however, unlike watercolor, casein, and egg tempera, although it differs from them in the following respects. Acrylic has greater brilliance; hence it has the tendency to produce coloristic effects rather than tonal effects. It has stronger *Covering Power. Drying of Paints* proceeds at a more rapid rate. Although acrylic will dissolve under the action of commonly used cleaning agents (such as petroleum and coal tar derivatives), it *can* be subjected to cleaning with soap and water (see *Restoration of Paintings*).

Acrylic paints are especially suited for painting that exploits transparent and semitransparent passages, such as *Glazes* and *Scumbles*. One can produce glazes of any degree of thinness by diluting colors with liquid acrylic medium—matt or gloss—which is described under *Acrylic Polymer Emulsion.* Because of the great transparency of thinned acrylic paint, transparent and semi-transparent passages can be superimposed in many applications. This cannot be done with traditional watercolor painting, in which only two or, at the most, three transparent *Washes* can be successfully employed; nor is it possible in oil painting, where two consecutive glazing applications are rare. Although acrylic colors can be extensively thinned, an overabundance of water will impair the bond of the pigment particles; therefore, when considerable dilution by water is desired, some acrylic medium should be added. Because the paint dries rapidly, superimposition of colors, one layer on top of another, can proceed without delay.

13

Because acrylic paints cannot be blended in the manner of oil colors—once applied to the support they dry almost instantly—other measures must be taken to produce color blending. This can be accomplished in the same manner as in watercolor painting; by crosshatching, as in *Tempera Painting*; and by *Drybrush Effects.*

Impasti can be produced by using *Acrylic Modeling Paste* or acrylic gel medium. The nature of these impasti is entirely different from those we see in oil paintings, however. To begin with, the modeling paste cannot easily be applied with a brush because its consistency is too dense and its body too stiff. Hence, this material must be applied with a painting knife unless the paste is sufficiently diluted with an acrylic color to become more opaque and brushable (the slight tinting strength of the white paste will not significantly reduce the intensity of the color). Any desired dry pigment can also be added to the paste which will, of course, increase its stiffness. This can be overcome by diluting the stiff paste with liquid acrylic medium. Even when diluted, the low viscosity of the paste makes it impossible to employ brushwork like that used in oil painting. Thus, though particularly adaptable for any conceivable texturing, acrylic paste is rarely used for representational painting.

Acrylic Gel Medium is a salve-like paste of very low viscosity and considerable adhesive power. Mixed with tube color, gel increases the thickness of the paint, makes it more brushable and more suitable for creating impasto effects. The gel can also be mixed with dry pigments. Because the gel has no color of its own, a pigment will appear in full strength when mixed with this medium. It is also quite elastic and can hence be applied to canvas.

It must be understood that when the gel is mixed with acrylic colors it will impart more body to them but at the same time will reduce their opacity and, if applied to nonabsorbent ground, will increase their drying time slightly. However, a point to observe is that impasto painting and transparency stand at cross purposes; impasto obviously reduces transparency. When gel is mixed with dry pigments, the consistency of the paint will become analogous to oil paint; that is, the paint configuration will retain brushstrokes. If applied to an absorbent ground, an impasto produced in this manner will solidify at once. But on a nonabsorbent surface, it may be ten minutes before the paint solidifies.

To repeat: as it comes from the tube or the jar, the acrylic paint is relatively liquid compared to oil paint, and, when applied (even undiluted by water), the paint film is thin. For fullest utilization of the unique character of the material, this characteristic should be maintained—except, of course, when the emphasis is on textural effects and impasti are called for. As mentioned, impasti can be produced with acrylic modeling paste, acrylic gel medium, or various other materials (sand, sawdust, etc.) added to the paint, to the medium, or even to the paste or gel.

Interesting coloristic and textural effects can be obtained by glazing an acrylic underpainting with oil color that has been conditioned by a resinous medium. Oil colors diluted by a resinous *Painting Medium* are especially suitable for glazing. Hence the acrylic underpainting would have to be carried out opaquely—and in predominantly light colors—to produce the sensation of luminosity associated with this technique. Such paintings should be varnished with *Damar Picture Varnish* or with *Matt Picture Varnish.* Acrylic emulsion cannot be used for this purpose.

Varnishing. Acrylic polymer emulsion can be applied as a varnish as soon as the painting is completed. It should be added that varnishing such paintings is not imperative, unless darker colors have become lifeless. Of course, an additional coating with the medium will afford greater protection to the paint surface because the emulsion becomes waterproof upon drying and can be cleaned, when necessary, with soap and water.

Some manufacturers recommend simply varnishing with the same gloss or matt acrylic medium used for painting. Others make acrylic varnishes which are distinct from the medium, though chemically similar. The gloss varnish or medium will produce a luminous surface; the matt varnish or medium will produce a satiny finish.

The use of petroleum-based acrylic varnishes is inadvisable since the water insoluble acrylic resin *will* be affected by petroleum solvents. A mild solvent (like *Mineral Spirits*) may not soften the surface at once but will penetrate it, thus causing adverse effects such as loss of opacity and spottiness.

ACRYLIC POLYMER EMULSION is an aqueous vehicle

employing a plastic (acrylic) resin emulsified in water. It is used in the manufacture of acrylic paints, for which the emulsion is the *Binder*; as a medium for *Acrylic Painting*; as an adhesive for various purposes (see *Restoration of Paintings*); and as a varnish to add durability and gloss to a finished acrylic painting. The medium comes in two qualities. One, usually called acrylic polymer medium, or gloss medium, imparts gloss to paints. The other, referred to as matt medium, produces a dull finish. They can be intermixed in any desired proportion to produce a finish midway between glossy and matt. It must be pointed out, however, that acrylic paints never produce a gloss such as we know it in paintings done in oil colors. Flatness is not a great fault in a light painting, but flatness does not enhance the appearance of darker surfaces; unless they are glossy, they lose their intrinsic value.

The acrylic resin, in the form of a fine dust, is suspended in water, giving the emulsion a milky appearance. When the water evaporates, the particles fuse to form a cohesive film.

The term "polymer" simply describes the molecular structure of the emulsion, in which a number of small molecules (monomers) form a kind of chain and become a larger, stronger molecule, or polymer. This more durable molecular structure accounts for the strength and stability of the emulsion and of paints made with this emulsion.

ACRYLIC POLYMER MEDIUM. See *Acrylic Polymer Emulsion.*

ACRYLIC RESIN, one of many synthetic resins, has been in use since the 1930s in plastics such as Plexiglas and Lucite. The adaptation of acrylic resin for fine arts purposes became widespread in the 1960s. See *Acrylic Painting; Acrylic Polymer Emulsion.*

ACRYLIC VARNISH. For varnishing a painting, some manufacturers simply recommend gloss or matt *Acrylic Medium*, depending upon whether the artist prefers a glossy or satin finish. However, some manufacturers produce a special form of *Acrylic Polymer Emulsion* specially suited for varnishing. Like the painting medium, this varnish comes in gloss and matt

varieties. The gloss varnish produces a surface similar to a varnished oil painting, with a distinct shine. The matt varnish produces a non-glossy finish so that the varnished painting appears unvarnished, with a soft, satin surface. It is usually wise to thin these varnishes with water, up to 50%, and apply two or more thin coats, rather than a single thick one; thinned varnish brushes on more smoothly and is less likely to trap air bubbles. Like the painting mediums, the varnish looks milky and opaque in the bottle, but it dries clear. Once dry, it is insoluble in water.

ADULTERATION OF PAINTS. See *Testing Paints for Adulteration.*

AGATE. A hard stone of great surface smoothness from which the *Burnishers* used in *Gilding* are made.

ALCOHOL. Methyl alcohol—also known as methanol, wood alcohol, denatured alcohol, and shellac thinner—is the most common variety of anhydrous alcohol (containing no water). Grain alcohol (ethanol, or ethyl alcohol) is the purest form of alcohol, also anhydrous. Both are miscible with aqueous solutions but not with turpentine or with most petroleum derivatives. Ethanol cannot be obtained tax-free, hence it is much more expensive than methanol. The vapors of ethanol are less poisonous than those of methanol. Anhydrous alcohol is indispensable in the *Restoration of Paintings*, in thinning shellac, and in dissolving dried shellac. See also *Butyl Alcohol.*

ALIZARIN CRIMSON, a brilliant, dark red is a synthetic dyestuff (a coal tar product) precipitated on an *Aluminum Hydrate* base (a white, very light, transparent pigment); as such, this color is referred to as a *Lake.* The color has been in existence since 1868. It belongs with the most transparent colors on the palette and has good tinting strength. In oil paints it is the slowest dryer, and its permanence is greater than that of *Madder Lake.* To improve the working quality of alizarin crimson oil paint, some of its binder can be eliminated by placing the paint on an absorbent paper and then replacing the binder with *Copal Concentrate.*

17

Alizarin crimson is used in aqueous vehicles as well as in oil. However, because the recently developed *Naphthol ITR Crimson* and the *Linear Quinacridone Pigments* have shown better compatibility with an alkaline medium, they have taken the place of alizarin crimson in *Casein Painting* and *Acrylic Painting.*

Because the color is transparent it is ideally suited for glazing and thin applications. Any color of such great transparency should not be used with any degree of impasto, however, because it loses its intrinsic value and takes on a blackish appearance.

ALLA PRIMA PAINTING means direct painting in oils on a white *Priming* or on an *Imprimatura*. The artist aims at achieving final effects while painting *Wet-in-Wet*, without underpainting (see *Oil Painting*).

ALUMINUM HYDRATE is a white transparent pigment of high oil absorption, used as a base for the precipitation of *Dyes* such as *Alizarin Crimson*. A color obtained in this manner is referred to as a *Lake*. Aluminum hydrate is also used as a *Filler* (adulterant) in the manufacture of cheap paints.

ALUMINUM STEARATE is a metallic soap (made by the saponification of tallow that is then treated with alum) in the form of a white bulky powder sold in various qualities. For use as a stabilizer in paint, only the mono- and the di- forms of the material are of value for aiding the suspension of pigment in oil (see *Grinding Pigments in Oil*). The material is also used for cutting (adulterating) colors.

AMBER is a fossil resin. "Fossil" refers to a material obtained from trees now extinct, hence amber is found underground. Known in antiquity, amber was used in the production of ornamental jewelry. It is found along the Baltic coast, the North Sea, and the English coast in chunks of various sizes. Its color varies from light yellow to dark brown; the knobs are sometimes translucent, more often opaque. Chemically related to the *Copal* resins, amber was used, according to some accounts, in painting as a *Varnish* and also as part of the *Painting Medium.* In order to be soluble in a volatile liquid or oil, amber must first be subjected

to *Thermal Processing*. Although extensive tests have demonstrated that the material has a strong tendency to yellow, amber is still made available by certain manufacturers.

AMMONIA. See *Ammonia Water*.

AMMONIA WATER is a common term for ammonium hydroxide, a solution of ammonia gas in water. When greatly diluted, it can be used for dissolving greasy films on dried oil-paint surfaces; when added to *Saponin*, it is an important and very powerful cleaning agent (see *Restoration of Paintings*). Ammonia water also lowers the surface tension of water, thus making it penetrate more easily the surfaces of fabrics such as linen or cotton.

Paintings hanging in environments affected by fumes (particularly those emanating from kitchens, dining rooms, etc.) will accumulate a greasy substance on their surfaces. Before being revarnished, such surfaces should be cleaned with a weak solution of ammonia water (the standard 28% solution mixed 1:4 with water) on a pad of surgical cotton.

Some oil primed canvases will not easily take charcoal marks or *Graphite Paper* tracings; after a treatment with ammonia water, this deficiency will be eliminated at once. The same remedy proves helpful when certain liquids (such as India ink or thin oil paint washes) trickle, refuse to go on evenly, and contract into little droplets on oil-saturated, dry, nonabsorbent surfaces.

AMMONIUM CARBONATE is a white powder (salt) which when dissolved in water gives off ammonia gas. A solution of ammonium carbonate can be used as a substitute for *Ammonia Water*.

AMYL ACETATE, also sometimes known as banana oil, is a product obtained from the rectification of alcohol. It is a strong solvent for synthetic (cellulose) and other resins, but has been recently superseded by *Butyl Acetate*.

ANHYDROUS refers to the absence of water in a particular substance. For example, the volatile solvent *Methanol* contains

19

no water; it is therefore anhydrous. Anhydrous denatured alcohols are solvents miscible with water. Anhydrous alcohol, *Turpentine* and *Toluol,* and mixtures of these solvents are primarily used for the cleaning of pictures. See *Restoration of Paintings.*

AQUA FORTIS. See *Nitric Acid.*

AQUA REGIA is a mixture of *Nitric Acid* and hydrochloric acid. It is used to dissolve gold and platinum.

AQUATINT is a technique used in *Etching*, whereby a metal plate is textured by being coated with *Rosin* dust which becomes attached to the surface when heating the plate. The plate is then placed in a bath of acid which bites around the rosin granules, leaving a rough surface which holds ink.

AQUEOUS means containing water. Aqueous paints are used in *Watercolor Painting; Casein Painting; Tempera Painting;* and *Acrylic Painting.*

ASPHALTUM (bitumen) is a tarry, black reddish-brown compound. Used as an oil color in many 18th- and 19th-century paintings, it has caused irreparable damage because it does not permanently solidify in oil. However, when dissolved in turpentine the pigment is valuable as a ground in *Etching* and also in antiquing gold and silver leaf applications (see *Gilding*).

ATMOSPHERIC PERSPECTIVE refers to the tendency of colors to pale and lose their intrinsic key as they recede into the distance. For example, an object that appears red when seen at close range will impress the viewer as being bluish when placed in the far distance. In fact, all local colors (local refers to any color seen close up and not influenced by atmospheric conditions) will fade out in the distance because of the prevalence of atmospheric

moisture. Hence, the dominant color of distant areas will be a pale blue or bluish green.

AUREOLIN (cobalt yellow) is an artificial pigment that, in spite of its fair permanence (if properly prepared) in oil, watercolor, and tempera painting, has become obsolete because of the availability of other modern, superior yellow colors. It may, however, still be obtained as a watercolor from some manufacturers.

AZURITE BLUE is an obsolete permanent pigment composed of a basic copper carbonate mineral found in San Juan County in Utah, in good quality. When the mineral is compounded with an aqueous medium (a solution of gum arabic in watercolor, or an egg tempera emulsion) its color is pale blue, comparable to inferior qualities of *Lapis Lazuli*. When ground in oil, it looks not unlike *Cerulean Blue*, but its shade is darker and its body more transparent.

BALSAMS (oleo-resins) are the resinous exudates from coniferous trees. When obtained from the heart of certain kinds of larch, they are known as *Venice Turpentine* or *Canada Balsam* and as *Copaiba Balsam.*

BANANA OIL is an obsolete term for *Amyl Acetate.*

BARIUM SULFATE. Also known as barium white, baryte, and blanc fixe, barium sulfate is a white inert pigment of considerable transparency. It exists as a natural mineral in many parts of Europe and America but is also prepared artificially. Its uses are twofold: as an adulterant, that is, an extender of other colors; and as a base for lake pigments, that is, for organic coloring matter or for dye precipitated on it.

BARIUM WHITE, also known as blanc fixe, barytes, and permanent white, is obtained from the mineral known as barite or heavy spar. It is used as an *Extender* in paints and also as a base for *Lake* pigments. As a pigment, it has little *Hiding Power*, but its oil absorption is low. Some colors that have high oil absorption require much less oil when ground with barium white.

BARIUM YELLOW, because of its weak tinting strength and great transparency, is useless. Coloristically, it is an equivalent to a pale *Naples Yellow*, a far more useful color.

BARYTES. See *Barium Sulfate.*

BEESWAX is an ancient material used for compounding encaustic paints, and resin wax paste (see *Waxes*). Formerly, it served as an additive in grinding certain pigments in oil.

BENZENE (benzol) is a highly flammable hydrocarbon. Obtained by the destructive distillation of coal tar, it is miscible with most organic solvents; its vapors are toxic. For this reason, benzene should be used in a well-ventilated area. For all practical purposes, it is identical to *Toluol* and *Xylene* except that its flash point is much lower. All are strong solvents used in cleaning old—that is, well dried—oil paintings.

BENZOL. See *Benzene.*

BERLIN BLUE. See *Prussian Blue.*

BINDER. A vehicle which holds the particles of pigments together to form paint. *Linseed Oil* is the usual binder for *Oil Painting.* Gum Arabic (see *Gums*) is the binder for *Watercolor Painting.* Egg is the binder for *Tempera Painting.*

BISTRE. A dark brown watercolor pigment, similar in composition to *Asphaltum*; it is now rarely used.

BITUMEN. See *Asphaltum.*

BLACK. See *Carbon Black, Graphite, Ivory Black, Lamp Black, Mars Black* (under *Mars Colors*), and *Vine Black.*

BLANC FIXE. See *Barium Sulfate.*

BLEEDING. The tendency of some colors in a dried paint film to diffuse and spread to other paint or varnish layers. For example, when marks made with carbon paper are overpainted with oil colors, the marks (though invisible at first) will reappear on top of the new paint film when dry.

23

BLENDER. A brush made of soft hair, such as squirrel, that is used to create delicate fusions of color (see *Brushes*). The word is also used to describe a long and very elastic painting knife for blending colors (see *Painting Knives*).

BLOOM. The white or cloudy surface appearance of aged varnish films, caused by the presence of cracks or pores that diffuse light, often confused with *Blush*.

BLOWN OIL is linseed oil which is processed with heat in the presence of air. In the manufacturing process an air current is passed through the liquid; this promotes *Polymerization* and a fast drying rate. In contrast with *Stand Oil*, *Blown Oil* yellows considerably and is inclined to wrinkle. It is not used for artistic purposes.

BLUE VERDITER, an artificial copper carbonate, is not unlike the now obsolete *Azurite Blue* and is similar in color but possesses a greenish cast. It was widely used in painting illuminated manuscripts. Today, *Phthalocyanine Blue* and *Phthalocyanine Green* are more useful and universally adaptable colors.

BLUSH is the turbidity or white appearance found sometimes in varnish films of old paintings, particularly on very dark, sleek surfaces. It is said that this is due to condensation of moisture within the film. However, the reason for the occurrence of blush is not well understood. Rubbing a thin film of *Copal Painting Medium* into the surface will remedy the condition at once.

BOLE is an ancient name given to white or colored clay, used as a surface coating on panels or as an undercoat for *Gilding*.

BORAX (sodium tetraborate) is a mildly alkaline salt that comes in powder form. It is used with silver solder for joining wires in the plique-à-jour technique (see *Enameling: Tools and Materials*).

BRAYER. A roller for inking metal plates and wood blocks for printing; it is also used for applying a soft ground in *Etching*.

Brayer.

BRAZIL WOOD is a natural dye of deep cherry-red color, obtained from certain woods in Ceylon, Jamaica, and Brazil. In medieval times it was used for coloring cloth, in painting, and in inks. The modern synthetic colors are superior by far in permanence and tinting strength.

BRIGHTS are short bristle brushes. See *Brushes.*

BRISTLE BRUSHES. See *Brushes.*

BROWN OCHRE. A variety of *Yellow Ochre*, containing a large quantity of the mineral limonite in addition to clay and silica, the principal components of earth colors.

BRUSHES are made of hair, such as hog bristles, sable, and various less expensive soft hairs, such as squirrel hair and oxhair. These are set in metal *Ferrules*, which are either flat or round. Depending on the nature of the hair, as well as the size and shape of the brush, they serve in different techniques. For *Oil Painting*, all types are used. For *Watercolor Painting* and *Tempera Painting*, sables are used most often. For *Acrylic Painting*, bristles and sables are used, as well as the new *Nylon Brushes*. Brushes can be classified as follows: bristle, flat sable, round sable, scriptliners and stripers, blenders, and miscellaneous brushes.

Bristle Brushes are made of hog's hair and are most often used for oil painting. Three kinds of bristle brushes are in use. Those called brights have relatively short bristles, which allow a more

vigorous workout because the body of short bristles has only moderate elasticity. Bristles that are too short, generally from prolonged use, are not suitable for painting (see "Preservation, Reconditioning, and Cleaning," below). Brushes called flats have a long body of bristles, which makes them much more elastic— actually too elastic for handling stiff paint. They are best for finishing a painting in fluid strokes and for blending viscous paint.

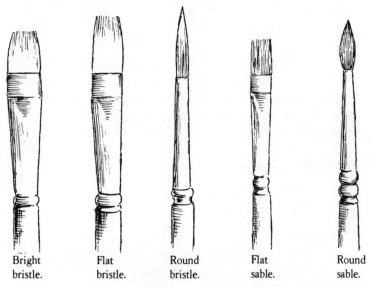

| Bright bristle. | Flat bristle. | Round bristle. | Flat sable. | Round sable. |

Although they are produced from the smallest size to about 2" in width, in practice bristle brushes smaller than No. 4 (about ¼" wide) are of little use because their narrow strokes create too harsh a texture. When a smaller size is needed, flat *Sable Brushes* should be used. Brushes larger than No. 12 (about 1¼" wide) are practical only for paintings of very large proportions.

Round bristle brushes are usable when the body of bristles is very long and elastic; they are useful for painting large paintings, for murals, and for certain very sketchy techniques. Short round bristle brushes are entirely useless because instead of depositing paint on the canvas they scrape it off. However, they can be used in *Acrylic Painting* for rubbing paint into the surface of a support (oil paint is too slippery for handling in this way).

Sable Brushes. The best sable brushes are made with hair from the tail of the kolinsky, an animal found in Russia; the less ex-

pensive types are made of fitch hair. Sables also come in three distinct categories: flat brushes; round brushes; and scriptliners and stripers. The characteristic of all these brushes is the softness of the marks they leave in the body of paint. Unlike the harsh bristles, they do not dig deeply enough into the layer of paint to mark it decisively; hence, these brushes produce smooth surfaces. This is particularly true of the flat brushes, which are most suitable for the delicate blending of colors. A width of about 1" should be considered the largest practical size. For the execution of miniaturistic details, the smallest of the round sables can be used.

Round sable brushes are used in oil painting, as well as in techniques that employ aqueous media and emulsions. A distinction should be made between brushes having a normally proportioned body of hair and those with extra long sable hair. The first allow precise, deliberate operation and, when they are small enough, permit the execution of the smallest, most accurately placed details. The larger of these brushes are well adapted for achieving *Linear* as well as *Painterly* effects.

Scriptliners and stripers are a class by themselves. The first, 1" to 2" long, terminates in a fine point. The second, of equal length (or longer in an extra large size), has a chisel shaped tip and can be used to produce broad lines. Unlike the shorter sable brush, the long body of hair in a scriptliner will not allow accurate demarcations, such as those required when painting details in a portrait, for example; nor will it allow precise definitions made on a small scale, because the long hair is too elastic to move with exactness over even very short distances. The great advantages of both these brushes are their mobility and the ability to take in a considerable amount of greatly thinned paint. The latter property allows the painter to work with the brush for a long time without having to turn to his palette for a fresh paint supply.

Blender. This is a brush set in a flat ferrule about 1" wide and made of hair too fine and weak to actually move oil paint; hence, when one brushes a wet oil-paint layer with it, only the very top surface of the color will be agitated, producing a very delicate blending of colors. A brush of this nature is also used in watercolor painting for laying a *Wash*.

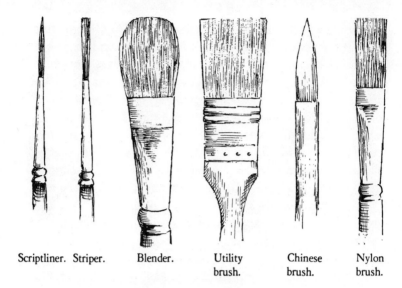

Scriptliner. Striper.　　Blender.　　Utility　　Chinese　　Nylon
　　　　　　　　　　　　　　　　　　brush.　　brush.　　brush.

Miscellaneous Brushes. The standard 1'' or 2'' *Utility Brush,* because of the elasticity of the hair and the capacity to shed liquids easily, is adapted for varnishing. *Chinese Brushes* (very soft, round brushes usually made of goat hair held in a bamboo handle) can be well used for calligraphic work in watercolor painting or in drawings, preferably those made with water soluble ink. Large, round brushes made of *Oxhair* and referred to as *Sabeline* are good substitutes for the large (and quite expensive) sable brushes. Lately *Nylon Brushes* have appeared on the market, primarily for use with acrylic colors.

Selection. Bristle brushes, as they appear today, date from the first part of the 19th century. The old masters' brushes did not have a flat metal ferrule that forces the body of the bristles into its characteristic shape; the ferrules of older brushes were elliptical or round. In order to respond with precision to the command of the painter's hand, the elliptically arranged bristles were constructed so that they curved to produce convex sides. This tapering shape is also a desirable feature in a modern brush, and well made brushes of the best brands are manufactured in this manner.

The long handles on modern brushes (they were shorter in earlier times) are not a handicap in aqueous mediums except in sizes smaller than No. 4; their balance suits their use. This is not the case with round sable brushes designed for oil painting. The

28

long handles on these brushes are decidedly disadvantageous; these tools are used in the same manner as writing or drawing instruments, and the excess length of the handle acts as a counterbalance, tipping the working end of the brush away from the surface of the canvas. Round sable watercolor brushes (which do not differ in quality from those used in oil painting) have short handles, but these are too thin as a rule. The handle of a properly constructed round sable brush should correspond in length and thickness to that of the standard pencil.

Preservation, Reconditioning, and Cleaning. The outer tip of the brush hair ends with a *Flag*, or split; the root of the hair is called the *butt*. The flag end tapers off, which contributes toward controlled handling of the brush. Therefore, trimming the brush, thus depriving it of its natural end, makes it useless for fine work.

When worn short brushes become worthless, but they can be reconditioned by cutting off a portion of the metal *Ferrule*. Because the hair in a well made brush reaches to the very end of the ferrule, considerable length can be added to the body of the hair by cutting away some of the ferrule. This is done by incising the metal all around with the edge of a file without, however, filing it through. Only in one place should the ferrule be cut through completely, and this vertically or diagonally to the filed line, i.e., along the length of the ferrule. Next, by using pliers and bending the portion at the filed line, one can break loose the metal; it will then peel off easily. The plastic adhesive which clogs the newly uncovered portion of the hair and the residue of paint which usually collects at the neck of the ferrule should be cleaned off with a paint remover. Strong scissors can be also used for cutting away the ferrule.

If still moist with oil paint, resin varnish, or tempera, bristle or sable brushes should be washed with soap and water. It is best to use the palm of one's hand as a ''washboard,'' rubbing the lathered brush on it to eliminate the residue of oil and or resin. Once saponified, the oil washes off easily with water. Particular attention should be given to dissolving any paint accumulated at the neck of the ferrule, for it is here where the decay of a brush, due to hardened paint, usually starts.

When painting daily, the artist can merely wipe oil paint off the brush and submerge it in a liquid called *Silicoil*, now generally

29

available in art-material stores. This mild solvent makes the residue of paint slide off the bristles or hairs. Before using the brush again, all one needs to do is wipe the brush dry. Brushes well hardened with oil, resin, tempera, or acrylics should be submerged in any commonly available *Paint Remover* and then washed with soap and water. Regardless of the length of exposure to these powerful solvents, even the delicate sable brush will not be adversely affected.

Even when dry, watercolor brushes made of sable hair or less expensive substitutes such as fitch, squirrel, or camel hair, can be thoroughly cleaned with warm water alone. When used with *India Ink*, these brushes should be washed with soap and water. A special liquid is available for dissolving dried India ink, but soap and ammonia will also prove effective in most cases.

Brushes (no matter what their nature) used in painting with acrylics should be washed with soap and water as long as the paint is still wet. When the paint has hardened, *Lacquer Thinner* or paint remover will soften the paint radically. As usual, soap and water should finish the job.

To keep a round sable brush in its proper shape, the hair must be brought into a perfect point after washing, then allowed to dry without disturbance. If the body of the hair cannot be made to terminate in a point, it should be tied up with a thread while wet, a measure that should be repeated, if necessary, to bring about permanent reconditioning. It should be noted, however, that hair worn short will not cling together and form a point. Upon washing, flat brushes of sable and soft hair should be pressed flat, and both sides should be pressed toward the middle to prevent the body of the hair from spreading sideways. When stored, these brushes should be protected by a moth repellent.

Bristle brushes should be treated in the same manner, but should the bristles refuse to hold their shape when they are pressed together, the body of the wet hair should be wrapped tightly with a piece of absorbent paper and left to dry. One or more such treatments will reestablish the original shape of a brush, provided that the bristles are not worn short.

BURNISHER. A tool with a tip made of *Agate* or steel. The
agate burnisher is used for polishing gold- and silver-leaf ap-

plications to a high gloss (see *Gilding*). When made of steel the tool serves to polish metal plates in *Etching*. The steel instrument can also be used for burnishing gold applications.

BURNT SIENA. This earth color is prepared by calcining (roasting) *Raw Siena* (which is a hydrated ferric oxide) with alumina and silica. In the process of being calcined, the color of the pigment changes radically, turning to a reddish-brown. Thus treated, its drying capacity and *Tinting Strength* become considerably enhanced. When undiluted by painting medium, burnt siena is quite opaque and rather dull, but when thinned its color attains a fiery tone which makes it most useful in glazing (see *Glaze*). The pigment can be used in oil, watercolor, and acrylic painting.

BURNT UMBER is an *Earth Pigment* and, like *Burnt Siena*, it is obtained by roasting the raw pigment (in this case, *Umber*) which changes its gray-brown to a dark reddish brown tone. Its composition also parallels that of siena. Because of their high content (up to 16%) of manganese dioxide, the umbers are the fastest drying colors on our oil palette. Adaptable to all mediums, burnt umber's *Opacity* and *Tinting Strength* are good and, as with all the earth colors, its permanence can be considered absolute.

BURR. A metal ridge formed on both sides of an incision made on a metal plate with a steel needle or a diamond point in drypoint (see *Etching*).

BUTT. The root of the hair used in making a brush.

BUTYL ACETATE is a strong solvent, similar in properties to *Amyl Acetate* (banana oil). It has a lower evaporation rate, greater leveling capacity, and hence better brushability than amyl acetate.

BUTYL ALCOHOL. On dried *Linoxyn* and lacquer, its solvent properties are stronger than those of ethyl alcohol. Butyl alcohol is miscible with most organic solvents, and it promotes the miscibility of petroleum products and ethyl alcohol. However, the vapors are toxic; it should be used with good ventilation.

31

CADMIUM-BARIUM COLORS. See *Cadmium Colors.*

CADMIUM COLORS (first introduced in 1846) appear on the market in two varieties: the pure (or, as they are labeled, C.P.) cadmium sulfides, dating from 1846, and the cadmium-barium colors. In more recent formulations, the latter are co-precipitates of cadmium sulfide and barium sulfide. (Co-precipitation is a manufacturing method that produces a homogeneous pigment.) The brilliance and durability of cadmium-barium colors are fully comparable to the much more expensive cadmium sulfides, and the co-precipitates should not be looked upon as adulterations.

The range of cadmium colors and cadmium-barium colors is as follows: cadmium yellow light, medium, and dark; cadmium orange; cadmium red light, medium, and dark. For all practical purposes, a painter could omit cadmium orange from his palette, for it can be obtained by mixing cadmium yellow and cadmium red. The darker varieties of cadmium red can be produced by mixing cadmium red light and *Alizarin Crimson*; the more crimson is added, the darker the color will appear. All cadmium colors are slow dryers. They possess great permanence, good *Hiding Power* and *Tinting Strength*, and are used in all mediums.

Cadmium Orange. This color can be obtained as such or can be produced by mixing cadmium yellow with cadmium red. The color is very powerful and, like all cadmiums, indispensable in flower painting. It dries very slowly, however, especially when applied with impasto.

Cadmium Red. Like cadmium orange, this color dries very slowly. Because of its bright, glowing hue, cadmium red light is perhaps the most "spectacular" color on the palette. As mentioned above, the darker, purplish variety can be purchased in tube form or obtained by adding alizarin crimson to cadmium red light. This will further delay its drying and will make the color more transparent. Cadmium red light closely resembles the classic (and still obtainable) *Vermilion.*

Cadmium Vermilion. A color of recent origin, its chemical composition consists of a cadmium mercuric sulfide, co-precipitated with barium sulfide. In this composition the mercury takes the place of selenium, which is part of cadmium red. With its mercury sulfide content, this pigment is really a combination of vermilion (a mercury sulfide) and cadmium red. It is just as permanent as cadmium red, and its brilliance is somewhat greater. But it possesses neither the opacity nor the firm body of vermilion.

Cadmium Yellow. This color is the brassiest of all the yellows on the palette. Its tinting strength is very great and its hiding power is quite good, but it dries slowly. Like all the modern cadmiums, it is considered absolutely permanent.

CADMIUM ORANGE. See *Cadmium Colors.*

CADMIUM RED. See *Cadmium Colors.*

CADMIUM VERMILION. See *Cadmium Colors.*

CADMIUM YELLOW. See *Cadmium Colors.*

CANADA BALSAM is a sap obtained from a certain kind of larch tree growing chiefly along Lake Ontario. This thick, viscous, aromatic substance is, for all practical purposes, identical with *Venice Turpentine.* As an ingredient in *Painting Mediums* or *Varnishes*, it is not desirable because it forms a weak and brittle film. However, this material is quite useful as an additive to the gelatinous adhesives used in *Relining Paintings* because it imparts elasticity and delays drying, thus facilitating the process of attaching the old to the new canvas. See *Restoration of Paintings.*

CANVAS. Although prepared canvas is available in art supply stores, the artist has greater control over the quality and character of his canvas if it is prepared in the studio.

Selection. Depending on the technique employed, the choice of a proper canvas can be of great importance to the final appearance of a painting, especially when the artist paints thinly or with only a slight *Impasto.* If the texture of the canvas is inferior and is not concealed in the final painting, the *Paint Quality* of a picture will be adversely influenced; of course, this will not occur when many paint layers completely obscure the surface of the fabric. Linen canvas is preferred by most professionals for its lively, faintly uneven texture. As a rule, cotton fabrics possess a monotonous, mechanical texture. In canvas made of synthetic or glass fiber, the mechanical appearance of the grain is so disturbing that its use for artistic purposes must be ruled out.

To determine the nature of a canvas, a thread should be unwound. If made of cotton, it will form a fluff; if made of linen, it will show long fibers. Thin cotton fabrics do not possess the toughness of equally thin linen, but the heavier grades, usually referred to as cotton duck, are adequately durable. Moreover, the tensile quality of linen canvas is much greater than that of cotton. This becomes apparent when stretching: there is practically no "give" to the stretched raw-cotton material, but linen can have considerable elasticity in its woof. This elasticity makes the texture of canvas prepared in the studio more variegated because the woof and the warp need not form right angles.

In choosing the weave of linen canvas, the following considerations should be kept in mind. For *Alla Prima Painting* the fabric should be very closely knit and, upon sizing and priming (see below), its tooth should almost disappear. Canvas used for portrait painting should have a moderate tooth, so as not to lose it completely even after a second underpainting, and its threads should be of equal thickness and free from knots. (Knots and rough and uneven threads can be desirable when many underpaintings are planned, however.) Cotton canvases can also be fine or heavy toothed, but their threads will always be uniformly thick or thin.

Stretching. For canvases up to 40" x 50", standardized stretcher bars are used. For larger sizes, the bars must be made of

heavier stock and should be equipped with crossbars. When the artist stretches raw linen, the pull of the material may even make a 40" long bar sag in the middle; in such a case, a 1" x 2" strip should be affixed temporarily at the point of sagging before sizing and priming. (The temporary strip, or crossbar, as it is also called, need not be nailed in, for the pull of the canvas will hold it in place during the working period.) Once the sized and primed canvas is dry, the supporting strip can be removed. After joining the stretcher bars (especially the larger sizes), test the corners with a carpenter's square to see that they are correctly aligned to ensure that the stretcher will fit into the rabbet of the frame.

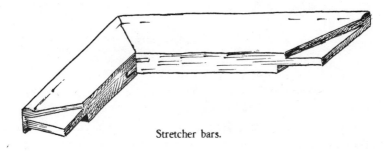

Stretcher bars.

Next, the canvas should be cut 1" larger all around than the stretcher size and nailed onto the sides of the stretcher bars as follows. First, nail the canvas to the middle of one bar with a single nail. Then pull the canvas taut toward both ends of the same bar and nail the ends down. (⅜"-long upholstery tacks are best for this purpose, or one can use a stapler.) Place additional nails between the end and middle nails, spacing them about 2" apart. The same procedure should follow on the opposite side; in addition to pulling the canvas sidewise, it should be stretched taut across the bar. On the third and fourth stretcher bars, the nails can simply be driven in one after another. There is no need to pull the canvas sideways, as this has already been done twice before, but maximum pressure should be exerted to pull the fabric across the bars. Those who have difficulty pulling the canvas with their

35

fingers can use a pair of canvas pliers. This instrument is not unlike the one used for bending wire, but its jaws extend horizontally to a length of 4''.

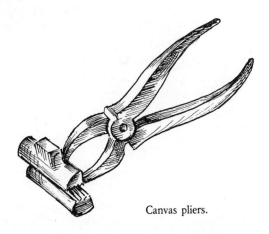

Canvas pliers.

The pressure of the canvas may cause some stretchers larger than 25'' x 30'' to twist from their flat position. Should this happen, the canvas, still wet from sizing, should be placed on the floor and weighted down on all four corners of its stretcher bars so that it lies perfectly flat. When it dries, it will remain flat.

Sizing. According to the traditional method, glue *Size* is prepared from 1 oz. hide glue mixed with 1 pt. water. It is applied to the canvas in a gelled condition, not as a liquid, because the liquid would easily penetrate in spots to the reverse side of the canvas, leaving the interstices of the canvas open and allowing subsequent primers to seep through. The gel, on the other hand, forms a thin membrane that completely closes the openings in the fabric. This glue membrane is very sensitive to heat while still wet. It should be allowed to dry at normal room temperature; any exposure to heat to accelerate drying would destroy the cohesion of the thin glue film.

When dissolved by heating, the size will gel at normal room temperature. As soon as it cools, the gel should be crushed to a mush with a *Spatula* and spread very thinly and firmly into the interstices of the canvas with this tool. To avoid forcing the

stretcher bars against the canvas surface and making creases, it is essential to keep the fabric as taut as possible. As a precaution, it is good practice to insert a piece of thin cardboard between the canvas and the stretcher bar when applying size. Still better, an aluminum panel can be constructed to protect the canvas when working on the areas over the stretcher bars.

Aluminum panel.

After the sized canvas dries, its surface fuzz, hardened by glue, is often quite rough and requires light sanding. This is true of linen but is not the case when sizing cotton. Because the sandpaper will remove some of the glue from the top grain, a second sizing will be necessary. This one will dry much faster. Priming can follow.

Priming. The best material for priming is the canned variety of *White Lead* paste (sold in most hardware stores), not the liquid paint. To spread the paste easily, it should be thinned a little with *Copal Painting Medium* and then be applied very thinly to the canvas with a spatula. It is essential to insert a piece of cardboard between the stretcher bar and the canvas to avoid making creases that will show in the fabric. The spatula should press the paint into the interstices of the fabric, but should not leave a substantial film. To accelerate the drying of the priming, add some raw *Umber* or *Burnt Umber* oil color or a few drops of *Cobalt Dryer* to each teaspoonful of white lead. A thin fabric may require only one priming, but as many as three primings may be needed, depending on the roughness of the fabric's texture. Allow each priming to dry for a few days before applying the next one.

After this work is done, the canvas often becomes slack. Should this happen, wooden *Keys* should be inserted into the grooves

37

provided in the corner of each stretcher bar. At first only one key should be hammered in gently to see whether it will make the canvas taut, then the next key, if needed, and so forth. Eight keys in all can be used, two in each bar. These should be secured from falling out by driving a nail in front of them.

Keys.

On one thin priming, painting may proceed in a week's time. A longer time should be allowed for drying several layers of priming. When kept in the dark, the priming prepared from white lead paste will yellow. This will not affect the color of the subsequent painting; moreover, when exposed to strong light again, the white will be bleached (see *Yellowing of Oil Paint*).

The canvas preparation method described above has been practiced since about the middle of the 15th century, when canvas generally replaced wooden panels in oil painting.

Priming with Acrylic Gesso. Because it lacks elasticity, traditional *Gesso* cannot be used for the preparation of canvas, but *Acrylic Gesso* is very suitable for this purpose. The first layer of priming (without prior sizing) should be applied with a large *Utility Brush* carrying very little paint, so as not to force the material through to the reverse side of the canvas. Subsequent coats can be applied with a painting knife or *Spatula*. The gesso priming solution, even if undiluted, is thin, and several applications are needed on a rough fabric to minimize its tooth. This will make the canvas relatively stiff, however, and not very responsive to the action of the painting knife.

CAPUT MORTUUM (Latin, "the head of the dead") was a term used one time in Europe for an iron oxide earth pigment containing a large quantity of hematite ore, which was responsible for its deep, dark purplish-red color. The modern equivalent is Mars violet (see *Mars Colors*).

CARBON BLACK is obtained by burning natural gas. It is a deep brownish-black and has great *Tinting Strength*. It cannot substitute for either *Ivory Black* or Mars black (see *Mars Colors*), because its color is too aggressive and its drying capacity (without the addition of a metallic *Dryer*) is very poor. This pigment is widely used in industrial painting.

CARBORUNDUM PAPER is a trademark for a variety of abrasive papers (known under the general term "sandpaper"), such as "Garnet," prepared from silicon carbide compounds.

CARDBOARD. A paper-pulp product having sufficient thickness to make it stiff. The designation refers generally to an inferior material not suitable for permanent art work. See *Illustration Board.*

CARMINE LAKE (also known as cochineal and crimson lake) is a natural organic dyestuff derived from the dried body of an insect that lives on various cactus plants in Mexico and Central and South America. The color is no longer in use. *Alizarin Crimson* and acra crimson (see *Acra Reds*) closely resemble its tint.

CARNAUBA WAX, the hardest, highest quality of all the *Waxes* used for the preparation of wax-resin compounds, is obtained from the leaves of certain Brazilian palms. The best quality is a light yellowish color; lesser grades are brownish.

CARPENTER GLUE is a product manufactured from clippings of animal hide; hence this glue is interchangeable with hide glue, considered to be a superior quality of the adhesive. Lesser grades of carpenter glue are prepared from the cartilages and mucous membranes of animals; the highest quality comes from the clippings of rabbit skins.

CASEIN GLUE is a complex organic compound belonging to the class known as proteins. The best quality (manufactured by Borden) is labeled "lactic casein." To dissolve it in water, put it in a double boiler (never place it directly over a flame or hot plate), and slowly heat it, stirring constantly. When the water in the bottom pot gets close to boiling, stir in *Ammonia Water Borax*, or *Ammonium Carbonate*. Continue stirring until the solution is smooth. The formula for a solution suitable for painting would be 8 oz. water, 3½ oz. casein, 1 oz. concentrated ammonia. To make it useful as a *Binder* for pigments—that is, to make it somewhat flexible—*Glycerin* must be added to the solution; but this will make the glue soluble in water, whereas one advantage of casein is that it is normally insoluble when dry. See *Casein Painting*.

CASEIN PAINTING. The utilization of casein as a binder for pigments reaches into antiquity. Once it has dried casein paint becomes largely water-insoluble. The formulations employed for the manufacture of artists' paints differ with various brands, and, to all appearances, none of them can be considered "ideal." The difficulty in producing a wholly satisfactory material makes the home production of casein paints inadvisable.

What are the advantages of painting with casein colors as compared with other water-based mediums such as watercolor or acrylics (see *Watercolor Painting; Acrylic Painting*)? In comparison with watercolor, casein is more suitable for *Gouache* painting, that is, for producing opaque applications that can be slightly pastose. Because of the paint's tendency to become brittle, however, only very moderate impasti are advisable. In contrast with pure transparent watercolor technique—where white paint is not used because the white paper serves this purpose—white is used in practically every color mixture in casein painting. This implies that, unlike watercolor, casein permits repeated over-painting. However, the rapid drying of the paint does not allow free manipulation of the material, and multiple overpaintings become brittle. Casein lacks the fluidity of watercolor and the solidity and flexibility of acrylic, which does lend itself to unlimited overpainting. For these reasons, casein paint has become obsolete since advent of acrylics.

CASSEL EARTH. See *Van Dyke Brown.*

CATALYST. A substance that brings about or accelerates a chemical reaction but remains itself unchanged. For example, an aqueous (water-based) material is not miscible with an oleaginous (oil-based) substance, but a catalyst such as glue or egg will form an emulsion combining these ingredients.

CEMENT, PORTLAND. This material, used for *Mural Painting*, is made of calcining limestone and clay in a furnace and adding sand or marble dust in proportions ranging from 1:1 to 1:3 and enough water to make the mixture a proper consistency. When lime is added to this mixture, it is called "mortar" instead of cement. Mortar possesses greater plasticity and adhesive power; it is used for cementing bricks, stones, etc. The term "concrete" applies to a mixture of cement, sand, and crushed stone, called aggregate. By mixing cement with sand or marble dust in the proportion of 1:1 and then using *Acrylic Polymer Medium* instead of water, plasticity and adhesive capacity of the material can be greatly enhanced. All these mixtures set rapidly but depending upon their volume, require hours or even days for their complete hardening or "curing," as it is called.

CERESIN. An earth wax of dazzling white color obtained from the crude wax Ozokerite found in oil fields near the Ukrainian town of Boryslav. It differs from paraffin (a refined petroleum product) in having greater plasticity and a higher melting point. Ceresin is sometimes employed as a substitute for *Beeswax.* (The melting point of beeswax is around 65°C., that of ceresin between 60° and 80°C., and that of paraffin about 55°C.)

CERULEAN BLUE (in use since 1860) is composed of a tin and cobalt oxide which forms a heavy pigment of excellent *Hiding Power* and *Tinting Strength*, great permanence, and good drying qualities. Because of its high price (it is among the most expensive of all colors), it rarely appears as a genuine pigment in tubes. Usually, the designation "cerulean blue" indicates a mixture of *Viridian Green, Ultramarine Blue*, and white or of *Phthalocyanine Blue, Phthalocyanine Green*, and white. It differs

from other blues in its greater opacity and from *Cobalt Blue* in its greenish cast.

CHALK is a natural form of calcium carbonate; it occurs widely all over the world. Crude lumps of the material, when ground with water and subjected to *Levigation*, serve as *Gilder's Whiting.*

CHARCOAL is prepared by the carbonization of willow twigs. The sticks come in various thicknesses, averaging ¼" in diameter. Their degree of softness also differs. Charcoal that has been subjected to shorter roasting is hard and of little use. Charcoal is undoubtedly one of the oldest and most versatile *Drawing* instruments.

Charcoal stick.

CHIAROSCURO is a term that originated, most likely, during the 15th century, denoting the light-shade relationships in a painting or drawing. It was often used to refer to a painting with well defined areas of light and shade. Only the use of a focal light from a specific direction, not a dispersed light, can provide such chiaroscuro effects.

CHINA CLAY (kaolin, pipe clay) is the basic material used in ceramics. Deposits of this clay that have great plasticity and are free from iron oxide are found all over the world.

CHINA WOOD OIL. See *Tung Oil.*

CHINESE BRUSHES. This general term is used for brushes made of very soft hair, usually goat hair, always thick at the mouth of the ferrule but terminating in a very fine point. Such brushes were originally used for Chinese calligraphy and Chinese painting styles, in which a rapid transition from the finest to the widest marks needs to be accomplished. Chinese brushes are also adaptable to *Watercolor Painting* and to ink *Drawing* techniques favoring a style similar to Chinese graphics.

CHINESE WHITE is used for *Watercolor Painting*. It is a combination of the pigment *Zinc White*, the binder gum arabic (see *Gums*), and *Glycerin,* which is a standard additive for all watercolors stored in tubes. Because *Flake White* (white lead) does not retain its color in such combinations, it cannot be used in aqueous solutions, but *Titanium White* is suitable for use in watercolors as well as in *Acrylic Painting.*

CHROME GREEN is an obsolete color, made by mixing *Prussian Blue* and *Chrome Yellow* (the latter has been superseded by cadmium yellow). Chrome green is sometimes called *Zinnober Green.*

CHROME YELLOW (lead chromate) is an impermanent, obsolete pigment that has been superseded by cadmium yellow (see *Cadmium Colors*).

CHROMIUM OXIDE GREEN OPAQUE (in use since 1862) is one of the densest, most opaque pigments. Of great permanence and *Hiding Power*, it dries moderately quickly and can be used in every technique. Its color is quite dull. Because of these qualities, it should be mixed only with colors of compatible tinting strength, such as the *Iron Oxide Reds* and the *Cadmium Colors.*

CINNABAR. See *Vermilion.*

CLASSIC PAINTING TECHNIQUES are those developed for *Oil Painting* in the 15th and 16th centuries.

CLEANING PAINTINGS. See *Restoration of Paintings.*

CLEAVAGE is the loss of paint film from a certain area. Where this occurs in an oil painting on a canvas or a panel, a putty prepared from *Flake White* and raw umber or *Burnt Umber* should be applied to the surface with a painting knife so as to make the damaged area flush with the existing (original) priming or underpainting. Repainting can then be done upon a thoroughly dried layer of this putty. See *Restoration of Paintings*.

COAL-TAR DERIVATIVES are hydrocarbons obtained from the destructive distillation of coal tar. Examples are *Toluene* and *Xylene*.

COBALT BLUE (discovered in 1802) is a very stable color of moderate opacity and *Tinting Strength*, good drying quality, and adaptability to all techniques. Its tone, somewhat sweet, limits its use chiefly to painting sky areas.

COBALT DRYER is a petroleum based liquid that contains salt of cobalt. It is used for *Acceleration of Oil Paint Drying* because oil paints dry by oxidation and this substance promotes their oxygen intake.

COBALT GREEN. Because of its very slight *Hiding Power*, low *Tinting Strength*, and poor drying qualities, this color is of little use to the painter. Essentially, cobalt green is a homogeneous compound of *Cobalt Blue* and *Zinc Yellow*. A green produced by mixing cobalt blue, cadmium yellow (see *Cadmium Colors*), and some white would yield a far more useful color.

COBALT VIOLET. It possesses low *Tinting Strength,* great transparency, and slow drying qualities. This pigment is of little use, therefore, in oil painting but it is well adapted for painting with aqueous mediums.

COBALT YELLOW. See *Aureolin.*

COCHINEAL has been superseded by *Alizarin Crimson.*

44 COLLAGE is a technique that employs materials of every

description (paper, fabrics, even rigid objects), affixing them to a support (canvas, panel, paper) to create variegated patterns of color and texture. The materials are generally incorporated into layers of paint, preferably acrylic, because it dries quickly and possesses considerable adhesive properties. The incorporated materials can then be painted or left in their original state.

If applied to a dry surface, the collage materials are glued onto the support. For this purpose, one can use *Acrylic Polymer Medium*, *Acrylic Gel*, *Acrylic Modeling Paste*, or *White Glue*.

COLOPHONY, generally referred to as *Rosin*, is the residue left after the distillation of *Turpentine*. Because of its weakness—easy solubility and deterioration of the film under the influence of moisture—it is worthless for use in painting. It is sometimes employed as an adulterant in the preparation of varnishes, as a substitute for a higher grade resin such as *Copal*. Its presence in products labeled *Copal Varnish* can be detected easily by submerging in water a glass slide that carries a dried film of the varnish. Whitening of the film will indicate substitution of colophony. In an *Emulsion* with glue, it is used successfully for *Relining Canvases*.

CONCHOIDAL FRACTURE. The shell-like, vitreous appearance of the broken surface of such materials as lumps of *Copal* resin.

COPAIBA BALSAM is an exudate from larch trees found in Brazil and Venezuela. Its quality and appearance vary considerably according to its origin. Because of its penetrating action, it was assumed at one time that this balsam could regenerate dried, brittle paint films; today this theory has been discounted. When mixed with *Turpentine* and left on the surface of a painting for a long period, however, it will soften an old oil varnish (a varnish that employs a resin dissolved in oil) and make this old varnish film more responsive to the action of various *Solvents* such as *Acetone*, *Alcohol*, etc.

COPAL resin is a term for a hard resin of fossil origin (i.e., an exudate from coniferous trees now extinct) which is found (like

coal) underground in amorphous chunks of varying size. The general designation "hard" resin is not quite specific. Many border cases are often classified as hard, and among themselves, the hard resins vary considerably as to chemical composition and the corresponding degree of hardness, purity, and color. The principal characteristics of the true hard resin are that it does not soften in boiling water (as does a soft resin such as *Damar*) and that it will not dissolve in any of the known solvents without prior thermal processing. It can, however, be softened to a gel in *Butyl Alcohol* or tetrachloretane.

The term copal resin is also not specific unless the place of its origin is named. The quality of resin that concerns the painter comes from the Congo, and is hence referred to as Congo copal. Among the resins found in the Congo, there are various grades of color, such as amber, straw, pale, and water white; the last is the lightest and purest grade of the material. The resin is used as a volatile varnish and as a component of an oil painting medium. For the latter purpose it is produced in the United States solely by Permanent Pigments of Cincinnati, Ohio.

Preparation. As mentioned before, the resin cannot be dissolved in any of the commonly used solvents. It dissolves only when it is submitted to high temperatures, is liquefied by the heat, and is then kept under the heat for a sufficient time to make it compatible (that is, soluble) with oil as well as with a volatile solvent.

The preparation of a hard resin was first described in the manuscript of Theophilus, written in the 12th century. Theophilus appears to distinguish between hard and soft resins, referring to the former as "glassa" and to the latter as "fornis." The method of preparation described in his manuscript remains essentially unchanged to our day.

The process of preparing copal for use in paints is referred to as "running," and the task should be carried out as follows. The lumps should first be reduced to small particles by crushing them in a brass mortar or by placing them in a linen bag and pounding them with a hammer. Next, the material should be put in a stainless steel or aluminum vessel (iron or copper would adversely affect the color of the melt). Depending on its quality, the resin should be subjected to temperatures ranging from $580°$ F. to about

630° F. After exposure to heat for one hour, the resin liquefies. When it starts to drip off the stirring paddle like hot oil, but *before* all the lumps have disappeared (to avoid the danger of overheating), the melt is poured through a strainer into shallow tin pans, where it solidifies upon cooling. As such, it is referred to as "run resin." It can be then broken up into small pieces.

Dissolving Run Copal. When it has been reduced to small lumps, the run copal will now dissolve like any soft resin in a *Volatile Solvent.* To fuse it into oil (to form *Copal Concentrate*) the oil must first be preheated to a temperature of 400° F. in a double boiler. For this purpose, it is better to use heat-treated oil, such as stand oil, instead of raw linseed oil. Within ten to fifteen minutes, the melt will combine with the oil in a homogeneous solution. To ascertain whether the resin has been sufficiently incorporated with the oil a few drops of the solution should be taken out after about ten minutes of heating, placed on a glass plate, and permitted to cool. If the drops remain clear, a state of homogeneity has been reached; if they are cloudy, the heating should be resumed.

While still hot the mixture should be filtered through several layers of cheesecloth to free it from impurities. (When it cools it becomes too viscous to be put through this operation.) The copal-stand oil combination is known as copal concentrate and serves to improve the viscosity and quality of paints. According to authoritative statements by Helmut Ruhemann and Dr. Paul Coremans, the copal resin constituted a part of the painting mediums used by some of the early masters whose paintings have remained unchanged by time, retaining their original brilliancy of color.

Testing Adulteration. To prove adulteration of so-called copal varnish by substitution of an inferior ingredient, the following test should be made. On half of a glass slide, the material to be tested should be brushed on, then allowed to dry for at least 48 hours. At that time, the end of the side that is free from varnish should be submerged in a vessel containing turpentine. Thus, the varnish film above the turpentine will be exposed to the action of its vapors. If after exposure of a few hours (or longer) the film becomes soft or spongy, the presence of an inferior material can be

assumed. Genuine copal varnish films are unaffected when subjected to the same test.

COPAL CONCENTRATE is a compound of *Stand Oil* and *Copal* resin. When added to tube oil paint, the concentrate changes its body from short to long (see *Short Paint; Long Paint*), enhances the depth of color, and forms a nonporous *Linoxyn* of great toughness and elasticity. It also serves as a picture *Varnish* in a 25% concentration. (The author's formulation of copal concentrate is manufactured by Permanent Pigments.)

COPAL PAINTING MEDIUM is a mixture of *Copal* resin, *Stand Oil*, and *Turpentine*. The proportions of the ingredients are adjusted to impart elasticity, durability, and non-yellowing quality to oil paint. A medium formulated along these lines allows the painter to *Glaze, Scumble*, and superimpose colors while painting wet-in-wet. (The author's formulation of *Copal Painting Medium* is manufactured by Permanent Pigments.)

COPAL VARNISH is a thin volatile fluid useful for making an *Imprimatura* and excellent for *Varnishing* well-dried paintings. (The author's formulation for *Copal Varnish* is manufactured by Permanent Pigments.)

COPPER PLATE is used in *Etching.*

CO-PRECIPITATION is an industrial method that combines two different pigments to form one homogeneous substance, such as the *Cadmium-Barium Colors.* In other words, it is an intimate combination of two substances that are precipitated simultaneously in one chemical reaction.

COTTON CANVAS is less expensive than linen canvas but is more mechanical in its weave and has a less interesting surface. However, with regard to durability, it is not inferior, although the tensile strength of its fiber is weaker.

COTTONSEED OIL dries slowly and forms weak films. It is not suitable for use in painting.

COUPLING AGENT. A solvent that makes it possible for two immiscible fluids to mix. An example is *Acetone.*

COVERING POWER. In a strict sense, this term refers to the extent over which a certain volume of paint will spread, in normal thickness, on a surface. In practical use, the term is interchangeable with *Hiding Power,* the capacity of a color to cover up a different underlying color. For example, when equal, normally thin films of *Zinc White* and *Titanium White* cover up any given darker colors, the underlying color will remain visible to some extent under the layer of zinc white, but titanium white will hide it completely. Thus, titanium white has greater covering power or hiding power.

C. P. denotes that a substance is chemically pure.

CRACKING of the dried oil paint film (*Linoxyn*) can occur because of the inherent incompatability of different paints or because of faulty formulation of paints common in the latter part of the 19th century and the beginning of the 20th century. Cracking can be due to one of the following specific reasons. (1) A faulty paint support resulting from (*a*) a brittle canvas priming due to sparsity of a flexible binder in the priming; (*b*) excessive thickness of the priming in relation to the fabric which holds it; (*c*) gesso ground applied to canvas. (The theory that "half-oil" grounds— that is, oil emulsified with gesso—will be sufficiently flexible is without substantiation.) (2) A faulty paint technique due to (*a*) the compounding of pigment with an insufficient amount of the binder; or *(b)* dilution of the binder with too much turpentine. This will make the linoxyn inelastic, and contribute to its flaking and powdering off. (3) Unfavorable atmospheric conditions, such as (*a*) prolonged excessive heat and relative low humidity, contributing to rapid dessication of the paint film and rendering it brittle; *(b)* continued extreme variation in humidity, heat, and cold; *(c)* prolonged excessive humidity, which softens the glue sizing of the canvas and promotes the development of mold. (4) Mechanical causes such as (*a*) forceful keying of the stretchers; (*b*) tight rolling of the canvas (especially when this is done with the painting face in); (*c*) pressure against the canvas.

A network of fine cracks—the so-called crackle covering the surfaces of many old paintings done on canvas—is due to the expansion and contraction of the canvas over a long period, caused by changes in atmospheric conditions. On panels, such cracks are even more evident; they run parallel to the wood grain. Shrinking of the wood or canvas support produces cracks with slightly raised edges around the fragments of the paint film. Cracks resembling alligator skin, called "alligatoring," appear on wood as well as on canvas supports, chiefly on 19th-century paintings; alligatoring is caused by an improperly formulated paint material. Deep fissures in paintings of the same period were caused by the bituminous paint, *Van Dyke Brown*. Sharp, circular breaks in the paint film and the priming are also found on late 18th-century and 19th-century paintings executed with extreme smoothness on a surface lacking the requisite texture or "tooth." Reticulated wrinkling of linoxyn—again a malady of some 19th-century paintings—is the result of using excessive amounts of *Siccatives* or paint too rich in oil (usually a cooked oil).

Properly formulated *Copal Painting Mediums* will eliminate the dangers of the following circumstances, once responsible for cracking: painting on a perfectly nonabsorbent surface or on a toothless surface; painting on an only partially dried priming or underpainting; a difference in drying time of underpainting and overpainting. When paint is compounded with a sufficient amount of copal painting medium and conditioned by *Copal Concentrate*, there is no danger of painting "lean on fat," a circumstance which would otherwise account for poor adhesion of the superimposed layers of paint. Proper formulated volatile *Varnishes*—no matter how heavily applied or how early—will not cause the linoxyn to crack.

CRADLE is a device that prevents a wood *Panel* from warping. It is a lattice that is affixed to the reverse side of the panel in the following manner. Strips of wood (about ½" x 1" in thickness), lying on edge, are glued to the panel, parallel with its grain, a few inches from each other. These are slotted so that cross strips can be guided through them, lying flat on the wood, the same distance apart as the other series of strips. These cross strips are not glued onto the panel, and thus allow certain minimal but unavoidable

Cradle.

contraction and expansion of the wood panel but do prevent it from warping. See also *Wood Panels*.

CRAWLING, also referred to as trickling, is the tendency of liquids to contract into droplets on a surface instead of spreading evenly. To remedy this in oil painting, turpentine should be brushed onto the surface and allowed to evaporate. In the case of water-based paints, a trace of common detergent or ammonia should be added to reduce surface tension.

CRAYON is a general term for various drawing instruments consisting of pigment in stick form. The black, soft, slate-like material commonly referred to as ''lead'' is found in natural deposits, and has been used since antiquity. A ''lead'' may also mean a crystalline form of carbon known as *Graphite,* also found in natural deposits. Crayons can also be colored. These are usually prepared from various inert materials, such as *Whiting,* with a colored pigment added, or they may be made from a pure pigment bound by a water-soluble glue. Some crayons are prepared with water-soluble dyes; their marks can be gone over with moistened brushes. Wax crayons contain—as their name indicates—an addition of wax. These leave more or less permanent marks. Wax crayons are used sometimes in connection with watercolors. The terms crayon and *Pastel* are not interchangeable. See *Drawing.*

51

CREMNITZ WHITE is a form of *White Lead* prepared by the action of acetic acid and carbon dioxide on *Litharge*. It is more crystalline than other types of white lead and was once quite popular on the European market. It is not manufactured in America.

CRIMSON LAKE. See *Carmine Lake.*

CROSSHATCHING is an optical device for blending colors and tones; it is produced by thin lines crossing one another. This kind of tonal transition is most often carried out in pen and ink or in quickly drying paints such as tempera and acrylics that do not allow blending in the manner of *Oil Painting.*

DAMAR is a soft resin, exuded by certain coniferous trees that grow in the East Indies, Malaya, and adjoining lands. The quality of the material used for artistic purposes is known as Batavia damar A/E standard. Dissolved in a petroleum solvent or in *Turpentine,* without thermal processing, it serves as a picture *Varnish.* Because of its perishability, it remains soluble in turpentine regardless of its age; it is not advisable to use it as a component in *Painting Mediums.*

DAMAR PICTURE VARNISH is a final picture varnish prepared from *Damar* resin. In the author's formulation (manufactured by Permanent Pigments), the resin is dissolved in turpentine with a small addition of *Stand Oil.* "Final" implies that the varnish should be used on well dried paintings—that is, about one year after their completion and even longer for paintings with heavy *Impasto.* This precaution is taken not because premature varnishing harms the paint surface but because the varnish does not last well on a surface that has not solidified sufficiently. The varnish should be brushed, not sprayed, on. Although it dries to the touch in a matter of minutes, this varnish retains a slight "tack" for a day or two.

DAMAR RETOUCHING VARNISH contains a much weaker concentration of *Damar* than does *Damar Picture Varnish.* The lighter solution is applied as soon as the painting is superficially dry—that is, in a week or two after its completion, depending on

the kind of paints and media used and the prevailing climatic conditions. This varnish will cause the dull paint surface to become glossy and reveal its true colors, but it will ultimately turn dull again. Therefore, during a period of a year, two or three varnishings may be required, followed by the application of final damar picture varnish or *Copal Varnish* when the picture is thoroughly dry.

DAMAR SOLUTION HEAVY is, as its name indicates, a heavy concentration of *Damar* resin in *Turpentine,* used in the preparation of emulsions for *Tempera Painting.*

DARKENING OF PAINT FILM. Inferior *Linseed Oil* and linseed oil containing an excessive amount of *Dryer* will turn to a brownish color. When low-quality oil is used to bind pigments, it will affect the light colors (especially white) and generally lower the tonality of an oil painting. Depending on its severity, such a condition can be remedied only with difficulty or not at all (see *Restoration of Paintings*). Darkening of the paint film is also caused by dirt incorporated in the film; normally, appropriate cleaning of the painting will remedy this. Darkening caused by faulty manufacture or deficiency of the paint is not encountered nowadays if permanent colors are used.

DAUBER is an instrument shaped like a very large pestle, with a core of fabric and a covering of *Tarlatan,* used to ink the plate in *Etching.*

DEAD COLORING is another term for *Grisaille.*

DECALCOMANIA PAPER has a gum arabic coating (see *Gums*) that allows drawings made on it to be transferred to a lithographic stone (see *Lithography*).

DESIGNERS' COLORS are opaque watercolors. See *Gouache.*

DIACETON ALCOHOL is a solvent used in the *Restoration of Paintings.* Its efficiency, however, is limited to reviving paintings that were executed with a medium containing *Mastic* resin.

Because of its strong dissolving action on the *Linoxyn* of such paintings, it must be used carefully and with a lint-free material, such as cheesecloth. After a short and gentle rubbing, the sunk-in colors and lusterless surface will recover their original appearance.

DIAMOND POINT is a diamond splinter set in a wooden handle. It is the most efficient tool for drypoint (see *Etching*).

DIOXAZINE PURPLE is a recently developed, very permanent organic deep purple. It is available on the market in such aqueous compounds as watercolor, casein, and acrylics.

DOUBLE BOILER. An arrangement of one vessel, containing material to be subjected to thermal processing (such as glue or wax), placed in another, larger vessel, containing water. Even when the water in the lower vessel is heated to its boiling point, the material placed in the upper vessel cannot be overheated. Furthermore, the fumes of solvents such as turpentine or mineral spirits (with boiling points from 150°C. to 180°C.) will not tend to ignite, since the boiling point of the water with which they are heated is only 100° C. (212° F.).

Double boiler.

DOWICIDE A; DOWICIDE B. Dowicide A is a trade name for sodium orthophenylphenate, a fine powder that serves (in the proportion of 1%) as a preservative for solutions containing gum arabic or casein. Dowicide B (sodium trichlorphenate) is especially

55

recommended to prevent animal *Glue* solutions from decomposing. (The alternate preservative used for this purpose is Phenol.)

DRAGON'S BLOOD is a dark red resinous exudate from the fruit of a palm indigenous to East Asia. When dissolved by being heated in *Damar* varnish or *Copal Varnish,* it is useful for coating metal applications (see *Gilding and Silvering*).

DRAWING. The character of a drawing is predicated on the materials used, specifically on the nature of the drawing tool and, to a lesser degree, on the character of the *Paper.* (The personality of the draftsman expresses itself directly through the tool, whereas the paper's surface contributes chiefly toward the effect of texture. The texture of a paper often materially influences the working of the drawing tool, however.)

There are two basic categories of drawing: wet medium, in which the marks flow onto the paper, and dry medium, in which the tool (such as a crayon) registers its marks through abrasion against the paper surface. Whereas a crayon or similar tool is capable of producing a great range of shades—depending upon the pressure placed on the instrument—ranging, for example, from the lightest gray to the deepest black—we possess but one ink of any given color, with which all effects are achieved either by detached lines or with washes (a technique used in *Watercolor Painting*) made by diluting the ink.

Drawing Tools. We may differentiate here between semirigid and rigid instruments. To the first category belongs the pen point, which shows various characteristics. Depending on the thickness and elasticity of its point, the pen can produce lines that are thin and delicate, thick and strong, and of even or varied width. The pen point can be made of many materials, among them gold, steel, a quill, a reed, and felt.

Metal pen points can be used in a handle or in a fountain pen especially made for *India Ink,* which cannot be used in an ordinary fountain pen. (Recently, however, a nonclogging India ink has been brought onto the market; it is claimed that this product can be used in standard fountain pens.) Obviously, the most valuable property of the fountain pen is that it obviates the necessity of

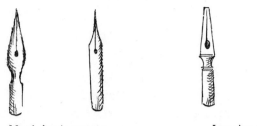

Metal drawing pens. Lettering pens.

dipping it into an inkwell and therefore allows uninterrupted work. Since the pen point cannot be changed easily in such an instrument, however, a number of fountain pens will be needed, each having a different point, to permit a large variety of strokes. About four such pens, in addition to a few steel-point pens having characteristics not commonly found in a fountain pen, will answer every possible demand.

The traditional quill (made of a goose or turkey feather) was the sole writing and drawing tool prior to the advent of the metal pen in the 19th century. The quill's chief advantage lies in the flexibility of its point, which allows a stroke of great delicacy as well as great strength. The Chinese reed pen, on the other hand, is static and semirigid; it is available in a variety of points ranging from thin to broad.

Still more tools are at our disposal. Ballpoint pens leave marks of a perfectly even width and are especially suitable for circular delineations. They contain inks of various intensities, some resembling the marks of a pencil, others resembling the inks used in pens. There are also perfectly rigid wire-nib points, best for straight lines and staccato effects. The felt- or fiber-point pens have nibs of various shapes and use a powerful black dye held in a tank. Finally, there is the round *Sable Brush.*

Lately, pens with nylon nibs of various thicknesses have appeared. These are equipped with cartridges that discharge a strong dye, black or colored. The common quality of all these quasi-fountain pens is their uniform stroke; they allow no variations in the intensity of the ink. (Remember that a hair-thin black line may appear on the white paper as gray in comparison with a thick line produced with the same ink.) An exception is the pen that is equipped with a valve that, when pressed down, allows a certain

57

amount of ink to enter the felt nib. The advantage offered by this instrument, which is sold under the trade name of Flo-Master, is that as the quantity of the dye in the nib diminishes, so does the intensity of the color; thus all shades can be produced.

Cutting Reed and Quill Pens. The first is an *Oriental* tool, generally made from a bamboo stick. Usually of Japanese origin, it is available ready-made in art supply stores, but it can be cut easily from any ½'' thick bamboo stalk. The nib should be split up the middle about ½'' to ¾''.

Cutting a reed.

Cutting the quill is done in three stages. The knife used for this purpose should have a razor-sharp thin blade. The first cut should be about 1'' long. Next, the split in the middle is cut to a length of about ¼''. Then the nib should be pinpointed on both ends.

The deficiency of both the reed and the quill pen is their incapacity to hold a sufficient amount of ink. Ink capacity can be greatly improved by coiling a fine copper wire closely inside the cut, about ¼'' from the penpoint.

Inks. For work with the pen, waterproof India ink is superior to any other material. It possesses a dense, heavy body, and is not readily miscible in water. Once dry, India ink becomes completely water-insoluble, and its marks, if not made on a hard-surfaced paper, cannot be effectively erased. It must be used only in a special type of fountain pen, the so-called barrel pen, because the ink will clog a normal fountain pen and make it useless. Even the barrel pen will become clogged if not kept clean and emptied of the

ink when not in use for long periods. However, a special cleaning agent, sold in art-material and stationery stores, is effective in dissolving dried-in residue. Recently, an improved India ink that has less tendency to congeal has been put on the market. Waterproof India inks are also available in a variety of colors, but these tend to fade.

Other mediums suitable for work with pen or brush are water-soluble black inks and Chinese ink sticks. The latter must be dissolved in water by rubbing them against the walls of an appropriate container. Such a container, a so-called "slate ink saucer" can be bought in some art-material stores. Concentrated Chinese ink can also be obtained in paste form; it can be thinned with water as desired. The advantage of this material is that an ink of a desired consistency—thin or dense—can be prepared to suit a particular technique.

Mediums other than ink are dyes contained in nylon-nib and felt-nib pens. These highly volatile dyes come in a powerful black and in a large range of colors, which tend to fade on prolonged exposure to light. Some of these inks are water-soluble, but most of them are not because they are prepared with a hydrocarbon solvent.

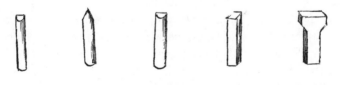

Felt pen points.

Ink Drawing Techniques. Felt- and nylon-tip pens, with only a few exceptions, cannot produce areas of solid shading. When one works with these instruments, detached lines must be used to achieve total differentiations. These lines can be done by hatching or crosshatching, arranged in straight lines, in curves, or in short, abrupt markings often referred to as staccato technique. Of course, several kinds of lines can be employed simultaneously.

The lines may be airily spaced, or densely interlaced. Black ink of identical density will produce areas that appear gray and others

59

that impress us as black, depending merely on thickness or thinness. The thinner the lines, the grayer their appearance; even when interlaced densely, thin lines will tend to look gray. This is due entirely to an optical phenomenon, for the white of the paper bordering the lines reduces their impact. On the other hand, a sufficiently thick black line is able to assert its blackness over the surrounding white of the paper.

Shading can also be produced by means of tonal values, in which case we speak of a wash drawing. The principle of this technique is to make a linear definition first, whereupon ink washes are applied. These (as well as the underdrawing) can be done in indelible India ink, in a water-soluble ink, or in any color that retains its monochromatic character. Colors especially favored by the old masters were *Sepia, Bistre,* and dark *Iron Oxide Red.*

Pen-and-ink work can also be done on wet paper. This technique produces blurred effects—soft, fuzzy lines. The wetter the paper, the softer and more *Painterly* the general appearance of the drawing will be; the drier the paper, the more *Graphic* the drawing. The procedure is as follows. A sheet of paper should be soaked in water and then, while still dripping wet, should be placed on a *Masonite* board (preferably the tempered quality), to which it will cling tenaciously as long as it is wet. The drawing is made in India ink or water-soluble ink. A prolonged working period will call for repeated wetting of the paper. This can be done best by squeezing water onto the sheet from a sponge. To prevent the paper from wrinkling upon drying, it should be placed between sheets of newsprint, weighted down, and allowed to dry while under considerable pressure.

Crayon, Pencil, and Charcoal. The collective term "crayon" applies to all instruments (except those made of charcoal) that mark the paper through abrasion. The most commonly used is made of *Graphite* and known as a "lead" pencil; it is manufactured in wooden handles, in sticks, and in refill leads for mechanical holders. A variety of grades range from hard (marked H) to soft (marked B). The softest is marked 6B. Those marked HB are most commonly used for writing. Extra-soft pencils possessing thick leads are known as "Negro," "Layout," "Ebony," etc. Graphite crayons, which come in more or less

thick sticks, not in wooden handles, are useful for large surfaces. Vine charcoal is manufactured in sticks, in a variety of grades. To be of service to the painter, vine charcoal must be soft. When hard—that is, not sufficiently carbonized—the material becomes worthless. Charcoal is best for sketching on a canvas or panel preliminary to painting, because its marks can be easily deleted by rubbing them with a piece of cheesecloth or, still better, a chamois. This medium is also excellent for finished work on a larger scale, because delicate (as well as forceful) shading can be produced, quite different from the shading made with graphite.

Besides vine charcoal in stick form, charcoal pencils are available. These are made of synthetic material. Their color is intensely black, and their marks are more difficult to erase. The most useful grades are marked 4B and 6B; the hard charcoal pencil is less useful. The blackest and the most powerful charcoal instrument is the soft carbon charcoal sold in sticks ⅜" thick.

Carbon pencils are made of synthetic material, similar to that used for charcoal pencils, and leave marks of the most intense black. Carbon is also obtainable in stick form. It comes in various grades, the softest classified 6B. The marks of a carbon pencil (unlike those made by vine charcoal or by a conventional graphite pencil) are not easily erased.

The best-known colored crayons are known as Conté, the name of the French manufacturer who seems to have been the first to put the material on the market. Two colors are of particular interest to the painter: a reddish variety called "sanguine" and a brownish color which is known as "bistre." The first employs an iron oxide pigment; the second is no longer made of the original bistre color (which, as a watercolor, bleaches when exposed to strong light). Sanguine was greatly favored by the old masters for drawing, and bistre was a favorite in wash drawing.

Lithographic pencils and sticks are waxy, non-erasable crayons developed for use on lithographic stones and plates. (This material is also obtainable in liquid form; as such it is referred to as lithographic ink or tusche.)

Crayon, Pencil, and Charcoal Techniques. The chief advantage of these graphic mediums over ink is their capacity to produce quite painterly effects—that is, effects that rely on tonal

rather than linear definitions. This does not mean that a crayon cannot be adapted for purely linear work, however. Depending on the nature of the paper, a crayon line can be sharp as well as blurred. On smooth paper, a well pointed lead can produce lines almost as isolated as those made with a pen, but no matter how sharp the pencil lines may be, they will not be well suited for producing shading purely by means of lines; their very nature will dictate working with solid masses of tone.

If we consider the texture of the drawing surface, the texture of the paper itself is less important in pen-and-ink drawing than in crayon or charcoal work. In crayon, pencil, or charcoal drawing, the shading, whether light or dense, will always reveal the nature of the paper surface. And since a prominent grain in the paper always has a mechanical appearance (impressed by rollers in its manufacture), the sensibility of the painter's hand may be obliterated if he allows the grain to become too evident. Hence, in choosing paper for work with these graphic instruments, its particular surface quality should be well considered.

To produce soft, delicate tonal transitions in crayon, pencil, and charcoal work, a stomp can be used to rub the marks. This is a piece of soft paper tightly rolled into the shape of a small stick, tapered at each end to a fine point. To make a drawing indelible, *Fixative* should be used. The fixative for a drawing (unlike the varnish applied to a painting) can be sprayed from a pressure can.

Stomp.

Silverpoint. This technique was greatly favored during the Middle Ages and the Renaissance. Today, a simple way to make a silverpoint drawing tool is to buy a silver wire at a jewelry supplier and place it in a mechanical lead holder bought at an art supply store. When one draws the silver point over a paper surface coated

with a white abrasive material, traces of the metal rub off and become imbedded in the grain, leaving a delicate, gray mark. In time, these marks oxidize to a darker tone. Originally, calcined bone or chalk, bound by *Gum Arabic,* was used to prepare the white ground of the paper. Today the ground can be prepared with the common *Chinese White* watercolor or with *Acrylic Gesso.* Drawing with silverpoint relies on linear definitions only. Because of the delicacy of the marks produced, effects obtained spontaneously must be ruled out. It is a deliberate technique, demanding painstaking draftsmanship.

Eraser. Four types of eraser are of interest to the draftsman. The softest, called "kneaded rubber" is malleable, excellent for use in charcoal drawing but also serviceable for deleting other marks, if not too strong. A new type of vinyl artgum eraser (such as the one produced by Faber-Castell) is best for all-around work, except where India ink is concerned. This must be treated with either a special ink eraser, or with a typing eraser. There is also an eraser on the market in pencil form (the holder is made of wrapped paper); with it, small areas can be erased with great accuracy.

History of Drawing Instruments. The reed pen, made of hollow bamboo or the tubular stalk of coarse marsh grass, was known early in history. The common writing instrument of the early Christian era was the quill; as was done in antiquity, a thin strip of spring metal was often looped into the shaft and under the nib of the pen to hold a quantity of ink. Pens made of metal are not of modern origin, for bronze pens from ancient Rome and Pompeii have been preserved. The first modern steel pen was made in 1780, but it was not on the market until about 1822.

There can be little doubt that charcoal was used in prehistoric times. Graphite, widely distributed as a natural mineral, was known to the Greeks who confused it with lead (an error that has been perpetuated). Since ancient times it has been used as a writing material known as "black lead" or "plumbago." The pencil in all its present forms dates from the 19th century. It employs graphite compressed with very fine clay.

DRYBRUSH EFFECTS are used in brush-and-ink *Drawing,* in *Watercolor Painting,* and occasionally in *Oil Painting.* The brush

carries very little of the ink or paint and is handled so that the bristles lightly skim the paper or canvas, depositing color only on the high points of the irregular surface, leaving a soft, broken tone. Because of their greater resilience, bristle brushes are suitable for this purpose in oil painting. This manipulation is also referred to as "dragging" the brush.

DRYERS (siccatives) are metallic salts of cobalt, lead, or manganese, dissolved in a *Petroleum Derivative,* in which they form an ink-like, volatile liquid. For *Acceleration of Oil Paint Drying, Cobalt Dryer* is best. Commercial paints, as well as the now obsolete Siccatif de Haarlem and Siccatif de Courtrai (brand names) contain lead and manganese.

DRYING OF PAINTS. Oil paints dry by oxidation. All aqueous paints dry by evaporation of the water content of their vehicle. Emulsified mediums (like tempera) dry both by oxidation and by evaporation.

Agents that promote the drying of oil paints are constituents that promote the absorption of oxygen, such as manganese dioxide and ferric and aluminum hydroxides. Generally, the oxides promote drying and the sulphides delay it. Moreover, the addition of a metallic dryer (the safest of these being *Cobalt Dryer*) in a proportion of less than 1% greatly accelerates drying. However, excess dryer will cause *Yellowing of Oil Paint* and rapid *Embrittlement of Oil Paint.* The temperature of the air and its relative humidity materially influence the drying of oil paints. Under desert conditions (temperatures of 100° F. or more and relative humidity from 0% to 10%) and especially in the presence of wind, a painting may dry in a few hours; under adverse conditions, the drying time of the same painting may be a few days. See *Acceleration of Oil Paint Drying.*

The drying of watercolor is also contingent upon atmospheric conditions, the amount of water used and the amount absorbed by the paper, and the quantity of glycerin present in the tube paint. (Glycerin, a highly hygroscopic—water absorbing—substance, is usually added to the paint in order to make it elastic and to keep it from drying in the tube.)

The formulations of casein paints vary with the manufacturer

and are never disclosed, hence drying behavior cannot be predicted accurately.

The drying of acrylic paints has not been fully researched. When in jars or tubes, their drying is greatly inhibited. But once the paint has been applied to a surface—even a nonabsorbent one—acrylic will dry faster than watercolor will under comparable conditions.

DRYPOINT is a technique of working on a copper or zinc plate directly with a steel or diamond point. See *Etching*.

DYE is coloring matter that dissolves totally in liquids and imparts its color to other substances.

EARTH COLORS. See *Earth Pigments.*

EARTH PIGMENTS originate as minerals, ores, and sedimentary deposits, widely distributed throughout the earth. Among them are *Yellow Ochre, Siena* and *Burnt Siena, Umber* and *Burnt Umber,* and *Iron Oxide Red.* Earth colors are composed of clay, silica, and other inert pigments in addition to the coloring matter provided by ferric oxide in various forms.

Studio easel.

Lightweight easel.

EASEL. A wood or metal stand that serves to support a stretched canvas, a panel, or a drawing board in a more or less perpendicular

position. There are three general types of easels on the market: a heavy wooden studio easel; lightweight easels that are quite serviceable in spite of their rather primitive construction; and collapsible metal easels, practical chiefly when painting in the field. Watercolor easels are usually designed to hold a drawing board with paper tacked or taped to its surface and to adjust to various tilted positions.

EGG EMULSION is egg white and/or yolk used as a binder for pigments in *Tempera Painting.*

EGG TEMPERA. See *Tempera Painting.*

EGG WHITE is composed of water, albumen, lecithin, mineral matter, and other substances. Used at one time as a binder for pigments used to illuminate manuscripts, it was then referred to as *Glair.*

EGG YOLK is composed of water, fat, lecithin, protein, dextrose, cholesterol, lutein, and other substances. Upon drying, egg yolk becomes waterproof, and its film develops great toughness when used in *Tempera Painting.*

EGYPTIAN BLUE is an ancient color, now obsolete, containing copper, calcium, and silica. It was manufactured in ancient Egypt and went out of use many centuries ago. *Cobalt Blue* can be considered its modern equivalent.

ELEMI is a soft resin obtained from trees growing in the Philippines, South America, Africa, West Indies, and Yucatan. It is of no use to the painter. Sometimes it is employed as an additive to wax in the process of restoration and preservation of old wooden panels, in the belief that its highly aromatic smell will prevent rodents and insects from attacking it.

EMBRITTLEMENT OF OIL PAINT can be the result of the following causes.

(1) Insufficient dispersion of pigment particle conglomerates in oil.

This can occur only in hand-ground oil paint prepared in a careless manner (see *Grinding Pigments in Oil*).

(2) Loss of the binder (oil) through separation of oil and pigment. This is a common occurrence with certain pigments that are made without the addition of a stabilizer.

(3) Insufficient binding power of the oil used as a grinding medium. This oil will lose its adhesive strength when paint, though compounded with the proper amount of binder, is heavily diluted by turpentine or by a medium that contains an excessive quantity of turpentine.

(4) Prolonged exposure of a painting to heat, cold, humidity, or dryness. Heat at above 95° F., such as commonly found above a hot radiator in winter, will prove deleterious to the stability of the paint film. Excessive humidity, cold, and dryness are responsible for contraction and expansion of the canvas, which is hygroscopic (moisture absorbent); old *Linoxyn* cannot follow these movements.

(5) Excessive use of *Dryers*. Because of the accelerated absorption of oxygen caused by the metallic drying compound added to the body of paint, the linoxyn is rapidly deprived of its elasticity.

EMERALD GREEN (Schweinfurter green) is a bright blue-green copper aceto-arsenite, obsolete and quite poisonous. It is impermanent in many mixtures. It was a favorite color of Van Gogh, who used it unmixed; hence it has remained unchanged in his paintings. A similar tint can be obtained by mixing *Cerulean Blue* and *Zinc Yellow*.

EMERY PAPER is also called carborundum paper. Extra fine grades are used for polishing gesso grounds prior to *Gilding* and *Silvering*.

EMULSIFYING AGENT. A material that makes it impossible to combine immiscible liquids to make an emulsion. Egg is an emulsifying agent when used in combination with oil, varnish, and water to make various emulsions for *Tempera Painting*. Without the egg, the other ingredients would be immiscible.

EMULSION. A suspension of fine particles or globules of one liquid in another liquid. In paints, an emulsion is normally a suspension of an oily or resinous material in an aqueous liquid. Emulsions are used as binders in *Tempera Painting* and *Acrylic Painting*.

ENAMELING. Fusing enamel onto a metal surface for practical or decorative purposes is an ancient craft, as old as the discovery that certain vitreous materials, heated to their melting point, could be bonded to a metallic foundation.

The basic substance is a siliceous material of glasslike consistency and transparent appearance called flux. The raw material consists of various minerals such as feldspar and silica, of which there are rich deposits found in America. They are compounded in proper proportions to make them suitable for fusing on a metal base. An addition of other carefully balanced ingredients, such as metallic oxides, borax, and lead, gives the silica color and produces different grades of hardness, transparency, translucency, or opacity.

The colored vitreous material can be purchased in lumps of various sizes or in powdered form. The lumps have to be ground in a mortar—a tedious process—until the enamel reaches the desired fineness: 60, 80, 100, or 200 mesh. ("Mesh" designates the number of openings in a square inch of the metal sieve through which the enamel is shaken onto the object being decorated.) 80 mesh is best suited for regular use. 200 mesh is almost as fine as face powder; this is best for delicate enamel work, like Limoges. When deposited on the metallic foundation and exposed in a furnace to temperatures from about 1400° F., the layer of enamel liquefies; then, when slowly cooled, it forms a glossy, smooth surface.

When handled with care, enameled objects are very durable. Golden trinkets adorned with enamel were unearthed in Egyptian tombs. Portraits done in Champlevé during the 4th and 5th centuries were found in Byzantium. French noblemen were depicted in the Limoges technique by Leonard Limosin in the 16th century. The most splendid example of early enamel work is the famous retable in Klosterneuburg, Austria, dating from the 13th century.

Tools and Materials. The kiln is a muffle furnace for firing the enamels. There are different types on the market; an electrically heated kiln is the best choice. A thermostat is attached to the kiln for automatically retaining the desired temperature; however, experience and a watchful eye soon teach the enameler when the firing is complete.

Kiln.

As mentioned above, enamel colors can be bought in powder form in different grades of fineness and in a great variety of shades.

Copper is the best surface for enamel work. It is easily hammered into any desired shape and responds well to proper treatment. A vise, although not absolutely necessary, is a great help in metalwork; it consists of two movable strong iron jaws that keep the object to be worked on firmly in place. The vise is usually screwed to the worktable. A bench pin to aid in hammering and sawing is a simple device made of an oblong piece of wood (about 8'' x 3'' x 3'') with a V cutout, attached to the worktable with a clamp. A stake is a piece of metal with a polished round top used for shaping metal.

Other tools and materials include: a planishing hammer and one or two small hammers; a mallet made from rawhide or wood; shears for cutting metal; files, both flat and half round; a scraper and a burnisher; a torch and an asbestos support for annealing the metal to make it pliable; a compass, a ruler, and pliers; a pickling solution which is prepared from 1 part sulphuric acid and 8 to 10 parts water (always pour the acid into the water, never vice versa);

a pickle pan made from copper (never dip an iron tool into the pickle—use copper tongs); carborundum stone, emery cloth, and steel wool; a polishing motor, with felt and cotton wheels, a rouge stick, and tripoli; small flat dishes of china or plastic with well-fitting covers to mold small portions of enamel during work, preferably the type of dishes that can be stacked; small brushes (sable hair are best); a big spatula for lifting small, hot enamels after firing; small spatulas (some enamelers prefer to work with these instead of using small brushes—they are easily made by annealing the end of a knitting needle and flattening it with a hammer, and using a bottle cork pierced through the center for a handle).

Rack.

Spatula.

Tongs.

Enameling fork.

Further equipment includes: long iron tongs for handling work before and after firing; metal screens or nets in sizes to fit easily into the kiln, used to deposit work for firing (if made of iron, a screen must be painted with rouge to prevent the work from sticking to it); sieves (80 mesh) for shaking enamel onto metal foundation (after use, sieves must be very well cleaned); gum tragacanth, which is used to make enamel adhere to the metal base before firing; asbestos gloves; trivets made of clay and other individual small gadgets to hold odd-shaped enamels during firing,

like small tripods; carborundum stone to remove flaws, fine files and an awl to open the tiny blisters that sometimes form during firing (which then have to be recharged and fired again); liquid gold to add decorative touches; gold and silver foil to be used under transparent colors; a mortar and pestle for grinding enamels to a finer mesh; a frosted glass plate and a muller for grinding paint enamel used in the Limoges technique; *Oil of Spike* and *Oil of Cloves*; scouring powder and a detergent; silver solder and *Borax* for joining wires in the plique-a-jour technique.

Technique. To become acquainted with the individual colors—their peculiarities and their compatibility with different metals—it is advisable to produce one's own charts. Because many powdered enamels look quite different when fired, these preliminary tests are a great help in avoiding errors in choosing colors for a planned design. For this purpose oblong strips of copper have to be prepared first: one fused over with solid white, a second one covered with clear flux, a third one left plain and just polished. Then small patches of each color should be set next to each other on every strip, numbered, and fired. When experimenting with silver, one will discover that transparent shades of blue and green are especially effective on this metal.

1400°F. to 1500°F. is the recommended firing temperature for the kiln. How long to leave the work in the kiln is a matter of experience and careful watching through the peephole. Sometimes slight overfiring is not objectionable; this procedure causes the melted colors to flow and fuse together, thus creating an attractive abstract pattern.

Enameling can be done on various metals, but some, such as steel and aluminum, need experience and special skill to be worked on. The most satisfactory metal is copper, 16 or 18 gauge, although silver provides an excellent background for some transparent colors. Copper is easily hammered into a desired shape. Properly cleaned, freed from scratches, and polished to a high sheen, it also shows transparent colors to great advantage. Hammer marks left on the surface of the metal give the work the charm of a handcrafted piece.

All materials, tools, metals, and enamel colors are now ob-tainable in most shops that handle supplies for the craftsman.

Copper can be bought in sheets or as ready-made objects, such as trays, plaques, vessels, and small geometric shapes for jewelry. It is advisable to obtain enamel colors ready-made, that is, in powder form, 80 mesh.

If the metal is bought as an 18-gauge sheet, a piece of an approximate size should be cut off with metal shears and flattened with a rawhide or wooden mallet. Then the desired shape is marked on it (to produce a perfect circle, a compass is used), and the piece is cut down to the precise size. To make a tray, the copper shape has to be domed; that means giving it a shallow, raised shape by using a stake and a mallet. Since this process hardens the metal, it is necessary to anneal it to make it pliable again. If the edge has to be corrected, this is done with a file and then smoothed with emery cloth and steel wool. Whether the metal object is made by the enameler or bought ready-made, thorough cleaning is imperative before applying the enamel. This is done first by using steel wool and then by painstakingly scrubbing the piece with scouring powder and water. After this procedure, the object should not be touched with the fingers before putting on the enamel.

The ground coat of enamel can be applied to the metal object and fired in the kiln at 1500°F. There are several different ways of putting the ground coating of enamel onto the metal base, but the dry process seems to be the most practical. First, a thin film of watery *Gum Tragacanth* is sprayed or painted on the metal with a soft brush. Then the powdered enamel is shaken on gently and evenly through an 80 mesh sieve. This can be done either on the front or top surface only or also on the back, where it is called counter enamel. Excess enamel should be caught on a clean sheet of paper that has been spread on the table; this enamel can be used again, but it should be perfectly dry before it is poured back into the container. On the object itself, the slight amount of gum tragacanth is sufficient to make the enamel powder adhere to the metal, but before firing every trace of water should be dried off, which can be done in the moderate heat on top of the kiln.

Now the work is ready for firing. Opinions on the exact time of this process vary, but experience soon teaches the enameler the right moment to withdraw the object from the furnace—when it appears liquid, luminous, and glossy. There is no finer moment

for the enamelist than when a perfectly finished piece emerges from the kiln, and, slowly cooling, the colors solidify, the different hues revealing their true beauty.

There are five specific types of enamel work: cloisonné, champlevé, plique-à-jour, bassetaille, and painted enamel (Limoges technique falls into the category of painted enamel).

Cloisonné. This is the method of filling enamel into wire cells called cloisons. First the metal base is fused over with a layer of soft flux. This type of flux has a high lead content and, thus, a low melting point. Flat silver wire, 32 gauge and about 1/32" wide, is rolled into a coil to keep it from melting when heated, and annealed to make it pliable. Then it is shaped into the outlines of the design with small pliers or tweezers, and put upright onto the flux ground. An adhesive, like a watery solution of gum tragacanth, is used to keep the wire pieces in place. A light ''bake on'' follows. Loose wires are gently pressed down with a wide spatula.

Now the cloisons are filled with water-moistened enamel. Then the water must be sucked off with a blotter; in addition, the piece has to be thoroughly dried on top of the kiln. After firing, flaws are removed with carborundum. The grinding is best done under running water to float off particles of removed matter. Hollows and uneven spots have to be recharged with enamel. Sometimes this procedure has to be repeated a few times until the piece comes out of the kiln with an even and glossy surface.

Plique-à-jour. Here the enamel is seen without a metal background, giving the impression of stained-glass work. The procedure is as follows. Flat wire is shaped into the outlines of the design as if for cloisonné, but heavier wire is recommended. The finished wire skeleton is assembled on a sheet of mica, and the joining points are soldered. Big openings between the wire forms should be avoided. Now the spaces within the wire design, which is still resting on the mica support, are filled with water-moistened enamel, very well dried in the warmth of the top of the furnace, and fired. For this type of work only transparent enamel should be used. Open spots have to be recharged with more enamel. The finished piece can be lifted easily from the mica sheet.

Here is another way of producing plique-à-jour enamel. A metal base is fused over with a coating of flux as if for cloisonné. It is

important not to put a counter enamel on the back of the metal, which will be exposed later to the etching action of acid. It is advisable to have a line drawing of the planned design on paper, for bending and shaping the wire is much easier when following the lines. Then the pieces of wire are assembled, arranged on the flux ground, and attached with thinned solution of gum tragacanth. A very light firing follows to prevent the wire design from sinking into the metal ground. Now charging the cloisons, firing, repairing flaws, recharging, and firing are repeated until the surface is smooth and shiny.

Up until now, the method used is the same as in cloisonné technique. To make the piece transparent, however, the exposed metal background has to be removed. This is done by etching it away with a solution of 1 part *Nitric Acid* or sulphuric acid to 2 parts water. The surface which is not to be etched is covered with *Asphaltum,* including a narrow strip of metal at the edge, thus giving the rim support. If domed, like a tray or a vessel, the object is inverted, filled to the rim with acid, then left until all of the metal is eaten away. Needless to say, great care has to be taken in handling the strong acid solution because of its corrosive effect.

Repoussé. 18-gauge copper is used. The design is produced by hammering the back of the metal, thus raising it to a relief. After the surface has been thoroughly scrubbed and polished to a high sheen, a thin layer of transparent enamel is fused over it.

Champlevé. Here the design is engraved into an 18-gauge metal base or etched into the surface. For this procedure, the metal object is covered with asphaltum solution through which the design is scratched (as in *Etching*). Then it is put into a bath of nitric acid or an *Iron Chloride* until the exposed metal design has been eaten away to the desired depth. The asphaltum is carefully removed with turpentine, and every trace of it is scrubbed off. Then the recessed parts are charged with enamel, thoroughly dried, and fired till glossy. Surplus enamel is taken off the raised metal surface with a scraper and steel wool. Hollow spots are recharged. After the last firing, the metal is polished.

Paint Enamel. The Limoges technique, in which enamel is painted on porcelain or on metal that has already been enameled white, belongs to this category. This delicate work is very well

suited for small pieces such as jewelry. The enamel should have the consistency of face powder. It has to be ground with a muller to a soft paste on a carborundum-roughened glass plate, using oil of cloves or oil of lavender as a medium. The material should be kept immaculately clean, free from lint and dust, and tightly covered when not in use. The design is painted on with very fine brushes (sables are best) between successive firings until it gives the impression of a dainty relief. It is important to know that a piece painted with this type of enamel has to be "smoked off" before every firing; that is, it has to be held at the open door of the kiln till the volatile oil has evaporated. These very finely ground painting enamels also come in many shades. They can be used for tinting the white relief design before the last firing.

Paint enamel is the term given to yet another branch of enamel work. This is the technique most frequently used. The object to be worked on is first coated with a layer of enamel and baked. A preliminary sketch of the planned design can be drawn on the enamel ground in fine lines with regular watercolors. When the enameled surface is perfectly clean and free from fingermarks, lines made with gum-arabic watercolors will adhere, though superficially, to the surface. When the enamel colors are made ready for use, small amounts of the shades one plans to work with should be placed in shallow little trays (they come in sets and can be stacked); 80 mesh is usually the desired fineness for this type of work. Should one want finer powder, it has to be ground down in a mortar with a pestle. Then the enamels have to be levigated (see *Levigation*). This is done by slowly filling the little dish containing the enamel with water. Gentle tapping makes the fine enamel powder settle on the bottom of the dish, and a milky slush stays on top, which has to be poured off. This is repeated until the water is clear of all impurities. The little trays are now lined for working.

Gold and silver foil are effective as an underlay for transparent colors. Tests should be made first—not all transparent colors are right for metallic foil. The delicate foil is put between two layers of tissue paper on which the outline has been sketched, then carefully cut. The spot where the foil is to be placed is slightly dampened, the piece picked up with a damp brush and placed on the work. It has to be pricked with a fine needle to let air escape during firing, allowing the foil to bake on flat.

Some enamelers like to give their work a special effect by melting small beads and things of that kind onto the surface, thus giving it texture. Ready-made little gold stars, dots, circles, etc., can also enhance a design. They should be fused over with soft clear flux for protection.

Then the enamel colors, moistened with water, are simply scooped up in little portions with a small spatula or fine brush (again, sable is best) and put next to each other, following the design. After the piece has been carefully dried, it is fired. Details like shading, glazing, and fine lines can be added with very finely ground enamel, using oil of cloves or lavender as a painting medium. These colors must be especially well dried to allow them to volatilize completely.

Sgraffito. This old pottery technique was adapted from enameling. The piece to be decorated first receives a coat of ground enamel. After firing, a thin spray of watery gum tragacanth is put over the object and a layer of opaque enamel is shaken on with a sieve. Then a line drawing is scratched out with a stylus, thus exposing the underlying color. After careful drying—which is best done on a hot plate at low heat—firing follows.

Technical Comments. The enameler should have two important qualities: patience and cleanliness. Enamelwork and metalwork should be strictly separated; dust, bits of metal, and filings are detrimental to enamels. The colors should always be tightly covered when not in use.

Some enamelers have the habit of licking fine brushes to a point. Since many enamels contain lead, this habit is dangerous.

Acid must be handled with care—always pour the acid into the water, never vice versa. Protect hands, eyes, and clothes from its corrosive effects. Wear asbestos gloves for putting work into the furnace and removing it.

In planning a design, one should always consider that it has to be adjusted to the technical possibilities of the medium and at the same time be well balanced within the given space.

An opaque, pure white background is a good choice to show most colors—painted on top of it—to their best advantage.

Leftover bits of enamel should be collected together in a special container. The mixture results in an agreeable neutral grayish

color and can be used as "counter enamel" on the backs of objects.

It is not necessary to polish an enamel with a buffing wheel to retain its original gloss. The action of the wheel can force minute particles of dirt into the tiny pores of the enamel. An occasional gentle rubbing by hand with a soft cloth is sufficient.

ENAMELS. See *Enameling.*

ENCAUSTIC is a form of painting in which *Beeswax,* with a small addition of *Varnish* and *Linseed Oil* (these ingredients are added in order to make wax more resistant to heat and abrasion), is used as the binder for pigments.

Vehicle. The components are combined in the following manner. 7½ oz. of wax that has been melted in a tin or aluminum pan over a hot plate or stove burner should be mixed with 1½ oz. *Damar Solution Heavy* and 1 oz. linseed oil. This mixture should be kept warm in a *Double Boiler,* because the wax-resin-oil blend will serve during the entire working period as the vehicle for the dry pigments. With prolonged heating, however, the turpentine that the varnish contains will volatilize, and the oil will polymerize and thicken; when this condition occurs, the mixture must be discarded and a fresh one prepared. Hence, the quantity of the prepared material should not be too large, and the temperature should be no higher than needed to keep it liquid.

Palette, Tools, and Medium. As soon as the vehicle is removed from the container in which it is heated, it will congeal. To keep it warm while mixing it with pigment, the palette must be heated. The heating arrangement can be identical to the apparatus used for heating the metal plates in *Etching* when inking it. Other tools needed for encaustic include *Brushes* and *Painting Knives* (the same ones used in oil painting), a large heating lamp with a reflector, and a small heating lamp. Turpentine is the only medium that can be used for thinning the wax-resin-oil compound. Work is done exclusively on a rigid support, preferably on a gessoed *Masonite* panel. Either traditional *Gesso* or *Acrylic Gesso* can be used. Because the encaustic paint film is rather inelastic canvas cannot be used as a support.

Technique. To produce paint from the pigments and the heated wax-resin-oil vehicle, the materials must be mixed with a stiff painting knife or with a spatula on the warm palette.

As in the case of *Alla Prima Painting,* it is well to start with an *Imprimatura,* which will provide an excellent attachment of the subsequent paint layers. An underdrawing can be made either on the white gesso with charcoal (made indelible by fixative), or on top of the imprimatura with turpentine-thinned paint. For the imprimatura itself the paint should be thinned with turpentine. For the initial color, *Burnt Umber,* or *Raw Umber, Burnt Siena,* and *Raw Siena* are good choices, but another stronger color can also be used.

Because the paint transferred from the warm palette to the cold primed panel congeals rapidly, work must proceed speedily. The immediate drying of the paint does not allow much brushing; consequently, a strong *Impasto* may develop quickly. To smooth any paint that has dried on the panel painting knives that have been previously heated can be used. This smoothing operation can be quite complex, and a large variety of differently shaped knives will be required. These will be used mostly for work in small areas, on which the small heating lamp will also be very effective.

Heating, or burning-in, with lamps is done as follows. The panel is taken off the easel and placed on a horizontal table. The lamp is then moved over the surface of the panel—close but not touching—until the wax paint softens. The more heat applied to the paint, the more thoroughly the strata fuse without obliterating details. The process of painting with solid and thinned wax paint and subsequent remelting should proceed until the desired effects are achieved.

Glazes can also be applied at *any* stage, not just as a final step as in oil painting. Paint used for glazing can either be simply thinned with turpentine or be specially compounded by mixing the pigment with a greater quantity of the wax-resin-oil vehicle to produce a transparent color. Tube oil colors can also be mixed with the encaustic medium to create paints for glazing.

The encaustic painter should note that paint made with heavy pigments—such as *Flake White* in all its mixtures, *Vermilion, Prussian Blue,* the *Cadmium Colors, Naples Yellow,* and the dark *Mars Colors*—will settle in the lower paint strata during the

burning-in period. The lighter paints—such as the umbers, the sienas, *Alizarin Crimson*, and *Phthalocyanine Blue and Green*—appear on the surface. These "sinking" and "rising" properties allow extraordinary effects of transparency, glazes, scumbles, and texture to be produced by judicious manipulation of the encaustic material. Once finished, an encaustic painting appears matt; the surface may be polished with a cloth to a soft sheen, if a glossier appearance is desired.

History of Encaustic. One of the oldest methods of painting, encaustic was used in ancient Egypt, but the best preserved examples come from 2nd-century Roman Egypt. Most of these so-called "Coptic" encaustics are rather realistic portraits taken from mummy cases in Alexandria. If executed on a solid support under favorable conditions, encaustic painting is among the most permanent painting techniques, for the paint film is impervious to the kind of deterioration commonly found in works done in water-based and oil-based mediums.

ENGLISH RED is an unspecific designation for a bright *Iron Oxide Red.*

ENGRAVING. See *Etching; Woodcut and Wood Engraving.*

ERASER. Made of rubber of various kinds and qualities, erasers serve for deleting marks of ink, crayon, pencil, etc. (see *Drawing*).

ETCHING is the term commonly given to a variety of work done on metal plates from which prints are produced. Because all these processes involve making indentations in the metal that will hold and then deposit ink (etching is just one of the processes available) the generic terms "gravure" and "intaglio" are now frequently used to cover all these techniques. The plates used for this purpose are made of cold-rolled 16- or 18-gauge copper or zinc. The choice of metal depends on personal preference and on the technique to be employed. Zinc plates, which are softer, are often preferred for bold, free techniques, whereas copper is more suitable for controlled work; although the latter is more expensive, it lasts longer during the rigors of printing. The plates must be polished to

perfect smoothness, cleansed of grease, and free from all defects such as scratches or dents, for the slightest imperfection on or in the surface will register its presence in the prints.

The principal tools used for etching are a variety of points made of steel, diamond points, roulettes, burnishers and scrapers, a fine flat file, a metal-cutting saw, and an assortment of carborundum and special polishing papers.

The purposes of these tools are as follows. Steel points are used to mark the metal directly or to scratch through the film of the protective etching ground. A more efficient tool for cutting into the metal directly is the diamond point, because less pressure is needed when drawing with it on a hard surface. A roulette is a small wheel, or a small round or oval rotating drum, that is studded with sharp points. When rolled over the plate it creates a pattern on the surface. The burnisher serves to produce a high polish, to eliminate scratches, to flatten a burr (a ridge of thrown-up metal on one or both sides of an incision), and to reduce surface roughness in order to produce tonal transitions. A scraper, as its name indicates, is used to erase undesired marks on the plate prior to polishing.

Diamond point.

Roulettes.

Burnisher.

Scraper.

Polishing paper is used to produce delicate grays, and carborundum paper, depending on its grade, can be used to create heavy tones, determined by how deeply it scratches the metal. The finest polishing paper is also capable of minimizing roughness on the metal surface, and when well-worn it can act as a burnisher. A metal saw is needed to cut plates to the required size when the metal is bought in large sheets. The edges of such plates must first be beveled with a file and then burnished with the burnisher. All other materials required will be discussed in connection with the particular techniques for which they are designed.

Seven basic intaglio printmaking methods can be employed: drypoint, etching, aquatint, lift-ground, soft-ground, mezzotint, and engraving. Moreover, the basic techniques can be combined. These procedures are listed below, starting with the simplest and progressing to the more difficult.

Drypoint. This is the technique of incising the metal directly with the needle. Delicate tonal gradations, from the lightest gray to the deepest black, can be produced in drypoint better than in any other intaglio technique. It is erroneous to assume, however, that the immediacy of a drawing can be achieved in this seemingly easy technique. To make a direct incision in the metal pressure is required, and this impedes the impulses of one's fingers. The type of needle used, as well as the pressure exerted and the angle of the cut, will be largely responsible for the character of the line. Different types of needles will condition the manner of working, but a diamond point will lend itself to practically every operation desired. Other useful tools for work in drypoint are roulettes of various types and *Stomps* made of emery paper.

Etching needle.

While digging into the metal the drypoint needle forms a rim called a burr at the edge of the incision. Because the depth of a

82

drypoint cut cannot be gauged as easily as that of an etched line—where a certain length of exposure to the mordant makes the effect fairly predictable—frequent trial inking and printing is necessary to test the marks made on the plate. Corrections—strengthening, weakening, or completely deleting incisions—can be made more easily in drypoint than in etching, however. To strengthen a cut, a deeper groove (producing a stronger burr) will be required; to weaken an incision, burnishing, then scraping, and repeated burnishing is required. In the process of burnishing a cut, the burr can be forced back into the groove, or the burr can be cut off with the scraper, which will materially reduce the strength of the line.

When a drypoint plate is printed, the burr is, to a greater or lesser degree, part of every mark made. This gives this technique its chief characteristic for, unlike an etched line, it is the burr which gathers most of the ink, and this gives the drypoint its soft, velvety appearance. The range of grays obtained in a drypoint print can never be obtained in an etching, which is cold by comparison and emphasizes linear rather than tonal effects. A drypoint line is also much more vulnerable than an etched line, for the burr wears down quickly, and the fine, shallow scratches that provide the lightest grays may disappear after a few prints are made. Such plates should always be steelfaced before using them to print large editions.

Etching. In its most precise sense, the term ''etching'' refers to a technique whereby a needle is used for drawing on a metal plate that has been covered with an acid-resistant etching ground. When pressed against the ground, the needle removes the protective film, thus exposing the metal to the action of acid, or the mordant, as it is called. The etched line will later hold ink for printing.

The copper or zinc plate should be carefully cleaned with alcohol and chalk before the ground is applied, because any trace of grease or dirt may impair the protective coating. The liquid etching ground should be applied with a wide soft hair brush—to the back and the edges of the plate as well as to the front—and then allowed to harden.

It is practical to compound two etching grounds, a relatively heavy one and a lighter one. The heavier can be prepared by dissolving *Asphaltum* in *Turpentine* to form a liquid of syrupy consistency; this should then be mixed with *Damar Picture*

Varnish in a proportion of 2:1 by volume. The asphaltum solution alone is sufficiently strong to resist the action of acid; however, it is too brittle for work done with a needle, hence the addition of damar. The elasticity of the asphaltum ground is also improved by adding ¼ oz. melted *Beeswax* to every ounce of the solution.

The lighter formula calls for a solution of asphaltum in turpentine of 1:3 by volume, mixed with a solution of *Rosin* in *Acetone* of 1:3. The asphaltum-turpentine rosin-acetone solutions should be mixed together in the proportion of 1:1.

When dry, the ground can be worked on directly with the needle, or an existing drawing can be traced onto it. Because the color of the ground is very dark, a tracing made with the customary carbon paper on India ink would not be visible. Hence, a white *Transfer Paper* should be used. If not commercially available, it can be made by rubbing *Zinc White* or *Titanium White* pigment into a sheet of tracing paper. The pigment can be applied with a piece of rag, and the loose powder that does not adhere to the surface should be brushed off. Such paper will serve to transfer a clear white drawing on the dark ground.

Quite a variety of etching needles are on the market; whether one chooses this or that type is a matter of personal preference, for the points vary in shape, thickness, and degree of sharpness—and all these characteristics influence the working of the instrument on the plate. Moreover, a needle may remove the ground without marking the metal, or it may cut into the plate. If lines of such forceful character appear to be desirable, the diamond point will prove much more efficient than a steel needle.

In contrast to the aquatint process (described below), only lines can be etched into the metal. To hold the printer's ink, these lines must be narrow, for a shallow, wide line will not hold ink. Thus, the technique employed in this kind of etching must rely on lines to produce tonal transitions. These lines can vary from the finest to about 1/16'' wide; however, to hold the ink the latter must be etched to a considerable depth.

The linear pattern of an etching is organized in a certain manner. It may consist of many parallel lines (*Hatching*) or of lines that cross one another (*Crosshatching*). In both instances, the lines can be straight or circular, and they can be carried out to meet at a shallow or at a steep angle. Depending on the density of

the net of etched lines, and the width of the lines themselves, tonal gradations from the lightest to the darkest values can be produced. If densely grouped and deeply etched, lines on a large surface may print as almost solid black.

Strong black delineations can be obtained by using *Nitric Acid* as the mordant (1:2 or 1:3 in water for copper, 1:10 for zinc), for it undercuts the metal, etching the line sideways as well as in depth. *Iron Chloride* (a noncorrosive acid salt) cuts vertically and produces finer, more precise lines. Use nitric acid with great care: avoid skin contact and do not breathe the fumes.

The entire process of "biting" can be accomplished in one operation—one acid bath for the entire plate—in which case lines of more or less equal strength will result. Or the "biting" can proceed in several stages for different areas of the plate. After every stage, the parts that are to remain lighter in printing must be stopped out by applying more etching ground, and further work may be done with the needle. When the newly applied ground is dry, the next bite can begin. As the mordant etches the plate, various stages can be observed and controlled on a test strip of copper, which should be submerged in the mordant simultaneously with the plate. It should be remembered that whenever the plate is lifted from the acid bath—before each reapplication of ground—it should be thoroughly rinsed and allowed to dry.

When the etching process is finished, the accumulated protective layers of ground must be removed with turpentine. Except in aquatint, no stronger solvent is required.

If a certain area of the plate needs additional etching or corrections, it should be covered with etching ground and then isolated by forming a wall of wax around it to a height of about ½". The mordant can then be poured directly into this newly formed receptacle. Re-etching an existing design is exceedingly difficult and is rarely successful; should the artist wish to create stronger accents, he can best achieve this by means of drypoint technique.

In order to rebite a plate, two measures can be taken; both, however, are problematic. In the first method, the etched parts of the plate should be covered with a tube watercolor paint mixed with a trace of a detergent (to reduce the surface tension of water).

When dry, the paint should be thoroughly cleaned off the top surface of the plate, but care should be taken not to remove it from the etched lines. Next, the plate should be protected with the etching ground, and then subjected to the same treatment as in lift-ground (below).

In the second method, a *Brayer* is used to apply the ground—the ground used must be of the heavy variety—to the top surface of the plate, without allowing it to run into the etched lines, which must remain exposed to the action of the mordant.

Reducing or eliminating etched lines can be accomplished with a scraper. The more shallow the scraped line, the lighter will be the printed effect. Scraping deeply etched lines is a tedious process, requiring much patience. After the scraper has done its work, the rough surface that remains must be burnished to perfect smoothness, for any imperfection of the metal will show up in printing.

Aquatint. This technique was introduced during the 18th century. The best known artist who employed it extensively was Goya. Aquatint produces a granular surface on the plate, and it is this roughness that holds the ink—the rougher the area, the more ink, and the deeper the black that will result. The processes involved are rather simple, and few materials and tools are needed. The essentials are: a copper plate, powdered rosin, and liquid etching ground, which can be obtained ready-made or prepared quite easily.

Iron chloride is the mordant best suited for aquatint. Because it works slowly, it affords controlled observation of the etching process and allows the execution of fine lines and dots. Iron chloride is sold in chunks and should be kept in a sealed glass container so as not to admit air, for the material is highly hygroscopic; when exposed to air, it will liquefy in time. For use in etching, iron chloride should be dissolved in three to four parts of water. The solution is not easily exhausted and can serve for many etchings without losing its effectiveness. This acid is also perfectly harmless to one's skin and is not injurious when inhaled. It should be poured into acid-resistant trays, made of hard rubber or glass, like those used in photography.

Other materials required are: cheesecloth for applying the rosin to the plate; a pair of pliers for holding the plate while the rosin

melts on it; a small and a medium-sized round sable brush; and an electric hot plate. Finally, a strong solvent will be needed to remove the rosin and the etching ground from the surface of the plate. *Paint Remover* is best for this purpose; when left on the plate for a short while it will soften the ground, thus obviating the necessity of hard rubbing, which can injure the plate.

Before applying the aquatint ground, the plate must be thoroughly cleaned with alcohol or household ammonia, mixed with chalk, to remove every trace of dirt and grease from its surface. Once this is done, the drawing can be made on the plate with a small sable brush. India ink may serve this purpose, but to make it go evenly on the polished plate the *Surface Tension* of the liquid must be reduced. This can be done by adding a trace of a detergent to the ink. Should one wish to trace a drawing onto the plate first, a homemade carbon paper (dry pigment rubbed into tracing paper) can be used. Of course, a polished plate will not allow a perfect tracing; to eliminate the gloss, the plate can be submerged for a minute in a solution of one part iron chloride to ten parts water.

Next, a quantity of rosin should be placed in a small bag made of several layers of cheesecloth. By holding the bag about 12'' above the plate, and then tapping it lightly with one's finger, a fine cloud of dust will be released. To visualize the distribution of the rosin dust, the plate should be held at eye level; the rosin should cover it in a uniform pattern, neither too densely nor too sparsely. If too dense, the rosin will fuse into a continuous film when the plate is heated, thus not allowing the mordant to act on the metal; if too sparse, the etched areas between the rosin granules will be too large to hold the ink when printing is attempted. In case of a failure to apply the rosin properly, the plate should be cleaned and a dusting repeated. Incorrect distribution of the rosin may be attributed to several circumstances: the bag has too many or too few layers of cheesecloth; a draft in the room is disturbing the settling of the dust on the assigned area; or the shaking or tapping of the bag is too vigorous or too weak.

Once the ground is well covered with rosin dust, the plate should be held over an electric heater (or a gas flame) with pliers. It is very important to watch for the moment when the rosin starts to melt on one part of the plate. When this happens, the plate should

87

be moved immediately to a different position to allow another area to become sufficiently heated. The precise moment of melting can be easily observed, for the originally opaque white particles of the rosin become at once transparent and colorless. Finally, the pliers themselves should be moved to another corner of the plate to allow the rosin on the spot where the plate was held to melt also.

Next, the reverse side of the plate and its edges should be protected by a coat of etching ground.

The design should be produced in the following manner. First, all parts that are supposed to appear white are stopped out with liquid etching ground. After the stopped-out areas have dried, the plate can be submerged in the acid bath. When sufficiently etched, the plate is removed, rinsed free of the etching ground, and covered with more ground—and the process of etching is repeated to create darker tonal areas.

After about five minutes in the mordant, slight etching of the exposed surface will take place. In printing, this will produce the lightest gray. After an exposure of ten minutes, the gray will deepen, and after twenty-five minutes black will begin to assert itself; forty minutes will bring about a still darker tone; finally, after one hour, the darkest black can be produced. In practice, four phases of etching are the norm; but depending on the purpose and on one's style of work, more or fewer etchings can be carried out in the acid bath.

When etching the plate, it is advisable also to submerge a small test strip of copper simultaneously with the plate in the mordant. The strip should be divided into several sections, and marked with a needle: 5 min., 15 min., 20 min., etc. This will allow checking of the etching process. By removing successively the ground from the sections, the depth of the particular bite can be accurately observed. Seeing the bites side by side on the strip allows one to check the etching process systematically. By comparing the sections, the depth of the bite for each time period can be accurately observed.

The process of etching, rinsing, and further stopping outs can be repeated until a full tonal range is achieved. It is important to rinse the plate thoroughly after every bath in the mordant, and to let it dry before every fresh application of the ground. Round sable brushes are the only instruments used for detailed work, but a flat

brush can serve to apply the ground on large areas. After the termination of the multiple-phase etching process, the plate should be washed, dried, and its surface coating of rosin eliminated with a paint remover.

After the etching is completed and the plate is cleaned, one can ink parts of it to see how deeply the acid has worked itself into the metal. Then various corrections and improvements can be made if necessary.

(1) The acid may have penetrated the etching ground in certain spots, thus leaving undesirable marks on the plate. A scraper is used to eliminate these. By holding the cutting edge of the scraper at a low angle to the plate, such marks can be removed. This can be quite tedious, however, if deeply etched lines or dots mar the surface. Moreover, after the work with the scraper is done, a burnisher must be used to restore the original smoothness of the metal. One should remember that even the slightest imperfection will show up in printing.

(2) Transitions between areas etched for different lengths of time are always hard-edged. One can soften and blend these transitions with the burnisher. Burnishing becomes easier when the metal is oiled slightly with a fine machine lubricant.

(3) Surfaces may appear too deeply etched (i.e., they will print too dark), in which case burnishing is required. This should be done carefully, for the aquatint surface yields quickly to the pressure of the burnisher.

(4) Surfaces may be insufficiently etched. Re-etching an aquatint bite can be successful only if one does not object to a different appearance of the newly etched surface. A re-etched surface can rarely be made identical to the original etched surface. However, an appropriate *Roulette* can be used for retouching small areas.

The process described above is pure aquatint. Quite often, however, the design is made first by etching contours in line, prior to aquatint treatment.

Lift-Ground. Although it is not easily handled, lift-ground affords greater freedom to the painter than any other technique, because it allows him to use a brush in much the same manner as

89

making a brush-and-ink drawing. Round sable brushes are usually used for this purpose, but for treating large surfaces flat sable brushes can be employed. Should one wish to transfer a drawing to the plate, this can be done with homemade carbon paper—dry pigment rubbed into tracing paper. Then the drawing should be gone over with a water-soluble substance such as poster color, heavy watercolor tube paint, or, better still, a syrup prepared from sugar and water and some writing ink to give it a distinguishable color. To make the metal plate accept the paint and to prevent the liquid from crawling, the surface tension of water must be reduced by first brushing water containing a trace of a detergent over the plate. When this is dry, the drawing can be made on the plate with the brush. Watercolor paint should be thinned to a brushable consistency with water containing the detergent.

The design should be carried out in the same manner as when drawing with the brush on paper, but without any tonal transitions, that is, the tone should always be visualized as flat. When dry, the entire plate should be covered with the protective ground. The one prepared from rosin and asphaltum is thinner than the asphaltum-damar varnish and therefore more appropriate for the lift-ground process. When the ground dries well (drying can be accelerated by an electric hot plate), the plate should be submerged in warm water. Penetrating through minute openings in the ground, the water swells the water-soluble syrup, watercolor, or poster paint, lifting the protective film of the asphaltum ground on top of them, thus exposing the metal underneath. Carefully brushing these marks with a soft brush while the plate is soaking will help lift the film and dissolve the original drawing.

Again the plate should be dried, and the areas still isolated with ground can now be strengthened with more etching ground for better protection of the areas that are not to be etched. Now the exposed design should receive an aquatint ground, as described earlier and, to produce the desired tonal variations, the plate is treated as an aquatint. As in aquatint, the process described above can be repeated on the plate until a full range of tones is achieved.

Soft-Ground Etching. As the name indicates, the ground used to isolate the plate remains soft; hence designs made on it will have a different appearance than those described in the preceding techniques. A soft ground (if not available ready-made) can be

produced by adding petroleum jelly, axle grease, or tallow to a thick solution of asphaltum dissolved in turpentine. The grease should be about one-quarter to one-half the weight of the solution to change it from liquid to semisolid consistency. To apply such a substance, the plate must be preheated, whereupon a quantity of the ground paste can be placed on it and evenly distributed with a soft rubber or leather brayer.

Drawing on the ground can proceed by using a variety of tools and by other means. One can use a wooden stylus, blunt metal points, small cutting blades, a comb—any instrument capable of removing the soft ground from the plate. A special thin paper of high absorbency can also serve for this purpose; when the paper is placed on the plate and drawn upon with a pencil, the ground becomes attached to the areas of the paper touched by the pencil, and when the paper is lifted off, these areas of the plate are deprived of their protective layer. Moreover, the grain of the paper is impressed onto the soft ground, and the marks in printing will resemble those of a drawing.

When removing the ground, the artist must remember that only lines which remain sufficiently narrow will hold the printer's ink. Wide lines or areas of tone will have to receive an aquatint application in order to allow printing. For etching the plate, the same rules apply as for aquatint. The preferable mordant for the soft-ground technique is iron chloride.

The handicap in working on a soft ground is its vulnerability to the touch. The hand cannot rest on the plate. As a support for the hand, a panel 6'' wide (but longer than the plate) should be provided. Raised at both ends by legs less than 1'' above the level of the plate, such a panel will serve as a hand rest. The plate underneath can then be moved to the desired position.

Mezzotint. This technique was highly popular during the 18th and 19th centuries, when it served for reproduction of paintings, for portraiture, and for book illustrations. Today, it has little currency because it is not suited for free, spontaneous work, and photography has entirely supplanted it as a means of reproduction. A mezzotint plate is prepared by roughening it with an instrument called a rocker, which has a convex steel surface covered by fine, sharp teeth; after rocking it over the plate systematically and evenly from several angles, a surface is produced which, if inked,

would make a perfectly black print. This surface is worked over with a scraper, gradually reducing the roughness of the surface, thus creating areas which hold less ink and will produce lighter tones. The lightest effects are made by burnishing the plate. Areas of the plate that become very polished appear white in printing.

Line Engraving. The techniques previously discussed do not differ essentially from those employing a pencil or a brush, inasmuch as the same manual reflexes are used in all of them. Thus, anyone possessing a faculty to draw can, by following written directions, succeed in making an etching.

Engraving is a discipline that relies on an entirely different kind of manual operation, requiring systematic workshop practice and a great deal of specialized skill. It is a very old craft, predating etching by many centuries.

The difficulty of executing an engraved line lies in the fact that—unlike all the other techniques where the tools are used in much the same way as in drawing—the engraver's instrument (the burin) must be pushed deep into the metal in a direction parallel to one's body. The changes in direction of the lines are brought about by manipulating the plate with the other hand as the tool is pushed. To be able to twist and turn the plate continuously, it must rest on a well polished surface, such as glass or formica. Professional engravers use a leather cushion for this purpose. The burin comes in various sizes; the most useful ones range from No. 7 to No. 10. They must be sharpened frequently, for unless the cutting edge is perfectly keen, it will slip off the metal.

Printing. In printing metal plates, the nature of the press is of the greatest importance. Even the best—that is, the heaviest—tabletop press, having an upper roller 5'' in diameter, will not produce prints that are equal in quality to those made with a floor-model press used in professional printing shops.

To ready the plate for printing, a blanket is placed between the plate and the roller. Felt suitable for this purpose is on the market and comes in ⅛'' and ¼'' thickness. One can use either two or three of the thinner blankets or one thick blanket. After much use, these become stiffened by the size in the wet paper used for printing and must be washed in order to retain their elasticity.

An electric heater is needed to keep the plate warm while inking and wiping it because the ink is too viscous to be easily distributed on the plate when cold. The heater should be placed under a small table with a steel top 3/16'' thick, on which the plate rests.

Printer's ink is, as a rule, black or brown-black, but it is also obtainable in a variety of other colors. The plate is inked with a *Dauber* made of cloth and covered by tarlatan.

The ink should be distributed evenly all over the plate by rocking the dauber back and forth, and excess ink should be wiped

Dauber.

off with a wad of tarlatan. If this is not available, a piece of starched cheesecloth is equally serviceable. After the surplus ink has been removed, final wiping is done with the side of the palm. This operation must be done very delicately, the palm hardly touching the plate. If printed in this condition, the print will be soft and its highlights slightly dimmed by a faint trace of ink picked up during the printing.

If strong contrast between the lights and darks appears desirable, the following measure should be taken. The side of one's palm, while the ink still clings to it, should be dipped in a receptacle containing chalk which will attach itself to the skin. Again, when the palm moves over the plate, the thin veil of ink can be wiped from the parts that are to remain perfectly white. Soft lines can be produced by moving the wiping pad (which should be

93

preheated) very closely against the plate, thus modifying the ink in the grooves. All this is done on the warm top of the heated steel table.

Before starting to print, the pressure of the press should be adjusted. To do this with accuracy, a metal plate having the same gauge as the one to be printed, a blank piece of paper, and the felt on top of it should be placed on the press. Next the setting screws should be turned to achieve the needed pressure. The *Paper* used for printing should be heavy and soft; papers with a hard finish or too much sizing are not well adapted to this purpose. The required supply of paper should be briefly immersed in water, then stacked alternately between sheets of paper toweling or newsprint, and the whole lot left under pressure overnight. The sheets of paper must be quite damp for printing, but not dripping wet; any surplus water should be brushed out with a soft brush. After printing, the papers should again be stacked with alternate sheets of absorbent paper and allowed to dry while under pressure.

Steelfacing of Plates. When executed in drypoint and aquatint technique, plates will show signs of wear after twenty to forty prints have been pulled, depending on the depth and durability of their intaglio (lines and areas sunk below the surface) and the manner of printing. Hence, if a larger run is required, it is advisable to steelface the plate as soon as enough trial proofs have been made and no further corrections are needed; once this is done, any number of prints can be made. As a rule, every printing shop has facilities for steelfacing.

There is no basis for the generally held opinion that a print pulled off a "red" plate (the untreated copper plate) differs in quality from the one that comes off a steelfaced plate. After most careful examination of his own prints made before and after steelfacing, the author could not detect the slightest difference in their appearance. When needed (e.g., if further corrections are required, or if rust has damaged the surface), the steelfacing can be removed easily by submerging the plate in a 1:10 solution of iron chloride. After a minute or two, the steel film will come off the plate, whereupon the plate should be well washed to remove all traces of the weak acid.

94 **Storing the Plate.** Immediately after prints have been pulled, the

plate must be thoroughly cleansed of ink. This can be done with turpentine, *Varnolene,* or *Kerosene.* Well-dried ink can be eliminated with paint remover. After this has been done, the plates must be protected from corrosion. Copper plates oxidize in storage and steelfaced plates rust. To prevent deterioration, they should be coated with petroleum jelly and tightly wrapped in strong tissue paper. A heavy coat of the asphaltum ground used in etching can also serve this purpose.

History. Printing from copper plates originated in the 15th century. Engraving was the technique first used by the masters themselves. With the growing popularity of printed images and greater commercial demand, engraving was done by skilled craftsmen, who copied the drawings of the masters. Work in drypoint appeared during the 16th century, etching came into general use in the 17th century, while mezzotint and aquatint appeared in the 18th century. Lift-ground and soft-ground etchings are rather new methods.

ETHANOL is grain alcohol or ethyl alcohol (see *Alcohol*).

ETHYL ALCOHOL is grain alcohol or ethanol (see *Alcohol*).

EXTENDER. An inert material used to adulterate or increase the bulk of paint, gesso, etc. As a rule, this weakens the product's intrinsic character. For example, an expensive pigment will often receive an addition of a colorless, inert pigment of considerable bulk such as *Aluminum Hydrate,* which will increase bulk but weaken tinting strength.

FAT OVER LEAN. One of the basic rules of oil painting technique is that the first layers of paint (see *Underpainting*) should be relatively low in oil and the final layers (see *Overpainting*) should be higher in oil content. This means that upper layers of paint will be more flexible than the lower layers, thus reducing the possibility of cracking. The application of lean (rigid) layers over fat (flexible) films is likely to cause poor adhesive and cracking. See *Fat Paint; Lean Paint.*

FAT PAINT. Oil paint which has a relatively high percentage of oil. Such paint is best used for the final layers of a painting in which the earlier layers are lean, or lower in oil content. See *Fat Over Lean; Lean Paint.*

FELT POINT or FELT TIP. A drawing instrument employing a thin stick of felt into which a dye is fed directly or through a valve. See *Drawing.*

FERRIC CHLORIDE. See *Iron Chloride.*

FERRULE. The part of the brush handle that is made of metal and holds the bristles or the soft hair.

FILLER. An inert pigment—such as *Aluminum Hydrate, Barium White,* and *Chalk*—added to extend paint. The term filler is synonymous with *Extender.*

FISH OIL is a non-drying oil, but can be made to dry when cooked with *Siccatives*. It is sometimes used in industrial paints, but has no value for the artist.

FITCH HAIR BRUSHES are an inexpensive variety of sables (see *Brushes*).

FIXATIVE or FIXATIF. A thin varnish prepared from shellac or a synthetic resin and sprayed on a *Drawing* to make charcoal, pastel, crayon, or pencil marks indelible.

FLAG. The end of the hair (in a brush) which, in its natural state, is split, forming a fine, pointed fork. As such, it holds the paint better and moves it with greater delicacy and precision. The flag is also called the "split."

FLAKE WHITE is a basic carbonate of lead (white lead). Because of its excellent all-around qualities, it is the most important of all the white oil paints—though it is not used in water-based paints, in which a paint film of white lead, lacking the protective coating of oil, would blacken. European brands employing a slightly different manufacturing process are often labeled "Kremitz White."

The characteristics of flake-white oil paint are as follows. Its oil content is materially less than that of any other color, making it the "leanest" and most solid paint on our palette; hence its use in priming and underpainting is imperative. Its drying capacity is better than that of any other white; when either of the other two white paints available in the trade *(Titanium White* and *Zinc White)* rivals the drying time of flake white, one can assume that a drying agent has been added. The hiding power of flake white is also good, but not as effective as that of titanium white.

The tinting capacity of flake white is not as strong as that of titanium white, but this should be considered an advantage rather than a failing, for a strong white will reduce the chromatic action of other colors, thus making them less effective. With the progression of time, flake white becomes more translucent because of partial saponification, and this accounts for the mellow appearance of the white lead applications in old-master paintings.

Chemists believe that this saponification accounts for the fact that white lead forms such a homogeneous, solid, and durable film. Every restorer has found that it is relatively easy to attack most old color films with certain solvents but that white lead offers great resistance to even the strongest solvents.

When the white lead pigment is ground in only 9%linseed oil, the small quantity of oil will suffice to make the paint brushable. The pigment is very reactive to the acidity and polymerization of oil; hence it is easy to change its consistency from *Short Paint* to *Long Paint*. When a small amount of *Copal Concentrate* is added to white lead, however, it will (unlike all the other colors) merely stiffen instead of becoming long. This is attributed to the quick formation of lead soap in the compound due to the high acidity and polymerization of the copal concentrate. Hence, a relatively large addition of copal concentrate is required to produce long paint.

At times flake white has had a bad reputation, and assertions are often made that sulfides will blacken the white pigment. This is indeed the case when flake white is mixed with improperly prepared paints containing free sulfur, a condition which is non-existent in modern paints. It is true that when flake white is exposed to highly sulfurated air—a possibility hardly ever encountered under normal conditions—blackening will occur; but when the paint is exposed to strong daylight, this effect will disappear.

The same applies to yellowing, which will take place if too much linseed oil is mixed with the pigment and if the painting is then allowed to dry in darkness and remain stored there. Moisture will aggravate this condition. Exposure to light, however, causes the paint to bleach, provided that the oil used was not inferior.

It is frequently asserted that paintings in the National Gallery in London have darkened because of sulfuric gases in the atmosphere, but this does not appear convincing. Rather, the yellowed and darkened condition of these paintings must be attributed to the use of what we may classify as a "coach varnish"—varnish that has been improperly prepared from linseed oil boiled in an open kettle, copal resin, and an excessive amount of lead dryers, for the express purpose of achieving the brown "gallery tones" so much favored during the 19th century. In fact, this circumstance accounts for the bad reputation of copal resin on which uninformed writers

have blamed the yellowing and darkening of these paintings. Today, after the removal of the old, dirty, and darkened varnish, the white lead applications seen on the old masters' paintings are as bright as they were centuries ago.

Concerning toxicity of the material (reports are often heard about the "danger" of using it), this has never been substantiated except in cases where an actual allergy exists. Locked in the oil vehicle, the pigment particles of white lead cannot enter the body in normal use, but sustained inhalation of the dry pigment while grinding the paint, or its internal consumption, is definitely detrimental to health if done without precautions. Because of the effort involved in compounding flake white with the requisite amount of binder, hand grinding of the pigment is inadvisable anyway, and it is best to buy the manufactured tube paint.

The manufacture of white lead reaches into the most distant history. Without modification or improvement, it is the only artifical pigment that served the painter exclusively as white coloring matter in *Oil Painting, Encaustic,* and *Oil Tempera* until the introduction of zinc white.

FLASH POINT is the temperature at which the vapors of a solvent will ignite when brought into contact with flame. Fluids with a low flash point must be handled with care.

FLATS are long bristle brushes (see *Brushes*).

FOSSIL RESINS, such as *Copal* and *Amber,* are *Hard Resins.* They are exudates from trees now extinct and are found underground.

FRAMING. The style of frames is subject to change according to the fashion prevailing at a certain time. Most types of frames that were in vogue twenty years ago are no longer acceptable today. Only designs that follow antique (15th- to 19-century) patterns have perennial currency. Besides these, a modification of the Baroque style—the so-called Barbizon frame—is still in use. These elaborate frames cannot be manufactured by a layman. However, even an amateur can acquire the technique of antiquing, that is, producing an antique finish, on all types of moldings.

Proportions. As a general principle, moldings for small paintings can be proportionately wider than moldings for larger pictures. Small paintings need "breathing space." Pictures up to about 10" x 12", for example, can receive a 4" wide frame in addition to a 2" insert (the flat wood molding between the frame and the picture), or a narrow wood molding (1" or less) could be placed around a 4" insert. Pictures up to 16" x 20" could have a 2" insert and 3" frame. The larger the painting, the less important the insert. Any size larger than 30" x 36" need not have an insert, and the molding can be quite narrow. Frames for many modern paintings have been reduced to narrow strips (¼" to ½" wide) which are simply nailed onto the side of the stretcher bar. Such strips are available ready-made. The forward edge of the narrow molding is often gilded and frequently does not project beyond the surface of the painting.

When framing pictures under glass, the ruling principle is to have a wide mat made of cardboard and a narrow frame. (A mat is similar to an insert, but the cardboard mat is used only in conjunction with pictures under glass.) The sides and top of the mat should be of equal width—not less than 2½"—but can be much wider, regardless of the size of the picture. The bottom should be about ¼" to ½" wider than the top and sides. If the mat is cut an

Barbizon frame.

equal width on all four sides, an optical illusion would make the mat seem narrower at the bottom.

Moldings. These are made of a variety of woods. Those made of chestnut, oak, walnut, or mahogany (because of the nature of their particular grain) can be used in their natural state, with slight finish or color modifications. Most other kinds of wood frames will have to be covered by a finish that completely obliterates their original appearance.

The wood inserts always require complete concealment of their grain. Raw oak frames, made up in standard sizes (9" x 12", 12" x 16", 16" x 20", 18" x 24", 20" x 24", 24" x 30") without inserts, are available in art material stores. Picture moldings of various designs can also be obtained from various mail-order houses.

A variety of standard builders' moldings are stocked in lumber yards. The principal types are known as "crown" (which comes in several profiles), "back bend," "chair rail," and "cove". However, these standard moldings do not come with a rabbet to hold the picture, however, and a suitable rabbet must be constructed. Moldings of any design can be ordered from most lumber mills. As a rule, the mills accept such jobs when the molding is to be fabricated in sufficient quantity. The person ordering the molding is also required to pay for the special knife used for cutting a particular profile.

Crown molding
with insert.

Chair rail molding.

Cove molding.

Back bend molding.

Joining Moldings. To join moldings the appropriate tools are required as well as great accuracy in manipulating them. First, a miter box, a saw, and a Stanley Marsh vise are needed. The last is designed expressly for joining frames. It clamps both pieces of molding together while the joints are glued and nailed. The miter box should be equipped with a stop block. This device enables one to cut the mitered pieces to the same length. It can be made in the following way. A yardstick should be attached to the back of the fence of the miter box; on the opposite end from the saw blade, a block of wood is fastened to the yardstick with a small clamp, so that it can be adjusted to any position on the yardstick.

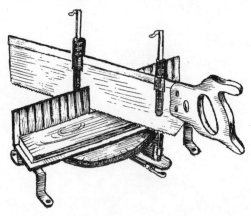

Miter box and saw.

When cutting the miter, the following factors should be taken into consideration. Both mitered ends of a piece of molding must

be cut to an exact 45°angle, and the saw must be held vertically to the molding. The two end pieces of the frame must be the same length and the two side pieces must also be exactly the same length for the 4 pieces of molding to fit together in a true rectangle.

Before mitering, a long strip of molding is cut straight across into four pieces of the required lengths. In cutting these lengths, twice the width of the molding and twice the width of the insert must be added to the picture dimension. For example, if you have a 16'' x 20'' painting, a molding 3'' wide, and an insert 1½'' wide, the two long pieces would each measure 29'' (20'' plus 6'' plus 3''), and the short ones 25'' each (16'' plus 6'' plus 3'').

To cut the miter, the box saw gauge should be set at a 45° angle, and the four left ends of the moldings should be cut. The miter box should be permanently attached to the work-bench or securely clamped down. The piece of molding should be face up, with the rabbet edge at the bottom, and should be held firmly against the fence to prevent its shifting, which would cause the corners to be rough.

After the four pieces have been mitered on the left end, the saw gauge should be turned around to the opposite 45° angle. Before mitering the right ends, the following simple formula must be observed to determine the exact measurements for the cuts, using the 16'' x 20'' picture size and a molding with a ¼'' rabbet as an example. Along the extreme inside edge of the frame, which is the lip of the rabbet, 15¾'' should be measured from the already mitered end, and marked with a pencil; this is the point where the right miter cut will begin for the short piece, while 19¾'' will be correct for the long piece. These figures are arrived at thus: 16'' picture dimension, plus ¼'' tolerance, minus ½'' (twice the width of the rabbet) equals 19¾'' for the long piece. A similar computation establishes 15¾'' as the inside length for the short piece. Next, the right ends of the pieces should be cut at the correct markings.

White Glue and finishing nails are used to join the four moldings together. With one long and one short piece held firmly in position in the Stanley Marsh vise, a hole should be drilled entirely through the first piece and just a little into the second piece; this is essential to accommodate the nails. Next, the first piece should be taken out of the vise and glue applied to the

103

mitered end; it should then be replaced and tightened firmly before driving in the nail from one side. Then the second piece should be drilled, and then the nail driven in, making sure to place the holes so that the crossed nails do not hit each other.

When joining the first set of two pieces with the second set to complete the frame, it is necessary to place a support under the end that is not in the vise. If this precaution is not observed, the unsupported joint may open up because of the undue strain. Two sizes of nails are usually required for joining, the longer nail in one molding, the shorter in the adjoining molding. They should be counter-sunk with a nail setter and the holes filled with a crack filler or with *Acrylic Modeling Paste*. The joints should be as smooth and flush as possible. Should there be a slight discrepancy, it should be in the back of the molding rather than on the face. For frames with inserts, the insert is made first with the same precision and procedure described above, and then the frame is made to fit it.

Finishing Raw Wood Moldings. Hardwood moldings are most suitable for finishes utilizing the natural texture of the wood, but if the grain is sufficiently interesting, even soft varieties of wood can be used. First the molding should be sanded to a smooth finish. For coloring, dry pigment mixed with *Wax Paste* is best. Only a few colors are suitable for this purpose: *Burnt Umber, Burnt Siena*, and *Yellow Ochre*. These can be intermixed, and *Ivory Black* can be added if darker nuances are desired. Rubbing the colored wax paste into the molding and polishing it with a cloth will provide a permanent finish. The wax paste used for this purpose can be the commercial variety that is sold under different brand names.

The natural grain of the wood can be further enriched with a patina applied on top of the colored surface. In this instance, an underlying wax finish is inappropriate because the patina will not adhere to it. Therefore coloring must be achieved with another medium, the best of which is acrylic paints, to which the patina will adhere. When dry, acrylics become water-insoluble, and the superimposed liquid patina will not dissolve them. Here, too, the range of colors best suited for the purpose is quite limited (as suggested above), for the final color effect should generally be neutral so as not to interfere with the colors of the painting. The acrylic colors can be used directly as they come from the jar or

tube, or dry pigments can be mixed with *Acrylic Polymer Medium*. In either case, the paint should be thin enough not to cover up the characteristic grain of the wood.

The patina applied over the colored surface is prepared from *Acrylic Gesso* mixed with *Burnt Umber* or *Raw Umber* (either dry pigment or liquid paint) to the color of dust. (Of course, traditional *Gesso* can also be used; but unless it is protected with wax or a similar sealer, it will remain water-soluble.) The purpose of the patina is to produce an antique, "dusty" effect. It should be applied on top of the darker color of the dry wood quite thinly but in a solid film. While it is still wet, the patina film should be rubbed off with a moist rag, leaving a light *Scumble* on the dark surface, chiefly imbedded in the grain of the wood. Such treatment is often referred to as "pickling," and it is effective only when the grain of the wood is open enough to allow the patina to penetrate into its crevices. A patina should be matt; it should not be polished or varnished. It is here that acrylic is most useful, because it does not require a protective coating of wax or varnish.

Gessoed Moldings. These can be of simple design, or can have a more complex profile; they may be richly carved and partially or completely gilded. Normally, acrylic gesso is preferable, but when the frame is to be gilded the traditional *Gesso* should be used because it flows more smoothly, forming soft configurations, and allows easy sandpapering, which is a decided advantage when one is dealing with carved surfaces. Whenever gilding is used, it should be applied to a white gesso foundation, coated with red gesso. If silver leaf is used, the second gesso layer should be gray or ochre. These traditional color choices have proven the most appropriate.

To create a simple design, the entire molding should be gessoed as usual; when the frame is not to be gilded, acrylic gesso is used. As it comes from the can, this material is thick and holds brushmarks; when thoroughly dry, these are difficult to eliminate by manual sanding, although an electric sander will facilitate the work. One can use the gesso well thinned with water, however, in which case several applications will be required. (Even when it is applied in its normal consistency, the traditional gesso can be smoothed more easily than acrylic gesso which should be sanded before it hardens completely.) After the initial white gessoing, a

105

thin layer of gray gesso should be applied, which serves as a patina. The color of this semitransparent patina should be produced with raw or burnt umber and white, or with umber, *Ultramarine Blue,* and white if a cooler tone is desired. Dry pigment should be used for the color mixtures, with the gesso serving as white. When dry, the molding can be sanded and polished with steel wool, or a glaze can be superimposed to enliven and enrich the texture of the finish. The glaze is prepared from a dry pigment and acrylic polymer medium; the coloring matter should be quite thin and transparent. Dry pigments are used because their particle conglomerates are not completely dispersed in gesso or medium and hence leave their mark when the surface is sanded. The minute particles of pigment act as separate coloring matter, enhancing the coloristic effect of the finish. When they are sufficiently thin, several glazes differing in color can follow one another. When the total effect appears too dark, a light scumble can be used. This, like the patina, is prepared from white gesso and dry pigment, mixed to a thin consistency, so that the underlying color can assert itself.

All these operations can be best carried out with acrylic gesso and medium. The traditional glue gesso and glue-bound colors would, because of their solubility, offer obvious difficulties; each layer would have to be isolated (made waterproof with varnish) before the next application. It must also be remembered that the final sanding and polishing with steel wool unifies the color films.

Textured Effects. These can be produced by gessoing the molding in several ways. Both acrylic and glue gesso lend themselves to texturing, but it can be done only when the paste is neither too soft nor congealed. Hence, one must carry out the work precisely at the time when the material has partially dried to exactly the right consistency. One can learn by experience to recognize this optimum state.

Various patterns can be made in the gesso with such simple instruments as a piece of comb, a razor blade nicked in several places to produce irregular combing marks, a *Stylus*, and a stiff brush. By pressing a coarse-grained fabric or a wire screen into not too thickly applied gesso, interesting textures can be obtained. Raised ornaments can be modeled best in *Plaster of Paris* or with

Acrylic Modeling Paste. When mixed with glue *Size* instead of with pure water, the drying time of plaster can be retarded to allow prolonged manipulation of this material. (Broken and missing parts of antique frames, such as those of the Barbizon type, can be replaced with plaster of Paris.) Its capacity to adhere, however, is not too strong; to overcome this problem, ornaments can be modeled *in situ*, removed when dry, and later glued back on with white glue.

Coloring Textured Effects. The patterns formed by the white gesso (preferably acrylic gesso) are modified by a patina of a neutral color, spread over the entire surface. Sanding the surface will uncover the white at the texture's high points; in the depressions, the patina remains in its original condition. Should the white effect be too strong, a glaze of any appropriate color can be spread over the entire surface; this will condition the color of the patina and also color the white pattern. A light polishing with steel wool will further improve the general effect.

An alternate method calls for dark gesso. Here, acrylic gesso will offer some difficulties because the whiteness of the material (*Titanium White*) is difficult to subdue. Hence gesso should be prepared from dry pigments (*Chalk* plus burnt or raw umber, ultramarine blue, *Venetian Red*, or similar dark color or colors) dispersed in acrylic medium. These pigments should be well mixed—or still better, ground with a muller—to a smoothly flowing consistency, then applied to the molding, and finally textured. When the dark gesso is dry, a patina of a very light color is applied to the entire surface, and polished with steel wool.

Inserts. The appearance of small and medium-sized paintings is greatly enhanced by the presence of an insert, which can be finished in two standard ways. It can either be gessoed or be covered with raw linen. For a gessoed insert, the best color is a neutral gray, which can be warm or cool. Thus umber, or umber and ultramarine, should be mixed with acrylic gesso or glue gesso and applied evenly to the entire insert.

Linen can be glued to the entire insert or to the top only; in the latter case the bevel of the insert should be finished in white gesso or it should be gilded or silvered. Such finishes, now in use for several decades, have proven to be perennially attractive. The

linen should be glued first to a cardboard corresponding in size to the face of the insert, whereupon the linen-covered cardboard is glued onto the insert.

All four sides of the insert can be covered with a single piece of linen, or each separate strip of the molding can receive the linen before being joined. The preferred way is to glue on the fabric in one piece. The adhesive used for this purpose can be white glue, or traditional hide or rabbit-skin glue. In either case, it should not be too liquid, to avoid penetrating to the face of the linen. If defaced in this way, however, the linen can be salvaged by gessoing it in much the same way as a molding. Animal glue is preferable to the synthetic material because should the fabric detach itself in spots from the insert, one can remedy the condition by wetting the surface and pressing it down. Furthermore, glue stains on the fabric can be removed with water; white glue, however, becomes water-insoluble once it dries.

Frames for Pictures Under Glass. Prints of all sorts, water-colors, gouaches, pastels, and drawings need the protective shield of glass. A wide mat should be used with a narrow molding, ranging between ½'' and 2'' wide, depending on the size of the picture. The mat should be no less than 2½'' at the top and sides, and about 3'' at the bottom, preferably wider. For quite small prints, a mat 3½'' at top and sides and 4½'' at the bottom will do well.

There are, however, exceptions. Large color reproductions of paintings can receive a regular picture frame, but because of the glass one can dispense with the insert. In the end, it all depends on the character of the frame chosen for a particular reproduction.

Mats. For prints and drawings, the mat should be made of medium-heavy cardboard, white, off-white, or colored, depending on the picture, the frame, and where it will be hung. The window cut in the mat should have a beveled edge. In cutting cardboard, a suitable knife is of first importance. It must have a thin, pointed razor-sharp edge. Professional mat cutters use knives with an adjustable blade that allows repeated resharpening. Besides the knife, a heavy metal ruler with a beveled edge and a pencil compass are all the tools needed. To keep the ruler from slipping strips of fine sandpaper should be glued to its underside.

The knife should be held at a slant and, never changing the angle of the cut, should be drawn firmly from one corner of the marked window to the other. After the cut has been made on all four sides, the center rectangle to be cut away will usually still adhere at the corners of the window. A razor blade, held flush with the bevel, should be used to detach the board completely. Cutting paper dulls the knife even more quickly than cutting wood; therefore, it will be necessary to resharpen it frequently on a flat sharpening stone that has been moistened liberally with machine oil.

Mat knife.

Before cutting the mat, measure the picture area which is to show through the window; then establish exactly the width of the mat on all sides. The placement of the window on the mat is done by scribing. The pointed prong of the compass should be held at the outer edge of the board and the leg with the pencil should mark the window; thus, the pointed prong of the compass, pressed against the outer edge of the mat, should slide along the edge, simultaneously allowing the leg with the pencil to mark a line on the mat. The top and the sides should be marked to the same measure; then, by increasing the reach of the compass by at least ½'' (or considerably more, depending on the overall size of the mat), the bottom should be marked. A correct alignment of the window will thus be obtained.

Recently, a very efficient mat cutter has appeared on the market.

Cutting Glass. The implements needed are a steel ruler and a glass cutter. A cutter with a diamond point is best, but the ordinary kind, obtainable in hardware stores, will generally serve the purpose. The following rules of glass cutting must be observed. Work on a perfectly flat working surface, preferably covered with cardboard. Immobilize the ruler to prevent it from slipping; a piece of adhesive tape should be pasted onto its reverse side. Clean the glass with alcohol and chalk (or a commercial glass cleaning solution) to allow the cutter to move over it with even pressure.

109

The cutter should also be perfectly clean; professionals usually dip it in kerosene before cutting.

Score the glass starting from the far end, drawing the instrument, held at a moderate slant, toward you with firm and constant pressure, in one straight line. Never go over a cut a second time or start cutting over the sharp glass edge, for this will dull the cutter. After scoring, the glass should be gently tapped on the reverse side at both ends of the cut (not in the middle!) and then parted by bending it, without undue pressure, downward from the cut.

FREE FATTY ACID. *Linseed Oil* can be "neutral" or it can possess free acid, which can be verified by touching the oil to litmus paper. In the presence of acid, the bluish paper will turn red. Acid can also be detected by its acrid odor; in contrast, neutral oil has a sweet smell. Acidity of oil is measured by *Acid Number.* Up to number 2, the oil is considered neutral. As such it has little *Wetting Power,* and when used for grinding it will produce stiff, short paint. Thickened, polymerized oil, having a high acid number, will make *Long Paint.* Polymerization and the consequent acidity can be produced by exposing oil to heat and/or air. Neutralization can be brought about by adding a teaspoonful of calcium oxide (quicklime) to a pint of oil, which should be heated and stirred. Then the powder should be allowed to settle at the bottom of the bottle. Its presence will keep the oil neutral by absorbing acid formed during prolonged storage. To remain neutral, the oil should always be kept in well-filled bottles.

FRESCO BRUSHES are made of pigs' bristles of considerable length, held by a round ferrule. The roundness of the brush contributes to its mobility, and the length of the bristles prolongs their usability when working on the rough surface of a wall. It also facilitates the distribution of the liquid paint material. (Flat bristle brushes are more useful when working with paint in paste form.)

FRESCO BUONO, FRESCO SECCO are Italian terms; the first is painting executed on wet plaster, the second, fresco done on dry plaster (see *Mural Painting*).

GAMBOGE is a yellow gum resin produced by several species of trees growing in India, Ceylon, and Thailand. It is obsolete as a color for oil painting, but because of its transparency, it is useful in antiquing gold applications (see *Gilding*). It is partially soluble under heat in *Varnishes, Linseed Oil,* and gum arabic (see *Gums*). Gamboge is still used by many watercolorists. In this medium, it is clear, highly transparent, warm yellow of medium tinting strength.

GEL is a jellified or semisolid substance such as glue size and *Acrylic Gel Medium.*

GEL MEDIUM is a semiliquid, salve-like, transparent paste which can be mixed with pigments to produce paint that is sufficiently elastic to create *Impasto* effects. The gel sets quickly and is very adhesive. It can therefore also be used for attaching canvas to a new support (see *Restoration of Paintings*), for making *Collages*, etc. See also *Acrylic Gel Medium.*

GELATIN is a refined form of *Glue.*

GESSO is the Italian term for *Gypsum*, which was formerly used in combination with glue size for priming panels for painting and for coating decorative objects prior to *Gilding*. Today, the term is used to describe two kinds of compounds (neither of which contains gypsum) that are used for priming and decoration: traditional glue gesso and acrylic gesso.

Glue gesso is composed of size and *Titanium White.* This mixture is preferable to the older, thicker solutions that call for whiting or chalk and zinc white because of its stronger whiteness and greater covering capacity.

The size, which holds the particles of pigment together, is prepared from *Glue.* Because glue comes in so many qualities, its quantitative relations with water are not always the same. If a good quality (hide glue or rabbit-skin glue) is used for gesso, 1 oz. dissolved in 1 pt. of water will produce sufficient binding power; for priming rigid supports like panels, 1½ oz. will not be excessive. Too little glue will render the gesso surface spongy. Too much will make it hard; the more glue is used, the more nonabsorbent the surface becomes.

Standard glue gesso (in contrast with acrylic gesso) is always absorbent to a degree. It is therefore unsuitable for oil painting unless the gesso is properly isolated with a glue size, which, when brushed on top of the gesso, will render the priming largely nonabsorbent. *Copal Varnish, Damar* varnish, or *Acrylic Polymer Emulsion* can also be used to isolate the gesso.

There is no special merit in casein gesso; under present conditions, it must be looked upon as obsolete. Of all types of gesso, the acrylic material is the best.

Traditional Gesso Priming. First soak 1 oz. of glue overnight in 1 pt. of water, then dissolve it by heating—but not boiling—it. Next, 8 oz. of *Whiting,* 8 oz. of *Zinc White* pigment, and 2 oz. of titanium white pigment should be stirred into the warm, liquid size until all lumps disappear. (The glue and other ingredients should be placed in a *Double Boiler* to keep the solution warm and to prevent the solution from congealing.)

A large 1'' to 3'' *Utility Brush* should be used to apply the gesso, while still warm, to such rigid supports as untempered *Masonite* and plywood. A second, third, or even fourth application will be required depending upon the covering capacity of the gesso. Each layer should be brushed on top of a completely dry surface, and the liquid gesso should be warm but not hot, or it will dissolve the underlying coat.

Whether one does or does not sand the top coat of the dried gesso is a matter of personal preference, but it should be noted that a perfectly smooth finish (such as that of commercially prepared

panels, where the gesso is sprayed on) has a mechanical appearance which can only favor techniques used for rendering minute details.

Acrylic Gesso. Painting in any medium can proceed on a two-coat priming of *Acrylic Gesso* without previous isolation to reduce its absorbency. Because of the elasticity of the material, it can be applied to canvas without prior sizing as well as to a panel.

Neither blue gesso nor acrylic gesso should be used on an oily surface. Thin the gesso with water to avoid brushmarks.

GILDER'S CLAY (gilder's whiting, white bole, kaolin, China clay) is an inert pigment similar to ochre in composition but softer and more unctuous. Hence it is suitable for use as a foundation for *Gilding* that is to be burnished to a high gloss.

GILDER'S WHITING. See *Gilder's Clay.*

GILDING AND SILVERING. The painter may require gold or silver applications for pictorial as well as decorative purposes. These materials may be applied to rigid surfaces (panels) or flexible ones (canvas) and may also serve for finishing frames.

Materials. Gold leaf comes in books of twenty-five leaves, each 3⅜'' x 3⅜'', separated by pages of tissue paper. It can also be obtained in coils ½'' wide or wider. So-called ''patent gold leaf'' is attached to the underlying tissue paper and can be applied easily and swiftly even by the inexperienced. Silver leaf books also contain twenty-five 3½'' x 3½'' leaves. ''Metal'' (brass) leaf and aluminum leaf are also sold in books containing twenty-five leaves, 5½'' x 5½''.

For wax gilding, powdered bronze or aluminum, obtainable in a large variety of shades, is mixed with *Wax Resin* compound to make bronze or aluminum paste; or it can be bought ready-made under the trade name ''Treasure Gold.'' A product with the trade name ''Liquid Gold'' is also available ready-prepared, or one can mix any metallic powder with *Gold Size*. True powdered gold is produced in ⅛ oz. tablets and in even smaller weights placed on tiny shells; this material is sold as a watercolor, not suitable for use in oil painting.

A *Burnisher* made of agate is necessary for gilding. If an agate burnisher is not available, the standard steel burnisher used in etching will do. *Shellac* (white and orange), *Dragon's Blood, Gamboge*, and *Asphaltum*, are also used for various gilding processes.

Applying Gold Leaf. To apply gold leaf to a rigid surface like wood, the wood should first be sized (1½ oz. glue, 1 pt. water). If Masonite is used, one can dispense with sizing. The pigment used in the gesso used for priming is variously referred to as *Gilder's Clay*, China clay, and white bole. This material is especially adapted for gilding because it is soft and malleable, allowing gold placed on it to be burnished to a high luster. The pigment should be dispersed in the standard size. Remember that the stronger the size, the more difficult it is to polish the gesso to a smooth surface. Too little glue, however, will make the size too weak. In case the white gilder's clay is not obtainable, the gesso can also be prepared from equal quantities of whiting and zinc white mixed with the size; this gesso is not as well adapted for burnishing, however.

Gilding is rarely done directly on the white surface. As a rule, a coat of red or yellow *Bole* (ready prepared or compounded with glue size) is applied on top of the plain gesso. This underlying color enhances the appearance of the gilding, especially when the color becomes visible at certain spots, producing a rubbed or antiqued effect. A product called Heins Clay Gold Size (in red, yellow, and blue) is also marketed in paste form. Should bole not be available, *Red Iron Oxide* or *Yellow Ochre* pigment can be used, but here too, burnishing to a high gloss will not be possible. Before the red- or yellow-tinted gesso is brushed on, the white priming should be well smoothed with fine carborundum polishing paper. The same treatment should also be given to the red or yellow gesso. Thus treated, the priming will be ready to receive the gold leaf.

In the technique known as water gilding, only glue size can be used as a mordant (adhesive) for the leaf, as described below. If the gold leaf is to be applied on top of an oil painting, a water-based mordant must be ruled out; instead, the quick-drying gold size should be used. If this product is not available, a substitute can be prepared from *Damar Solution Heavy* or *Damar Picture Varnish* mixed with 10% *Stand Oil* or plain *Linseed Oil* and with about 2% *Cobalt Dryer*. A good mixture would be 1 tsp. damar solution, 15

drops oil, and 3 drops dryer (see *Measuring Small Quantities of Material*). A standard solution of shellac or *Acrylic Polymer Medium* can also serve the purpose.

Gilding with Non-precious Metal Leaves. If a rigid surface is to be gilded, it must first be primed. Metal leaf cannot be burnished to a really high gloss, so it may be applied on Acrylic Gesso, to which the leaf can be attached by one of the sizes (aqueous, resinous, or shellac) mentioned in the preceding paragraph. It is not nearly as easy to sand the well dried surface of acrylic gesso, however, as it is to smooth dried glue gesso. The acrylic material when used with even a slight impasto will leave brushmarks that are quite resistant to the action of the sandpaper. Therefore, polishing the surface should proceed when the acrylic-gesso film has dried superficially but has not yet hardened. Water applied with a flat, soft hair brush to a semidry surface will also aid in obliterating any brushmarks.

As with glue gesso, the white acrylic gesso should be brushed first onto the surface. When it dries well, a red acrylic color (red iron oxide or burnt siena) can be painted on top of it. This application can be very thin, in which case it will not leave brushmarks.

Wax Gilding. For this purpose, a rigid surface should be primed with either glue gesso or acrylic gesso. It is essential, however, to provide a smooth and highly polished surface for the wax gilt. Hence, after sanding with fine carborundum paper, the gesso should be burnished with an agate or steel burnisher. Both kinds of gesso surfaces can be burnished to a high gloss.

Gilding on Flexible Surfaces. Whatever gilding material may be chosen for this purpose, a priming of glue gesso must be ruled out. Because it is perfectly rigid, it cannot follow the inevitable expansion and contraction of the hygroscopic canvas; if used, it will develop a network of cracks. Because of its elasticity, acrylic gesso can be used on canvas. Gilding can also be done on a canvas with an oil priming. Gold and metal leaf, as well as bronze wax paste, are suitable for this purpose. The leaves should be attached to the painting by means of gold size or the previously mentioned resin-oil mordant. Gold applications on canvas cannot be burnished very effectively.

Water Gilding Technique. To apply gold or silver leaf to a panel, the leaf and its underlying tissue paper should be cut from the book to the required size, using sharp, clean scissors. It is important to use scissors that are free from grease and other impurities, or the leaf may be pulled off the paper. Chalk moistened with alcohol is the best cleaning agent for this purpose, as well as for keeping one's fingers clean, for the delicate leaf will attach itself easily to soiled fingers. (These precautions are not necessary when using patent gold leaf, which is actually attached to its underlying paper.)

Next, glue or gelatin size (1 pt. water mixed with 1½ oz. glue or with a slightly weaker concentration of gelatin) should be brushed onto the gessoed surface and allowed to dry. Before placing the leaf on the glue, the surface should be moistened with water and 10% alcohol to soften the glue and renew its tackiness. The leaf with the paper on top of it should then be placed on the surface and pressed down while the sized surface is sticky but not wet.

The professional gilder uses a slightly different method. The gold leaf is transferred from the book by means of a straight, long-bladed knife to the so-called gilder's cushion. This is made of a 6'' x 10'' wood panel cushioned with layers of cotton; the slightly convex surface is covered with chamois, nailed to the sides of the panel. The gold is cut to the required size on this cushion with the knife, then picked up with the 3'' width gilder's tip, which is made of one or more rows of camel hair set in cardboard. The gilder usually touches the tip to his face or hair in order to make the camel hair slightly oily (not, as is commonly believed, to generate electricity); one should not overdo the procedure, however, because the gold leaf might stick firmly to a brush that is too greasy.

Oil Grounds. When applying gold or silver leaf on oil grounds the leaves are handled in the same manner as described above, but they cannot be burnished. The mordant—gold size in this case—should be brushed thinly onto the support; when the size has dried to a tacky state the leaf should be placed on it and pressed down with the tissue paper. Depending on the nature of the mordant, it can take a few minutes or longer to become sticky.

116

Handling the flimsy gold or silver leaf is not easy for the inexperienced. This is not the case when one uses metal or aluminum leaf; these can be picked up with one's fingers, provided that the fingertips are perfectly free of grease or perspiration. Alcohol and chalk are the best cleaning agents when one handles the leaves manually.

Wax-Resin Gilding. Bronze or aluminum powder mixed with wax-resin compound can be rubbed onto a frame for a painting. The compound should be applied with a lint-free cloth and then polished to a gloss. This type of gilding appears most brilliant when applied to a glossy, well-burnished surface; after drying, the gilt itself is also burnished. This manner of gilding is very useful for patching worn or chipped spots of a gold frame.

Watercolor Gilding. The gold used for *Watercolor Painting* is prepared from 23-karat gold powder in a gum-arabic binder. It can be employed in the same manner as watercolor, chiefly for lettering and illuminating. Such gilding should receive a protective coating of an *Acrylic Fixative.*

Antiquing and Protecting Gilded Surfaces. Whether burnished or left unburnished, gold applications are usually protected with a surface coating. Should one wish to preserve the original color of the gold leaf, a thin layer of white shellac will be appropriate. A brilliant warm tone can be produced by coating the gold with gamboge and a darkened tone with dragon's blood. Orange shellac will provide the gold with a reddish, antique finish. A still darker, brownish color can be produced by applying an asphaltum solution, which can be used in addition to white or orange shellac. The asphaltum should be applied under, not over, the shellac, which provides much greater protection.

A patina can also be produced by glazing the gilded surface with burnt umber acrylic color and then dabbing the glaze, while still wet, with a piece of cheesecloth. The purpose of this cheesecloth is to produce a uniform pattern. Umber and black, applied in this manner, look particularly attractive on silver leaf. Oxidation effects can be produced on silver leaf by staining it with a solution of asphaltum in turpentine. In all, when heavy antiquing is desired, metal or aluminum leaf will do just as well as genuine gold or silver.

117

Quite frequently, a single application of gold leaf will require additions on places where the leaf tore or failed to become attached and a second or third partial gilding may be needed. To do this, the same size should be used as in the initial gilding. If real gold has been used, the patches of this highly malleable material will merge completely with the first application of the metal. A patina will, of course, cover up any irregularities that may appear on the gilded surface.

Gold Leaf Designing. Lettering—or any kind of design to be gilded—should be painted first with gold size on the canvas or panel. Because the size is rather colorless, some strong tint such as phthalocyanine blue or umber oil color should be mixed with the size to make it visible. When painting on a dark surface, the color added can be yellow. Since sable brushes are used for painting, the size must be liquid enough to be easily manipulated; when too thick, it can be thinned with turpentine. When the marks made with it become sticky to the touch, the leaf should be placed all over its surface and pressed down with its tissue paper to make the leaf adhere firmly to the marks made with the size. When dry, the gilded surface should be gently brushed with a soft-hair brush or rubbed with one's finger to remove the unattached leaf.

Whenever a size is used, and whatever its nature, it should be neither too wet nor too dry to act as an effective adhesive.

GLAIR is a vehicle prepared from the white of egg. Medieval directions call for beating the egg white on a platter with a whisk until the white is quite stiff and sticks to the platter even when it is turned upside down. Glair, the liquid that settles at the bottom of the froth, can be mixed with pigments for painting; once dry, this paint becomes water insoluble. Many medieval illuminated manuscripts show the use of this material. Because egg white decomposes quite rapidly, the technique of painting with glair was referred to in Italy as ''putrido.''

GLAZE. A transparent film of a darker color resting on top of a lighter color. See *Oil Painting*.

GLUE is used by the painter for sizing canvas and panels and for preparing gesso. The quality of glue depends on the raw material

from which it is obtained—animal skin, cartilage, bones, mucous membranes, claws, hoofs, etc.—and on its freedom from fatty substances and acid. The best qualities are known as *Rabbit Skin Glue* and *Hide Glue* (also called carpenter glue). The first comes in thin, semitranslucent, dark-brown flakes; the second is light brown, somewhat more translucent, and comes in irregular sheets up to ¼'' thick and about 3'' x 6''. Glue is also sold in granules and powder; the usefulness of such glue for sizing canvas can only be ascertained by its capacity to form a jelly.

Testing Quality. A sheet of glue should be hard and brittle. When shattered with a hammer, it should splinter almost like glass. Should one be able to break a splinter with one's fingers, the quality of the material is questionable. Dark brown, muddy-looking sheets may also indicate that they have been burnt or otherwise improperly manufactured.

The standard size for priming painting surfaces is prepared from 1 oz. glue and 1 pt. water soaked overnight, then warmed in a double boiler. In this concentration, the size should, upon cooling to normal room temperature, gel to a consistency that requires a spatula to reduce the jelly to mush—without the glue reverting to liquid or semiliquid state. If these conditions do not occur, the glue must be considered inferior and not suitable for use by the painter. Inferior grades of glue fail to gel even in stronger concentrations and at much lower temperatures (that is, below 60°F.)

The best grades of glue are not hygroscopic (that is, they do not absorb moisture from the atmosphere to any marked degree), but inferior material, when exposed during storage to humidity beyond 70%, will soften, the granules will coagulate, and in most instances mold will develop.

Preparing Size. Boiling glue or reheating it repeatedly will deprive it of its adhesive power. The flakes, granules, or broken pieces of the sheet of glue should be soaked in water overnight; they will soften and swell. In this condition, they will dissolve easily in hot water. Glue size decomposes quickly in warm temperatures (decay is indicated by the putrid odor) and loses its adhesive power. An addition of one teaspoonful of *Phenol* (carbolic acid) or *Dowicide A* or *B* to one pint of size will serve as an efficient germicide and preservative.

119

Gelatin. A refined, purified form of glue which can be used for sizing if no other material is available. However, its all-around properties are not as suitable as those of a good grade of hide glue. Gelatin comes in very thin, light yellowish, transparent sheets or flakes and, as such, it is used in cooking. It dissolves at once in hot water without prior softening, and it gels quickly. Gelatin is sold in various grades: some are designated as C.P. (chemically pure); some sell under the term "technical grade." The first is usually powdered, and the second, which is more useful for sizing, is generally granulated.

GLUE-GEL. Before it solidifies, a liquid glue solution turns to a gel. A 7% solution of glue, for example, will jellify at a room temperature of about 70°F. When used in such condition for sizing canvas, the gelled substance will form a membrane on top of the fabric, whereas liquid size will soak through even a densely woven fabric.

GLUE SIZE. See *Size.*

GLYCERIN, a heavy, hygroscopic oil-like liquid, that is colorless and odorless. It serves as a *Plasticizer* in the preparation of watercolors (see *Watercolor Painting*).

GOLD OCHRE, a natural earth color, is a transparent color sometimes strengthened by the addition of yellow pigment or dye. The color dries fairly well and possesses the highest permanence. It can be approximated by *Mars Yellow.*

GOLD SIZE. A quick drying, viscous, honey-like substance made of synthetic resin and heat-thickened linseed oil. It is used for attachment of gold and other metallic leaves to either a rigid or elastic surface. See *Gilding and Silvering.*

GOUACHE is a term used for opaque watercolors that use white color, not the white of the paper, for achieving white or light passages. Hence, standard transparent watercolor mixed with opaque white, as well as colors that are cut with white in their manufacturing process, are referred to as gouache. Casein (see

Casein Painting) is also a form of gouache. To manufacture gouache, colors are mixed with a white pigment such as *Whiting*. Their binder is, as a rule, gum arabic (see *Gums*). When put in jars or tubes, the product is often designated as *Poster Color* or designers' color.

Although painting tools and materials are essentially the same as for *Watercolor Painting*, gouache technique differs from that of watercolor mainly in the opaque character of the paint, which can be built up to a certain degree of impasto. This nullifies the color of the support to a great extent; hence, pastel colored, semirigid or rigid paper-covered boards are particularly suited for gouache technique. Unfortunately, toned papers are usually thin, a condition which can be overcome by pasting them onto boards. Because of the relatively inelastic nature of the paint, gouache painting on thin paper can be hazardous, because the impasto may crack and flake off if the paper is rolled.

In this technique, smooth-surfaced supports are generally preferable to rough ones; if the flat tones of the gouache rest on the peaks and the hollows of an uneven surface, the resulting effect is a mechanical texture. On a smooth surface, it is possible to build up one's own textures, while a rougher board dictates the texture from the start. Flat color is an essential characteristic of gouache. Gouache does not lend itself to blending in the manner of oil colors, and does not yield rich, dark tones.

Gouache paintings should not be varnished; for protection they should always be hung behind glass in the same manner as transparent watercolors.

GRAFFITO (also referred to as sgraffito) is a method of producing a design by incising a top surface of one color to uncover an undercoating of another color. The undercoating is usually dark, generally black or red, and the top coat is most often white plaster, which is laid over the dark tone in a thin skin. The incisions are made by a metal instrument with a blunted point called a *Stylus*. Very much favored during the Renaissance for exterior and interior decoration, graffito is still used in some European countries, particularly Italy, Austria, and the Bavarian part of Germany. A modification of the technique was used in Spain from about 1600 for the decoration of ecclesiastical statuary and carved

ornaments; generally a gilded undercoating was painted over with a color, and while the top layer was still wet, a pattern was incised into it. The oil color used for this purpose was thinned with gum arabic (1:2 in water) which rendered it suitable for this technique.

GRAPHIC refers to all techniques that rely chiefly on line rather than on tone or color, such as *Drawing, Etching, and Lithography.*

GRAPHITE is a crystalline form of carbon. In its natural form, the mineral is widely distributed throughout the world, but it has also been made artificially since 1891. It is used in pencils, crayons, and *Transfer Paper* (see *Drawing*).

GRAPHITE PAPER. A thin, translucent paper covered with a dense film of graphite dust. It serves for the transfer of drawings to another support (paper, canvas, etc.). Standard carbon paper is not suitable for this purpose; when the transfer is made on paper, its marks become indelible; when used on canvas, the marks will show through one or more layers of oil paint. See *Transfer Paper.*

GRAVURE refers to all printmaking processes that rely upon linear incisions or other textures imposed in metal plates (see *Etching*). It is the reverse of *Relief Printing.*

GREEN EARTH is a pigment consisting chiefly of the minerals glauconite and celadonite. These minerals are essentially magnesium and aluminum potassium silicates. When ground in oil, it becomes too weak to serve any practical purpose; thus, although available as oil paint, green earth is rarely used. Because of its particular mineral content and slight tinting strength, however, it can serve the painter well as a *Stabilizer* for *Grinding Pigments in Oil.* It is also sometimes used for aqueous paints. The early tempera painters used green earth for underpainting flesh tones, where its soft, delicate quality was appropriate. Although it may still be used by some tempera painters—and in formulating other aqueous paints—the effects of green earth can be more easily achieved with mixtures of more modern pigments, such as compounds that include *Chromium Oxide Green, Opaque*, modified to a very large extent by white.

GRINDING PIGMENTS IN AQUEOUS BINDERS. In contrast to the dispersion of pigments in oil—which requires considerable mulling or rubbing out with the spatula—mixing pigments with aqueous binders offers no difficulties because of the great wetting power of water.

Soft and Semisoft Watercolor Paint. The binder for watercolor is traditionally gum arabic (see *Gums*). A distinction should be made between the soft watercolor put into tubes, the semisoft watercolor put into pans, and the hard, dry cake color. In the soft and semisoft paint, powdered gum arabic, U.S.P. grade, should be mixed with an equal amount (one ounce by weight matching one ounce liquid measure) of *Glycerin*. The mixture should be dispersed in a mortar with a pestle with a smooth, vigorous stirring to avoid lumping of the gum. Next, an equal amount of water should be added, and the mixture should be stirred well for a few minutes until all gum is dissolved. To this thick solution the dry pigment should be added and rubbed down with a spatula on a palette; the pigment disperses quickly in this solution. The consistency of the paint will determine whether it will be put into tubes or into pans; the paint body is determined, of course, by the quantity of water and glycerine.

To inhibit the growth of mold, 1% of a 10% solution of *Phenol* or *Dowicide A* should be added to the ground paint.

Hard Watercolor Paint. To prepare paints for use in dry cake form, the pigment should be rubbed down with the spatula in a vehicle composed of gum arabic solution (one part gum, two parts water) and an equal amount of *Damar Solution Heavy* or *Copal Varnish*. First, the liquids should be emulsified by working them vigorously with the spatula; then the pigment should be added and all ingredients mixed well. The paint thus prepared is then put into small molds and allowed to dry. These colors behave like those commercially made in hard cake form, but they have more body and increased plasticity and elasticity. The pigments used for watercolor are listed under *Watercolor Painting*.

Casein Paint. The formula for hand-ground casein (see *Casein Painting*) serves for decorative painting on large surfaces like murals and is not to be used as tube paint. The required quantity of pigment should first be rubbed well with the spatula in a small

123

amount of casein binder to a loose consistency, then thinned with casein binder as required. As a preservative, 1% of a 10% phenol solution should be added to the liquid paint, which can be kept in small, tightly closed jars.

Acrylic Paint. Pigments suitable for dispersion in *Acrylic Polymer Medium* should be combined with the liquid binder in the same manner described above for casein. The amount of binder used depends on the consistency required. The paint is then placed in jars. No preservatives are required.

Tempera Paint. Pigments should be well ground with a muller in plain water to a thick consistency. The water-and-pigment paste should be kept under water in jars; prior to painting, the paste is mixed with the tempera medium (see *Tempera Painting*).

GRINDING PIGMENTS IN OIL. The dry, powdered color referred to as pigment must be compounded with a liquid called a binder or vehicle in order to produce paint. The liquid can be either oleaginous (oil), aqueous (watery), or a combination of both. The oil used must be of the drying variety, like *Linseed Oil, Poppyseed Oil*, or *Walnut Oil*. An aqueous vehicle must possess adhesive properties when dissolved in water. Such an aqueous substance can be mucilaginous (natural *Glues* of various kinds) or a synthetic water-soluble resin (see *Acrylic Resin*). An emulsion of both oily and watery vehicles, in the presence of a catalyst or emulsifying agent, can also provide the binding property. Such an emulsion is used in *Tempera Painting. Natural Resins* in a solution of a *Volatile Solvent* will also bind a pigment.

The term "grinding" is a misnomer. Pigments are purchased already ground to fine particles. In compounding them with a binder, the painter simply breaks up the particle conglomerates to make the fine colored dust disperse efficiently in the vehicle. This dispersion is more complete when the wetting power of the vehicle (its capacity to absorb the pigment) is increased. Oils that have been thickened (see *Polymerization*) by oxidation possess greater wetting power and will produce *Long Paint*. Pigment absorption varies with the nature of each pigment and the degree to which the oil has been polymerized.

124 **Oil Absorption of Pigments.** Although this depends to some

extent on the quality of the individual pigment (that is, the method of its manufacture) and on the type of oil used, the oil absorption of pigments may be expected to be fairly consistent. The following table gives the oil requirements of the principal colors, in the sequence of their quantitative absorption from the least to the most oil, measured by weight.

9% to 25%: white lead, Naples yellow, vermilion, zinc white.

25% to 50%: cadmium-barium yellow and red, chrome oxide green opaque, c.p. cadmium yellow and red, cerulean blue, Indian red, zinc yellow, Venetian red, titanium oxide, Mars violet, ultramarine blue, strontium yellow.

50% to 80%: yellow ochre, Mars yellow, raw siena, cobalt blue, raw umber, viridian green, burnt siena, burnt umber.

80% to 100%: ivory black, Prussian blue, raw and burnt green earth.

150% to 210%: alizarin crimson, phthalocyanine green, phthalocyanine blue.

The degree of a pigment's oil absorption largely determines the character of its body. Consider, for example, white lead and alizarin crimson (the first requiring 9% oil, the second 150%). When mixed with *Copal Concentrate*, white lead applied in a ⅛" layer forms a skin in a few days and solidifies throughout in a few weeks. Applied in the same thickness, alizarin crimson will not form a skin for many weeks unless the concentrate is added and will take a few months to dry throughout. If mixed with linseed oil alone, the process of oxidation will be considerably prolonged.

Grinding Oil. The linseed oil designated as ''pure, bleached'' that is obtainable in art-material stories is neutral and un-polymerized; it is suitable for grinding pigments to a short (stiff rather than fluid) consistency. There is a marked difference, however, in the manner in which different pigments react with oil (see below).

Grinding Tools. Depending on the quantity of paint to be prepared—a small amount prepared for a few days' use or a larger amount for storing in tubes—either a stiff spatula or a glass muller will be used. In the first instance, a palette serves for mixing the

125

pigment with the oil; in the second, a glass plate. The grinding surface of the muller should be 2'' to 3'' wide, and the plate, which should be about ¼'' thick, must be well roughened by mulling it with carborundum, about mesh No. 40. The abrasive should be mixed with water before it is used on the plate, where it will produce a pebbled surface.

Behavior of Pigments in Grinding. When preparing pigments for a day or a few days' work, no *Suspension Agent* or *Stabilizer* will be required. If stored in tubes, however, certain pigments will separate from their binder after a period of weeks, months, or years. To prevent this, various additives have been employed, the best of which is *Aluminum Stearate*, now universally used in the commercial manufacture of paint. An addition of 2% of this material (by weight) is considered sufficient for the purpose. Any excess must be looked upon as adulteration of the paint.

To incorporate aluminum stearate into paint that is ground by hand, the stabilizer must be first slightly moistened with alcohol, then with water, to form a stiff paste. (The alcohol makes the material receptive to water.) The paste should then be thoroughly mulled with a quantity of paint sufficient to fill a standard size tube. In studio practice the painter can also use the pigment known as raw *Green Earth* as a stabilizer. This pigment should first be ground in oil and then added in a quantity of about 20% (by bulk).

Only the principal colors will be listed here as those which the painter may wish to prepare himself. From a practical point of view, certain colors need not be considered because they are difficult to prepare by manual means. Such, for example, is white lead (*Flake White*), a color which disperses in oil only with hard mulling and with the use of a considerably larger quantity of the binder than is usually required. Moreover, it is very difficult to keep the fine dust from getting in the air, and inhaling it is injurious to health. Therefore, for all practical purposes, this color should be bought ready-prepared. Its short quality can be easily changed by adding copal concentrate.

Other colors which are difficult to handle if hand-ground include: *Prussian Blue, Manganese Blue*, and *Viridian Green*. Colors that are not much used or that do not offer any advantage when prepared in the studio are: *Phthalocyanine Blue* and *Phthalocyanine Green, Alizarin Crimson, Zinc White*, and *Titanium White*.

Grinding Process. To grind the pigment on the plate, a few teaspoons of the pigment should be placed on the surface; after adding just enough linseed oil to bind the dry pigment, the paste should be spread thinly so as to permit close contact of the muller with the surface of the glass plate. After a thorough mulling, the initially stiff paste will take on a more flowing consistency, whereupon more pigment should be added and the paste ground thoroughly until a proper paint consistency is achieved. After 24 hours, some colors may become too thin and may then require a further addition of pigment.

How Pigments Behave. Pigments that have a tendency to separate from the oil vehicle are: cerulean blue, Mars yellow, Mars orange, Venetian red, Indian red, and vermilion.

Pigments that require prolonged grinding include: white lead, cerulean blue, Prussian blue, viridian green, yellow ochre, Venetian red, Indian red, Mars violet, vermilion, and Mars black.

Pigments that require less grinding are: ultramarine blue, chromium oxide green opaque, Mars yellow, Mars orange, zinc yellow, Naples yellow, cadmiums, alizarin crimson, ivory black.

Colors that tend to become long include: Naples yellow, zinc yellow, Mars colors, and white lead.

Colors that tend to become short include: earth colors, precipitated colors (such as alizarin crimson), cadmiums, ivory black, phthalocyanine blue and green, and viridian green.

All colors conditioned by copal concentrate become more elastic, gain in depth, fusability, and toughness of the paint film. Hence, surfaces that contain copal concentrate offer greater resistance to atmospheric attacks.

Filling Tubes with Paint. Tubes for oil painting (with wide openings) are filled with ground color by means of a painting knife. For small tubes, the following method is used by pharmacists: the paint is placed on a sheet of nonabsorbent paper, which is then rolled to a narrow cylinder that fits into the tube; the paint is deposited in the tube by squeezing the paper cylinder.

GRISAILLE means painting in shades of gray. Grays are used in underpainting, chiefly in the flesh areas and in draperies, prior to glazing (see *Glaze*) with final colors. The technique of grisaille

underpainting is still used in painting. See *Oil Painting*.

GROUT. A mortar used for filling in spaces between tiles or tesserae in *Mosaic* work.

GUMS. The generic term refers to water-soluble exudates of various plants; hence the commonly used names "gum turpentine," "gum damar," etc., are misleading since these are not water soluble. The chemical composition of gums differs from that of *Glues* and gelatins, which are of animal origin. The most important gum, used for preparing watercolors, is gum arabic.

Gum Arabic is an exudate of a species of acacia which grows chiefly in the Sudan and in Senegal, but also in India and Australia. It appears on the market in the form of small, opalescent, yellowish lumps which fracture much like glass.

To dissolve the gum in water, the lumps must first be reduced to powder (by crushing them in a linen bag with a hammer, if a mortar and pestle are not available). The powder is then stirred slowly into boiling water in the proportion of one part of the gum (by weight) to two parts of water (by liquid measure). The boiling should be discontinued as soon as the powder dissolves. Upon cooling, 1% of a 10% *Phenol* solution (or *Dowicide A*) should be added to the gum solution to prevent decomposition. In this condition, when kept in well-stopped bottles, the solution will remain usable for many years. In this proportion, it will serve for preparing watercolors. Gum arabic was also used to size paper (for oil painting) but it has now been replaced by *Fixative*.

Gum Tragacanth. This water-soluble gum is of more or less theoretical interest to the painter, since its chief use is as the binder employed in the commercial manufacture of *Pastels* and chalk crayons. Gum tragacanth, which is found on the market in small, yellowish chips, does not dissolve in water but swells to form a gel. It is used as a glue in *Enameling*.

GYPSUM (also referred to as terra alba) is a calcium sulphate. It occurs widely around the world in several varieties. It was once used as part of *Gesso* and is also a component of certain artificial iron oxides, such as *Venetian Red*.

HANSA YELLOW is an aniline (coal tar) product. This strong, light yellow dye, precipitated on a substratum of a colorless pigment (*Aluminum Hydrate*) and hence referred to as a *Lake*, has little *Hiding Power*. Its strong color makes it a valuable addition to the painter's palette, however, especially in underpainting, where in mixtures with *Flake White* it forms a much leaner and denser paint (see *Oil Painting*). Hansa yellow has superseded *Indian yellow*.

HARD RESIN (like *Copal*) is used to prepare varnishes and painting mediums. It is the product of the resinous exudations of trees buried underground 10,000 years ago. These exudations are found in the form of amorphous chunks which have conchoidal fractures.

HARRISON RED. An impermanent red *Lake* which has now become obsolete. It has been superseded by the *Linear Quinacridone Pigments.*

HATCHING is a method of shading using parallel lines. See *Drawing.*

HEMPSEED OIL is slow-drying oil inclined to wrinkle and to yellow; it should not be employed for any purpose connected with painting.

HIDE GLUE (also known as carpenter glue) is obtained from

clippings of animal hide. It is considered to be a high-quality *Glue*. The best quality, however, is made specifically from rabbit-skin clippings and is called rabbit-skin glue.

HIDING POWER is the capacity of paint to cover an underlying color. See also *Covering Power*.

HOG HAIR BRUSHES are used mainly for *Oil Painting*. See *Brushes*.

HOOKER'S GREEN. This color is a mixture of *Prussian Blue* and the yellow pigment, *Gamboge*. It is only used in watercolor.

HUE. The shade that is a variety of a certain color. It is synonymous with the identity of the pigment being referred to—red, green, blue, etc.

HYDROCHLORIC ACID. A highly corrosive concentrated acid (37%) to be handled with the greatest care. (It should not be confused with the impure and much weaker form known as muriatic acid.) It is part of a formula used for patining copper and such copper alloys as bronze and brass.

HYDROUS. Containing water or its elements in some kind of chemical union, such as in hydrates or in hydroxides.

HYGROSCOPIC is a term that describes the capacity of a material to readily absorb water. A *Canvas* made of linen or cotton is hygroscopic to the extent to which it absorbs atmospheric moisture. The degree of hygroscopicity affects the tautness or slackness of the canvas. Linen fiber is more hygroscopic than cotton thread. The hygroscopic property of animal *Glue* used for sizing the canvas must also be taken into account in painting. Under prolonged storage when the relative atmospheric humidity is above 65%, glue (in granulated or in powder form) will coagulate and lose much of its adhesive property.

ILLUSTRATION BOARD. A semistiff board made of cellulose material usually containing a proportion of cotton or linen fiber, hence suitable for art work where permanence appears to be desirable.

IMPASTO. A heavy application of paint.

IMPRIMATURA is a thin, transparent *Glaze* of color prepared with varnish. It is used as a preliminary coating and is applied to the white ground of the painting surface. See *Oil Painting Techniques.*

INDIA INK, also known as Chinese ink, originated, as the second name indicates, in China, and its history can be traced back to antiquity. The material is still sold in its original form, small, domino-like sticks that are rubbed to the desired density in water in black ink saucers made of stone (also of Chinese origin). Thus the liquid substance may serve for gray washes as well as black lines. In liquid form two types of India ink are available, waterproof and water-soluble. The ink which becomes insoluble upon drying is made with a solution of shellac treated with borax. Different brands of the ink employ proprietary formulas, but the pigment in inks classified as ''India'' is always carbon black. It is obtained in the form of soot produced by burning various materials of animal and mineral origin. See *Drawing.*

131

INDIAN RED is an unspecified designation for a purplish *Iron Oxide Red.*

INDIAN YELLOW, a color of ancient origin, which was at one time produced from the dried urine of cows fed on mango leaves in India, has been superseded by *Hansa Yellow.* However, Indian yellow is still available from some manufacturers as a tube color.

INDIGO. A violet-blue vegetable dye originally derived from certain plants cultivated in India. It has been superseded since the end of the 19th century by a more reliable grade made synthetically from coal tar. It is not a permanent oil color and it is rarely found as a watercolor.

INDO ORANGE (Halogenated Anthanthrone). This is an organic pigment considered to be more permanent than alizarin crimson. The reddish-orange hue of this color has only been developed recently and it can only be used as a glaze in a water vehicle, as in *Acrylic Painting.* Its tinting capacity is moderate.

INK DRAWING. See *Drawing.*

INKS. Three categories are used by the painter: water-insoluble inks, water-soluble inks, and printers' inks. Water-insoluble ink, known as *India Ink*, is prepared from carbon and a resinous medium that becomes water-insoluble upon drying. The exact formulas are proprietary material and are kept strictly secret by the manufacturers. Writing ink is water-soluble and is not regarded as absolutely permanent because of its tendency to fade upon lengthy exposure to strong light. It is made of tannic acid, ferric sulfate, blue or black dyes, and other ingredients. The Chinese inks that are sold in stick form are compounds of carbon pigment bound by a water-soluble substance (see *Drawing*). Printers' inks are oil-resin colors ground in heat-processed *Linseed Oil* of considerable viscosity. They are used in printing metal plates, wood blocks, and lithographic stones or plates (see *Etching; Lithography; Woodcut and Wood Engraving*).

132 **INORGANIC PIGMENTS.** These are natural *Earth Pigments*

and pigments artificially prepared from minerals and ores. They are the most permanent materials on the painter's palette. *Raw Umber* and *Burnt Umber, Raw Siena* and *Burnt Siena, Yellow Ochre*, etc., are the inorganic pigments.

INTENSITY refers to the degree to which a color's chroma remains unaffected by the addition of white or gray. Thus, a pure color is at its optimum intensity.

IRON CHLORIDE (ferric chloride) is an acid salt used as a mordant in *Etching*. Since its action is slow, the etched line does not have the usual tendency to spread. For this reason this acid is valuable in *Aquatint*. It is harmless to one's skin and not injurious when inhaled.

IRON OXIDE. See *Iron Oxide Colors*.

IRON OXIDE COLORS. This group comprises a large number of *Earth Pigments*, natural and artificial (the latter are known as *Mars Colors*), representing the most stable and inert pigments on the painter's palette. Many of them were used in prehistoric times. The iron oxides are found in many deposits throughout the world, in varying degrees of purity, and in colors ranging from bright yellow (or even pale green) to the darkest brown and purple-red. They consist chiefly of silica and clay, and depending on the nature of the color, the coloring matter represents various forms of *Hydrous* and *Anhydrous* iron oxide.

IRON OXIDE REDS appear under various names. They can be found all over the world and vary widely in hue, depending upon the degree to which the iron oxide is combined with water. The lightest are labeled light red, *Terra Rosa*, and *Terra di Pozzuoli*. The clay content of these colors is greater than that of the coloring matter. The darker shades are known as English red, Indian red, and *Caput Mortuum*. The last name is an obsolete designation for an anhydrous dark purple-red containing hematite earth. Today, the identical hue is represented in Mars violet (see *Mars Colors*).

ISINGLASS is a form of gelatin produced chiefly from the bladder 133

of the sturgeon. It was once used as an adhesive but is now obsolete.

IVORY BLACK is a pigment made by charring animal bones in closed retorts. It was known and used by the ancients. Due to its black color it has good *Covering Power*, although its body is not particularly dense. Its *Tinting Strength* is also adequate. However, in oil painting it is one of the poorest dryers of all the colors. If some of its original binder is removed by squeezing color out of the tube onto absorbent paper and then replacing the absorbed binder with *Copal Concentrate*, the working quality of the paint will become materially enhanced. In spite of all its shortcomings, ivory black cannot be replaced by any other black color that is made commercially, such as *Carbon Black, Lamp Black*, and the most excellent Mars black (see *Mars Colors*). The particular beauty of its black tint makes ivory black unique. Compared to Mars black, ivory black has weaker tinting strength and hiding power. Both colors are used, however, in *Oil Painting* and *Acrylic Painting*. For *Watercolor Painting*, lamp black, a pure amorphous carbon made from the smoke of a luminous flame, is the more appropriate pigment.

JAPAN DRYER and JAPAN SIZE. Japan dryer is a metallic-salt compound. Japan size is a resinous varnish used as a mordant (adhesive) in *Gilding.* It is also an obsolete form of *Siccative.* Japan dryer and Japan size are not identical substances, but the terms are sometimes used interchangeably.

KAOLIN (also called China clay, pipe clay, and white bole) is the essential raw material of the ceramic arts, a natural hydrated silicate of aluminum nearly free of iron oxides. When mixed with water, its satiny luster and plastic qualities are highly valued in making pottery. When used as a base under gold leaf it is called *Gilder's Clay.*

KEROSENE is a distillate of crude petroleum, commonly used for burning in lamps and stoves. It is used in the arts to loosen the soft paint that clings tenaciously to the surface of implements used in grinding pigments, prior to cleaning them with soap and water. It has the lowest evaporation rate of all the *Solvents.*

KEYS. These are triangular wedges, about ⅛'' thick and 2'' long. They fit into the slots provided at the ends of the stretcher bars and serve to wedge the stretcher frames apart, thus making a slack stretched canvas taut again.

KNIVES. A number of different knives are needed by the painter to accomplish various tasks efficiently. The scraper should be used for removing dried paint from the surface of a canvas or panel. The so-called *X-Acto* knife should be used for cutting thin mats, thin cardboard, and paper along straight and curved lines. For cutting windows in heavy cardboard mats a special mat cutting knife should be used. A variety of cutting and saw blades are available for this particular knife. Finally, if a knife is used for sharpening

pencils it should have a thin, short blade and an extra long handle. See *Painting Knives*.

KOLINSKY SABLES are the finest quality *Sable Brushes*, made from the tail of the kolinsky, an animal found in Russia (see *Brushes*).

LACQUER. In modern usage the term lacquer designates a paint that, unlike oil color, dries rapidly through the evaporation of its highly volatile solvent. Lacquers are prepared from synthetic resins, cellulose acetate, viscose, etc.

LACQUER THINNER. A highly volatile and flammable liquid used as a *Solvent* for *Lacquers* and for acrylic materials (see *Acrylic Painting*). The name lacquer thinner is applied to a variety of solvents having different properties and sources of origin. The common quality generally sold in hardware stores is known under the technical name of ethyl acetate.

LAKE. A term used for a pigment produced by the precipitation of a dyestuff on a substratum of a colorless base such as *Aluminum Hydrate*.

LAMP BLACK. A nearly pure carbon obtained from the condensed smoke of burning tar and pitch. It cannot be considered as a substitute for *Ivory Black* or Mars black (see *Mars Colors*) in *Oil Painting* but is useful in *Watercolor Painting* for delicate tonal gradations.

LAPIS LAZULI (natural *Ultramarine Blue*) is a rare mineral mined in northeastern Afghanistan. It is an ancient, obsolete color. A very close approximation of this color can be obtained by mixing *Phthalocyanine Blue* and *White*.

LEAD DRYER. A liquid containing salt of lead which is used in industrial paints as an additive to accelerate the drying of oil by promoting its oxygen intake. See *Dryers.*

LEAD WHITE in tubes is labeled *Flake White*. Paste white lead is a designation for paint sold in cans for commercial purposes. The pigment used in both these types is the same, but the canned variety, prepared with an acid refined oil, is denser and of shorter consistency because of the manner of its manufacture and because its oil content does not exceed 10%. Its tendency to yellow, especially when not exposed to light, makes it unsuitable for the final steps of painting, but it can serve well in *Priming* and *Underpainting*, where this tendency is immaterial. White-lead paste is also considerably cheaper than the tube paint.

LEAN PAINT. Oil paint which has a relatively low ratio of the oil vehicle. Such paint is suitable for the early layers of a painting, over which "fat" paint (high in oil content) will be applied.

LEMON YELLOW. An unspecific designation for such colors as *Barium Yellow* or *Strontium Yellow*. The latter possesses a much better tinting strength than the former.

LETTERING PEN. A pen with a flat, wide nib. See *Drawing.*

LEVIGATION. When a mineral (such as ochre, for example) is reduced to a powder, the resulting substance is composed of pigment and mineral aggregates that are in coarse as well as fine particles. When ground in water, the fine particles float to the surface and the coarse ones settle as sediment at the bottom of the vessel containing the material. This process is known as levigation. Repeated washing and separation of the powdered substance, known as fractional sedimentation, are required to obtain the finely divided pigment in its pure form.

LIFT-GROUND ETCHING. See *Etching.*

LIGHTFASTNESS OF PAINTS. See *Testing Paints for Lightfastness.*

LINEAR refers to a pictorial treatment relying primarily on lines, not on tone.

LINEAR QUINACRIDONE PIGMENTS are sold under various trade names such as *Acra Reds*. These recently developed, extremely permanent, brilliant organic pigments are used in oil as well as in watercolors and acrylics.

LINEN CANVAS is the preferred material for oil painting. See *Canvas*.

LINOLEUM CUT. A print made from a design cut into a block of linoleum. The technique used in this case in cutting the design and printing the block is similar to that used in *Woodcut*.

LINOXYN. A dry oil film, formed by the oxidation of the *Linseed Oil* in oil paint.

LINSEED OIL. This is the most important of the drying oils. It is obtained from the seeds of flax, the plant from which linen fiber is made. Two qualities of the product are made: the so-called cold-pressed oil, which is extracted by means of presses; and the steam-extracted oil. The former is considered superior for use in oil painting, but it is not generally available on the American market. The oil which appears almost colorless in the bottle and is labeled "pure bleached" stays colorless only as long as it is in the bottle. When in use, it will not impart a lighter color than the oil that has not undergone the bleaching process.

Linseed oil serves as a *Binder* for pigment. Since its properties are more desirable than those of any other drying vegetable oil, linseed oil is employed in grinding pigments (see *Grinding Pigments in Oil*). It is also used as one of the ingredients in *Oil Painting Mediums*, which serve to dilute the paint during the process of painting.

Chemically, the oil is chiefly composed of linolenic, linoleic, oleic, and stearic acids, and three standard chemicals—alkali, sulfuric acid, and brine—are used to refine it. Alkali yields the best-quality oil, the one generally used by artists. All forms of linseed oil (except stand oil) are subject to yellowing (see

140

Yellowing of Oil Paint). The oil used for grinding purposes should not be deprived entirely of its *Free Fatty Acid*, which is neutralized in the alkali-refining method. In the process of aging, especially in the presence of air (when left in an open bottle, for example), the oil undergoes *Polymerization* and develops free acid, which increases its wetting capacity (its power to wet and hence to bind pigments).

Stand Oil. Another kind of linseed oil which is of interest to the painter is the heat-processed oil known as *Stand Oil.* When linseed oil is subjected for a period of hours to a temperature of up to about 600°F. in a vacuum or in the presence of carbon monoxide (that is, without oxygen), it becomes thickened (polymerized). The resulting product is considered to be the best of all oils used for painting because it is not inclined to yellow, and its resistance to moisture and changing atmospheric conditions is greater than that of any other form of linseed oil. It also dries to a tough, rather smooth, glossy film.

Stand oil sold on the market varies in the degree of its *Viscosity* (depending on the length of the linseed oil's exposure to heat), and its *Acid Number* may also vary considerably. It is not suitable for grinding pigments, because it produces "runny" paint which cannot be properly manipulated with the brush. Compared to *Long Paint* (often referred to as runny or stringy paint), *Short Paint* lacks elasticity and fusability. Neutral oil produces short paint; stabilizers and fillers used in the manufacture of paint also have the same effect.

Sun-Thickened Oil. Linseed oil which possesses similar qualities to those of stand oil is known as *Sun-Thickened Oil.* It is made from the raw oil by putting it in shallow vessels for several weeks and exposing it to the action of the sun. The sun bleaches and polymerizes the oil and also promotes its drying. The once-favored method of using lead vessels to thicken the oil and separate it from the water-soluble substances is no longer considered advantageous.

Blown Oil. The oil designated as open-kettle or blown oil is produced by heating the linseed oil in the presence of air. This type of oil possesses extreme viscosity and dries rapidly with con-

siderable gloss. However, because of its tendency to yellow and to wrinkle, it is not suitable for artistic purposes.

History. The theory that "oil painting was invented by the Van Eycks" was discarded some time ago. *Walnut Oil, Poppyseed Oil,* and linseed oil are all ingredients which were known in antiquity, and, according to written accounts, they were used for medicinal and cosmetic purposes. No definite record exists as to how they were used in oil painting. However, this does not preclude the possibility—indeed, the probability—that the value of drying oils as a binder for pigments must have been recognized early in history. It is a known fact that oil paints were used to produce transparencies during the early Byzantine period when colored glazes were applied to metals to enhance their appearance. Since the preparation of oil paints was described in the manuscript of Theophilus Presbyter (12th-century), it must be assumed that drying oils were used for grinding pigments before this date.

LITHARGE. This pigment is known as massicot and as a yellow lead oxide. It has been produced since ancient times. It appears in some Dutch paintings as late as the 17th-century. The color is not unlike that of *Naples Yellow*, but it is somewhat more reddish and of lesser opacity and *Tinting Strength*. See also *Massicot.*

LITHOGRAPHIC CRAYON. A specially prepared grease crayon used for drawing on lithographic stones, zinc plates, or paper used for transfer of drawings to the lithographic support. See *Lithography.*

LITHOGRAPHIC TUSCHE, also known as lithographic ink, is applied to the stone with a brush, and when thinned with water, it produces gray tones. See *Lithography.*

LITHOGRAPHY is a printing process that came into general use at the beginning of the 19th century, when it became a favorite medium for artistic as well as commercial purposes. A Bavarian by the name of Senefelder invented this process, which is based on a simple principle. The drawing is made with a greasy crayon on a slab of flat, porous limestone. The stone is chemically

142

processed so that the wax or grease adheres firmly. In printing, the stone is thoroughly wetted and the water adheres to those parts of the surface untouched by the crayon. A greasy ink is then rolled over the stone. The grease is repelled by the wet areas, but adheres to the waxy areas that were touched by the crayon. From the inked surface, a print can be pulled which duplicates the drawing exactly.

Lithographic Materials. Lithographic stones (the best quality is quarried in Solnhoffen, Bavaria) come in all sizes, 3'' to 4'' thick, and are so heavy that their transportation from the studio to the printer's shop is quite cumbersome. A 16'' x 20'' slab may weigh nearly 80 lbs. As it is quite unusual for an artist to own the stones and a printing press, drawing and printing are usually done in a professional shop. In modern commercial lithography, plates made of zinc or aluminum have replaced limestone. These plates, however, are not as desirable for artistic purposes because the mechanical character of their surfaces adversely influences the appearance of the prints.

Transfer paper, known as decalcomania paper, can be obtained commercially. This type of paper can also be prepared by covering a sheet of common drawing paper with a mixture of 2 parts gum arabic (see *Gums*), 1 part *Glycerin*, and enough water to make it brushable. A drawing is made on the paper with lithographic crayon or a lithographic drawing ink called tusche, then transferred to the stone by placing the paper face down and sponging it thoroughly with water. When pulled through the press, the drawing made on the transfer paper will attach itself to the stone. The advantage of using this method is that the reversed picture on the stone will become reversed again when printed, thus conforming with the original drawing. (When the drawing is made directly on the stone, the printed image will appear in reversed position.) Moreover, the transferred drawing can be further developed directly on the stone and thus given characteristic marks that exploit the distinctive character of the stone surface.

Lithographic crayons, made of water repellent materials, come in thin or thick rectangular sticks, and in pencil form. The degree of hardness of the crayons ranges from No. 0, which is very soft, to No. 5, the hardest. For general use, No. 3, which is neither too soft nor too hard, is the best. The same material that goes into

making the crayons can be obtained in a liquid form which is called "tusche" (the German expression for India ink). Tusche can be used in much the same way as India ink; with round *Sable Brushes* or flat *Bristle Brushes*, it will create all kinds of effects. Thick, rectangular sticks of rubbing ink are water soluble; they may be used like crayons or blended with water to produce liquid washes.

Technique. When an existing drawing is traced on stone, instead of using a transfer paper, *Graphite Paper* is used. An original drawing made with crayon on the stone does not differ from that done on paper, but tonal gradations are produced by the density or sparsity of the lines or the dots that mark the top grain of the stone, and will produce darker or lighter nuances. Tusche and rubbing ink may be painted on like drawing ink or watercolor, producing washes that range from solid black to delicate grays.

The texture of a lithographic print gives it its basic character; sometimes it is created by the paper serving for the transfer but more often by the grain of the stone (or plate). The nature of this this texture is the result of grinding the surface of the stone, which must be done afresh for every drawing. Depending on the coarseness or fineness of the abrasive material used for this purpose, smoother or rougher textures can be produced, and either texture can be used in crayon and tusche drawing.

When one works with crayon, its marks will rarely penetrate completely into the interstices of the stone surface unless the surface is exceedingly smooth and will therefore generally produce shades of gray. Tusche, however, will cover even the roughest surface with a solid black which will look rather flat in printing. Liquid material can also be used for *Drybrush Effects*, and *Linear* definitions can be executed by means of a *Lettering Pen* or a *Reed Pen*. Hairline white lines can be produced by scraping the black lines or surfaces with a sharp instrument such as a razor blade or a knife. Color lithographs generally require a separate stone for each color.

Printing. The basic principle of the process lies in making the blank areas of the stone's surface—the ones which are to remain white—impervious to the printer's ink. The standard procedure employed in this process (sometimes varied in detail) is as follows.

After the drawing has been made on the stone, the entire

surface is dusted with chalk to make the crayon marks more acid resistant, and then treated with a sponge dipped in a solution of 1 part gum arabic dissolved in 2 parts water and enough nitric acid to make the stone bubble slightly a half minute after its application. (An instantaneous bubbling effect will indicate that the acid solution is too strong, in which case it should be thinned with water.) The action of the gum-acid solution makes the bare stone attract water and repel the greasy ink. Only those parts that have been marked by the greasy crayon or tusche will take ink. After the stone dries, it is washed with water and covered with a solution of gum arabic, without the addition of acid.

Next, the crayon drawing is washed off the stone with turpentine. At this point, the surface appears blank and only faint yellowish marks of the original drawing remain. Again, the stone is washed with water, inked while still wet, and re-etched for a short while. Following this, the stone is sponged with water, and inked. A large roller is used for this purpose with a printer's ink of considerable viscosity that has been especially formulated for this purpose.

Prior to printing, the paper must be well dampened, though not wet. The sheet is placed upon the inked stone, which is passed through the press under considerable pressure.

LITHOPONE (zinc sulfate and barium sulfide) is a white pigment which has great hiding power, especially when mixed with titanium oxide. It is used chiefly for industrial purposes and often for *Poster Colors.*

LOCAL COLOR is the color of an object at close range, not modified by the momentary effects of light, weather, or distance. See *Atmospheric Perspective.*

LONG PAINT designates paint that will tend to level off when heaped up. This leveling is in direct proportion to the degree of the viscosity of its binder. The more viscous the paint becomes, the less will be its capacity to retain the shape in which it is applied. Long paint fuses and blends more easily. In its extreme form, long paint acts like an enamel. See also *Grinding Pigments in Oil; Linseed Oil; Oil Painting Medium.*

MADDER LAKE (Rose Madder) is a natural dyestuff extracted from the roots of the madder plant. Its color is almost identical with that of *Alizarin Crimson*, which is considered superior because of its greater *Tinting Strength* and permanence.

MAGENTA is an obsolete, impermanent, deep purple-red organic color. This fugitive dyestuff has been on the market since the middle of the 19th century, and it was once used as a watercolor. Its color can be approximated by adding a little *White* to *Alizarin Crimson*.

MALACHITE GREEN is a basic copper carbonate that was widely used in antiquity. It is no longer on the artist's color list because its color can be very effectively matched by conditioning the more readily available *Viridian Green* with cadmium yellow (see *Cadmium Colors*), *Zinc Yellow, Strontium Yellow*, or *Hansa Yellow*.

MANGANESE BLUE has been in use for about fifty years. Since it is weak in *Tinting Strength* and *Hiding Power*, its value in painting is quite limited; its cool, light blue hue can be produced by a mixture of *Cobalt Blue, Viridian Green*, and white. The oil painter can, however, make good use of manganese blue by adding it to other light colors in order to speed up their drying.

MANGANESE DIOXIDE is an iron salt which exerts con-

siderable drying action on oil paints. Large amounts are present in *Burnt Umber* and smaller amounts in *Burnt Siena* and *Manganese Blue.*

MANGANESE DRYER is a liquid that contains salt of manganese, used as an additive to oil paints and oil painting mediums in order to accelerate the drying of oils by promoting oxygen intake.

MARS COLORS are artificial *Iron Oxides* of fairly recent origin. The basic differences between them and the natural *Earth Pigments* are the artificial products' considerably greater tinting strength, better drying capacity, and tendency to become long (see *Long Paint*). These properties do not, however, necessarily make them more desirable than the comparatively weaker earth colors. When mixed with white, most of the Mars colors yield a purplish hue, which is not too pleasant to the eye. Nevertheless, when used judiciously, Mars colors can be important to the painter's palette. From the lightest to the darkest, their range is as follows.

Mars Yellow. Closely approximating *Gold Ochre*, this is a finely divided color of moderate *Covering Power* but greater *Tinting Strength* than the ochre.

Mars Orange. As a *Pigment* its body is dust-like, and it is therefore difficult to compound with oil without a considerable addition of *Aluminum Stearate*. For this reason the separation of the pigment from its *Vehicle* is quick and radical. Its color differs considerably from that of cadmium orange (see *Cadmium Colors*) and from mixtures of yellow and red that produce orange tints; its tinting strength and hiding power are also weaker. For these reasons its usefulness is rather limited.

Mars Red. To all intents and purposes its color and other properties are identical with the color designated as *Venetian Red.*

Mars Brown. This color is available in pigment form but not always as a tube paint. It comes in various shades ranging from a light reddish-brown to a deep chocolate brown and differs radically in tonality from the natural ferric oxides and earth pigments, as the *Sienas, Ochres,* and *Umbers.* The body of these Mars browns

147

is coarse, but they possess enormous hiding power and tinting strength, and, as in all Mars colors, excellent drying capacity. However, they turn purplish when white is added.

Mars Violet. In color, it is almost identical with the once ever-present paint (in Europe at least) called *Caput Mortuum.* Mars violet is opaque and has beautiful tonality as well as all the other characteristics common to the dark Mars colors. It is therefore a most useful addition to the painter's palette.

Mars Black. This color does not possess the depth and relative transparency of the indispensable *Ivory Black,* but it is by far superior to it in point of drying capacity, *Tinting Strength, Hiding Power,* and coarseness of its body. These qualities make it ideal for *Impasto* painting, for which ivory black is totally unsuitable. (The oil absorption of ivory black is about 80%; that of Mars black about 25%.)

MASONITE is a type of *Panel* manufactured from wood fibers compressed under heat and extreme pressure. Because of its inert nature, it is more reliable as a support for paintings than any panel made of wood. The panels come in thicknesses of ⅛'' and ¼''; generally, the thinner Masonite is preferable but for small paintings (that is, up to about 12'' x 16'') the thicker variety is also practical. For painting purposes Masonite should be un-tempered. The tempered variety is prepared with an oily or waxy additive that may threaten the adhesion of paint.

The weight of large panels of Masonite may tend to cause warping if only one side is gessoed. It is advisable in such instances to prime (see *Priming*) both the smooth and the screened side. Larger panels of ¼'' thickness are too heavy to be handled with ease.

MASSICOT, an ancient color now obsolete, was a heavy yellow *Pigment* (monoxide of lead) similar to *Litharge.* It was never considered permanent. Its dull pale yellow color resembled, but lacked the resonance and clarity of, *Naples Yellow.*

MASTIC. A soft *Resin* yielded by a certain kind of Pistachia tree that grows in Greek Archipelago, Portugal, Morocco, and the

Canary Islands. Commercial production of the resin, however, is confined to the Greek island of Chios. The resin comes in small, pea-like pale-yellow drops. It is soluble in alcohol and turpentine but not in mineral spirits. Much favored in Europe as a picture varnish (dissolved 1:3 in turpentine), its all-around qualities are not as desirable as those of *Damar Picture Varnish,* which is now used almost exclusively in the United States.

MAT. Made, as a rule, from cardboards of various colors, mats serve in the framing of watercolors and all kinds of prints. Experience teaches that the width of a mat (which may range from 2" to 5"—anything narrower or wider would not look good), should be equal on top and at the sides but somewhat greater at the bottom, or the picture will have a tendency to "droop." The opening of the mat is called the "window" and its edges should be beveled. Special instruments for cutting the bevel are available in art-material stores.

MATT MEDIUM. See *Acrylic Polymer Emulsion.*

MATT PICTURE VARNISH. A soft resin varnish to which wax or a flattening agent is added to produce a non-glossy surface. See *Varnishes; Varnishing.*

MEASURING SMALL QUANTITIES OF MATERIALS. A teaspoonful of liquid contains about 140 drops (use an eye dropper for measuring). A fluid ounce contains 6 teaspoonfuls of liquid (8 fluid drams). The gross weight of an average studio tube of oil paint is about 3 oz. The weight of a tube of *Flake White, Naples Yellow,* or *Vermilion* is 5 oz. or more.

In practice, the amount of *Siccative* added should be .5 % of the amount of painting medium; this amounts to about 6 drops of siccative for 1 oz. of medium. A 3 oz. tube of paint will receive ½ teaspoonful of aluminum stearate; this quantity amounts to about 1 % because aluminum stearate is very light and bulky.

MEGLIP is a painting medium made by dissolving *Mastic* in *Linseed Oil,* forming an unctuous, gelatinous substance that offers excellent working qualities. The medium was much used during

the 19th century but adversely affected the permanence of the paintings and was therefore discredited; nevertheless, it was reintroduced in the 1930s.

The combination of linseed oil and mastic resin was not compounded, as is sometimes reported, by using a mastic varnish (i.e., a solution of the resin in turpentine) but rather by a thermal processing of the resin in linseed oil. The 19th-century recipes also called for an excessive addition of lead dryers, with the result that paintings in which such a *Vehicle* was used became excessively brittle and often cracked. As with all pictures painted with a medium containing a soft resin (i.e., *Damar* and *Mastic*), future cleaning becomes a problem because of solubility of the resin, regardless of its age. A properly formulated resinous painting medium should contain a hard resin as its component. See *Oil Painting Medium.*

METHANOL is methyl alcohol, or wood alcohol (shellac solvent). See *Alcohol.*

METHYL ALCOHOL is wood alcohol, or methanol (see *Alcohol*).

MEZZOTINT. See *Etching.*

MINERAL SPIRITS is a general term for a variety of petroleum derivatives of more or less low evaporation rate, used to thin varnish and oil paint. These appear under such various trade names as *Varnolene, Sunoco Spirits, Texaco Spirits,* and *V.M. and P. Naphtha.* The type of mineral spirits in common use approximate turpentine as far as volatility, boiling point, and *Flash Point* are concerned.

MINIUM (an ancient name for *Red Lead*) is a rapidly drying orange-red color that was known in antiquity but is now obsolete. It can be easily matched by adding a little *Cadmium Yellow* (see *Cadmium Colors* to *Venetian Red*).

MODELING PASTE. A heavy, inelastic compound prepared from *Acrylic Polymer Emulsion* and marble dust. It can be used

for applying heavy textures to a rigid support. When heaped up with considerable *Impasto*, it contracts because of the rapid evaporation of water and shows some superficial fissures. This, however, does not impair the compound's adhesion to the support, and more paste can be added to fill in the fissures. See *Acrylic Modeling Paste*.

MOLD (mildew) is a fungus growth which appears on water-soluble substances. Prolonged exposure to high temperatures and relative humidity above 65% promotes its growth. Mildew may appear on the back of painted-on canvas and paper and on murals. It can usually be removed easily (see *Restoration of Paintings*).

Some fungus can be eliminated from paint, canvas, or paper surfaces by exposing the growth to ultraviolet rays or to sunlight. A more radical way of treating a moldy surface is to clean it with a 5% solution of thymol (paradichlorobenzene) in anhydrous alcohol.

This is done by carefully dabbing the surface with a wad of surgical cotton moistened with the solution. In the case of a surface which would not allow moistening (such as watercolor paper), the picture should be placed in a tightly closed box with thymol crystals so that it is subjected to their vapors.

MONOCHROME. A painting or drawing done in one color or in different shades of one color. *Drawings*, of course, are usually monochromatic, and monochrome underpaintings were often used by the old masters. Finished paintings which were executed in different shades of one color are referred to as monochromes. *Grisaille*, an underpainting in tones of gray, is the monochrome foundation of many old-master portrait and figure studies.

MONOMER. A simple, unpolymerized compound that has low molecular weight.

MORDANT. Any adhesive used to attach metallic leaves to gessoed surfaces or oil grounds (see *Gilding*). Also, an acid used in *Etching* to bite lines into a metal surface.

MORPHOLINE. A volatile liquid, miscible with water, serving as a strong *Solvent* for *Waxes* and *Shellac*. It also acts on hardened

oil-paint films and is sometimes used in the *Restoration of Paintings*.

MORTAR. A mixture of lime, putty, and sand used in *Mural Painting*; also a mixture of *Cement* and sand.

MOSAIC. Mosaic can be used either for purely decorative or for practical purposes. It can be set into walls and floors for adornment and protection, and can also be worked into plaques, pictures, table tops, and other useful objects.

It is not customary to give the term "mosaic" to a variety of materials—shells, wood, fabric, even paper—that are secured to a support in a piecemeal fashion. These, however, really should be placed in the category of collages, and the term mosaic reserved for compositions made from small pieces of colored glass or stone (usually ¾" x ¾" square) called tesserae. These are set next to each other in a strong bonding material such as cement.

Tools and Materials. The execution of a mosaic requires an adequate workroom with an ample sink and running water. A sturdy table with a perfectly level top, made from a thick hardwood board or plywood, is necessary to provide support which must be solid and rigid enough to withstand shocks and any impact that could crack the material. The basic materials are tesserae or related material—crockery, tiles, etc.—that has been cut or split to the size of tesserae. The cement mixtures and other adhesives used for binding can now be obtained from specialized shops. A form of cement called *Grout* is used for filling in the spaces between the tesserae. Water-soluble glue is needed for the indirect technique. Big sheets of sturdy paper and a variety of colored chalks are used for making sketches and can be used in the indirect method (see below).

A pair of goggles protects the eyes from flying bits and chips of tesserae. Mosaic-cutting pliers split the material and cut it to size. Special adjustable tile cutters are recommended. Regular glass cutters can be used for more delicate work. Small tweezers pick up and set the tesserae into narrow spaces. A spreader distributes the adhesive evenly. A spatula is used to force the grout into the crevices between tesserae. A stiff brush or scrub pad (not metal, to avoid scratching) removes excess grouting from the surface. A

tool, such as a screwdriver, lifts unwanted pieces from still-tacky adhesive.

Ample color charts of tesserae in many shades are available and can be hung on the wall near the working table to provide a very practical guide for color combinations.

Technique. Mosaic can be applied to any rigid surface capable of accepting the adhesive, either the standard synthetic cement used for setting tiles that is available in hardware stores or a specialized mosaic adhesive sold in art-supply stores. When treating small surfaces (such as table tops and boxes), however, any slow-drying glue may be used. Horizontal surfaces permit the use of the direct method in which the tesserae are set directly into the bed of moist adhesive. When the mosaic is perfectly dry, the *Grout* (the commercial grade used for bathroom tiles, etc.) should be spread over the entire surface and then rubbed off, leaving the material only in the interstices between the tesserae. Of course, a finished colored drawing will normally be needed to serve as a guide in setting the tesserae.

On vertical surfaces the indirect or reverse method must be used. A sheet of translucent paper should be used for the original drawing so that the outline of the design will appear when the paper is reversed. The reverse side of the design can then be colored with acrylics as a guide for the finished work. A water-soluble adhesive (such as gum arabic) is then spread over the colored reverse side of the transparent paper, onto which the tesserae are glued. Because the tesserae are now glued to the reverse side of the paper, the design is a mirror image of the original scheme drawn on the other side of the sheet; when transferred to the wall, the mirror image will reverse itself and be the right-way around. After a portion of the design is completed, the translucent paper should be turned original face up, tile side down, and a sturdy paper should be attached to the back of the first sheet with the same water-soluble adhesive. Now that the tesserae are firmly glued to this double sheet of paper, the mosaic section is carefully lifted and the tile side pressed to an area of the wall that has previously been covered with tile cement. When the cement is dry, the two sheets of paper on top of the tesserae should be sponged with water to dissolve the water-soluble glue; the paper is peeled or scratched off with a nonscratching scouring pad to reveal

the design. Finally, as on horizontal surfaces, grouting should be applied to fill the interstices between the tesserae.

In a third technique, the *combined method*, the planned design is drawn and painted in full color and size on heavy paper, but this time the paper is not reversed. The tesserae are pasted face up on the drawing with a water-soluble adhesive. The advantage of this process is that the final appearance of the work is in front of the artist. He can arrange the tesserae face up and adjust them in proper order, according to the prearranged plan. After the layout is finished and the tesserae, securely affixed to the paper, are dry, another sheet of paper is glued over the surface with the same paste. This, too, has to dry thoroughly. The work is now in three layers: paper-tesserae-paper. A perfectly level board (a wooden drawing board is best) now has to be slipped underneath the paste-up and another one put on top. The board should then be carefully turned over. Next, the paper on the back of the mosaic, which is now on top, has to be wetted and peeled off gently.

From here on, the procedure is the same as in the indirect method. The project is divided into segments, and these are attached to final supporting foundation. Dividing the project is important because of the heavy weight of the material. If a vertical surface is being used, there is the danger that too large a portion could slide down. A limited space the same size as each paper segment should be covered with the fairly quick-drying permanent adhesive. Do not cover the entire working surface; work section by section.

History. The first mosaics date from about 4000 B.C. Primitive examples, symbolic in nature, have been found in the Middle East; these are made of pieces of baked clay pressed into mud walls. As technique became refined, artists started to adorn all kinds of useful and decorative objects with such mosaic material as bits of colored glass, stones, and ivory. Fine examples of this kind come from Crete and date from the Minoan period (2000 B.C.).

The style and technique of mosaic decoration was ideally suited for formal interiors—church walls and ceilings, sumptuous baths, and garden paths. Throughout the world, one can find objects decorated in a manner that falls into the category of mosaic. Mosaic decoration was widely employed by the Romans; it

flourished during the reign of King Constantine in Byzantium; and it developed to its full glory in Italy during the 6th to 10th centuries A.D. Particularly fine extant examples of work from that period are in Ravenna, Palermo, Venice, and Torcello. Effective modern adaptation of this ancient technique can be seen in Mexico City, where murals on buildings of the university campus have been executed in mosaic. The stylized manner of Mexican design lends itself successfully to this type of artistic work.

MUCILAGE. Animal or vegetable *Glue* or *Gum* possessing adhesive qualities.

MURAL PAINTING. Traditionally, painting directly on the wet plaster of a wall is designated by the Italian name *Fresco Buono*; if it is done on dry plaster, it is called *Fresco Secco*. Mural painting, as a general term, can also refer to any large painting on canvas or panel that is affixed to a wall; in this case the painting technique will not differ from that of oil painting or from that of any other particular medium used. Painting directly on wall, especially on wet plaster, endows the work with probity and character and with a surface quality that is far more compelling than anything that can be done on a support that is later attached to a wall.

Today fresco buono is done only on very rare occasions because of the difficulty in coordinating the work of the artist with that of the construction men. The social and economic conditions of the modern world are not conducive to the execution of murals in this ancient technique. Moreover, real plaster has become outmoded in many buildings and fresco painting is therefore not possible.

Under ideal conditions fresco buono is considered absolutely permanent. However, such conditions are not to be found today— the air in modern cities is polluted by destructive gases. In air-conditioned interiors, of course, hazards to the permanence of a fresco would be minimized. Fresco paintings can be cleaned with water. In some European villages, in fact, the exteriors of buildings are covered with century-old frescoes which remain in good condition despite their exposure to all kinds of weather.

Nature of Fresco Buono. In this technique, work is done on a wet, freshly applied lime-plaster wall with pigments that have been

ground in water. The entire chemical reaction is based on the behavior of lime. As it sets, the calcium hydrate combines slowly with carbon dioxide, which is always present in the air, to form calcium carbonate, and this creates a semitranslucent surface into which the pigments are bound. In this condition, the colors become an integral part of the wall instead of being superimposed on top of it.

Composition of the Wall. Brick or stone is the base, but cement- or cinder-block walls are most frequently found in modern buildings, in which case plastering is done directly on a metal lath. This method is advantageous because the air space between the lath and the wall prevents any seepage of water that might effect the plaster. Although a fresco can be washed with water, moisture penetrating the painting from within the wall will cause the colors to flake.

The first coat of plaster applied to the wall should be composed of 1 part lime to 2 parts coarse sand and finely pulverized bricks. This is called a scratch coat. The second coat can be made of 1 part lime and 3 parts finer sand. The sand should always be thoroughly washed to remove all soluble impurities. It should be added to the lime when still moist, so that the lime will adhere to it. The roughness of these initial coats is essential, for they give bond to the final surfacing, which is composed of 1 or 2 parts of fine sand and marble dust and 1 part of lime putty. In commercial plaster walls only lime putty is used. The marble dust not only reduces the porosity and roughness of the plaster but it makes it much whiter. It should be added in moderate quantity to the mixture.

To sum up, in preparing a wall for the classic fresco technique two or three basic preparations are needed. For the surfacing of murals to be exposed to outdoor conditions (for example, in the decoration of house facades), first a scratch coat, then a second lime-and-sand coat is required. For indoor frescoes, a third coat employing marble dust is mandatory; this surface allows the finesse of execution expected in artistic representations. Of course, this surfacing is not laid down, a priori, all over the wall; only on the portion to be completed during a day's working period is surfaced, so that the plaster remains wet while being worked on.

Lime is produced by burning calcium carbonate (limestone, chalk, marble, oyster shells) with wood in a kiln. When mixed

with water, lime turns to calcium hydroxide or hydrated (slaked) lime. Before using it to prepare plaster suitable for fresco painting, the lime putty (as it is called today) should be aged. This improves its plastic quality and allows complete slaking. Aged lime putty is sold by several large commercial companies with a guarantee that it is two years old. When hydrated lime mixed with water is used to form putty for fresco, it should be allowed to stand overnight. This material is quite caustic and bites into the skin, so before starting to work, the hands should be well protected. This precaution is superfluous when working with aged putty because it is mild and smooth. This, of course, makes it much safer to use.

Plastering Procedure. The tools used for plastering are a trowel, a wooden float, a large trowel-shaped painting knife, and a large brush or sponge. The initial coat should be troweled onto the surface, and the next day it should be well soaked with water before applying a second coat as smoothly as possible. A day later the final coat should be spread evenly on a thoroughly wet wall until it is from ⅛" to ¼" thick. This coat should cover only as large an area as one expects to finish during a day's painting. When the next area is to be covered, a trowel-shaped painting knife should be used to draw the new plaster smoothly up to the previous day's work.

The main difficulty in making a perfect joint that will not show in the finished work lies in preserving exactly the same level of plaster. A slight change in level will catch light or shade and be far more disturbing than a little surface roughness. The plaster should be rubbed with the wooden float, dripping a little water from a sponge onto the face of the float, until all irregularities are smoothed out. It should then be polished with the trowel. However, lingering too long over this and over-polishing will result in a dead surface which does not take the color well.

Transferring the Drawing. Full-size drawings should be made ahead of time on tracing paper. The outlines can be pricked with a little spiked wheel; then the drawing is placed over the wet plaster and the outlines pounced through with a small cheesecloth bag of dry pigment. Tap the bag against the perforated lines and the dry pigment will penetrate both the cheesecloth and the perforations to reach the wall and leave a dotted line. A tracing can also be made

157

by going over the outlines with a pointed instrument and pressing the point into the wet plaster. These indentations will show in the finished fresco, however, particularly if a strong side light is used to illuminate the work; they are not obliterated by the subsequent loose washes of color. This method must have been used extensively in the Renaissance, since many of the great murals of that period show this type of indented outline.

Colors Used in Fresco. The range of colors is limited as they are all used as dry pigments ground in water with a muller on a slab. The *Earth Colors* are the standbys: *Ochre* in all its shades; the *Mars Colors*—yellow, orange, red, brown, and violet; *Venetian Red, Iron Oxide Red,* raw and burnt umber; raw and burnt siena; *Green Earth; Viridian Green* and *Chromium Oxide Green Opaque; Ultramarine Blue, Cobalt Blue,* and *Cerulean Blue*; Mars black and *Ivory Black*. For white, lime putty and *Titanium White* are used. For highlights, one may work thinly and keep the white ground for the whites, or the lime putty mixed with titanium white can be used.

Tools. Tin cans, little enamel pots, and a white enamel palette (or a sheet of glass with white paper under it) should be used. Unlike in oil painting, where a white *Palette* is inappropriate, in mural painting the white surface upon which one paints calls for such a palette. If there are large masses of color running through much of the design, such as sky or earth, pots of color may be mixed, big enough to serve for the whole painting. The *Brushes* which should be used are large, long-haired flat and round *Bristle Brushes* and round and flat *Sabeline* brushes. Special fresco brushes, made from the hairs of a cow's tail, shed the lime best.

Fresco Painting Technique. The most favorable time for painting is when the wall is most absorbent and therefore easiest to paint on. This occurs three to six (or sometimes as much as eight) hours after the plaster is laid, depending on climatic conditions and the nature of the lime putty. Avoid scrubbing away the smooth surface, as it is very difficult to restore it. After the plaster has become somewhat dry and repellent, one can still lay on the lightest colors heavily, but they must contain a large amount of lime putty to hold. Lime water is also sometimes added to colors,

but this will give them a whitish cast because the particles of lime become distributed through the mass of the pigments. On the whole, because of the whiteness of the wall, the entire color scheme in fresco painting has a luminous appearance. All colors, unless gone over more than twice and mixed to a dense consistency, function as glazes on the white surface.

While the plaster is still wet, one can draw freely on it with a long, pointed brush, improvising and then wiping out mistakes with a small soft sponge. The large color areas should be laid in flatly and simply and lightened, if need be, by taking some of the color off with the sponge. As a rule, however, linear definitions should prevail in the fresco technique. These definitions are executed with long-haired brushes which act like *Scriptliners*. Long uninterrupted definitions can be made without having to dip this brush into the pool of paint. These characteristics of the paint and the instruments with which it is applied are very similar to those used in egg *Tempera Painting*, where transitions from dark to light and from color to color are achieved by single, detached lines and *Crosshatching,* rather than by blending paint in the manner used in oil painting.

Progression of Work in Fresco. Since only a certain portion of a large mural can be completed in one day's work, the section of the plaster prepared for this task must be left in a condition that will allow it to be easily joined with the next section. If the surface is divided in even rectangular sections it is very difficult to make the joins invisible. Therefore, it is best to cut the plaster along some existing contours, like those of a body, a landscape motif, or any other demarcation in the design. This is done with the trowel. After one has worked out how large an area can be covered in a day, the planning of these areas in relation to the whole pattern becomes a very important part of the work.

Corrections on a Finished Fresco. On drying, a fresco painting becomes lighter in tone, and through the years it gains in clarity of color. Large-scale corrections cannot be made effectively because overpaints have a heavy, opaque quality and thus differ in appearance from the original fresco. Minor retouchings can be carried out, however. Formerly these were made with tempera or casein colors, but the advent of acrylics has made these colors obsolete.

159

Fresco Secco. This term is used to refer to a painting executed on a dry plaster wall. This ancient process calls for thoroughly wetting the plaster wall with lime water and painting on it with tempera or casein colors. Usually the wall is saturated with water a day before painting and then wet again immediately before commencing the work. These materials can also be used to paint on a perfectly dry plaster wall without the use of lime water, but in this method the pigment particles do not become even partially imbedded into the wall, a condition that makes these colors less durable.

When painting on a dry wall, aside from the consideration of its soundness, the adhesive properties of the paints used are of prime importance. These qualities are found in *Acrylic Paints* to a higher degree than in the traditional materials. Hence, under present conditions, these should be the painter's logical choice for mural decorations.

Oil Painting on Walls. This is inadvisable for both esthetic and practical considerations. First, the gloss of an oil-paint surface will make many of its parts, particularly those facing a window, shiny and therefore invisible from certain angles. The type of varnishing that produces a matt surface on an oil painting is unsuitable for murals because such varnish films will become glossy when they are cleaned and wiped. Matt paint surfaces that are produced by diluting the binder with turpentine or another solvent produce an unstable paint film, which is subject to deterioration. Even a lean (low in oil content) paint film will in time lose its cohesion and powder off; cleaning such paint surfaces is impossible without the danger of causing serious damage.

However, should oil painting on a plaster wall be required for some reason, initial priming of the wall can be done with *White Lead* in paint (not in paste) form. The absorbency of the plaster should be tested by wetting a small area slightly. If the water is rapidly absorbed, the plaster must be sized prior to priming; otherwise the underpainting will be deprived of its binder.

The traditional materials used for sizing, such as glue, casein, and diluted shellac solution, have all been superseded by *Acrylic Gesso*, which can be applied directly to any wall made of plaster or sheetrock. The standard solution of this gesso is rather thick and will leave brushmarks that can become quite a problem when

overpainted. To avoid this the gesso should be thinned with water, and two coats of the solution should be applied. These can follow right after one another. A soft, large utility brush should be used for the application. Oil painting can be done on this priming as soon as it is dry to the touch. When priming the wall with oil paint, a waiting period of at least a few days is usually required.

History of Mural Painting. Of all painting techniques, this is the oldest. It existed some 20,000 years ago, and the cave paintings of that period in northern Spain and southern France are still in an excellent state of preservation. Murals done on a plaster wall, as we know it today, date from the time of the Minoan culture that flourished about 2000 B.C. Analyses made of well-preserved material found in the Minoan palace at Knossos on the island of Crete show that the composition of the plaster walls, as well as the technique of color application, was identical to that used through the following ages. Greek murals have not been preserved intact, but Roman frescos found in Pompeii and Herculaneum, which were covered in A.D. 79 by ashes and lava from the eruption of the volcano Vesuvius and thus preserved, show this art to have been at the height of technical and esthetic perfection at the time.

Some murals date from the Byzantine era, but by that time mosaic was the preferred medium for wall decorations. Romanesque work (12th and 13th century) is, on the whole, crude. Only with Giotto (ca. 1266-1337) did the art of fresco painting start to reassert itself, but by the time of the Renaissance in Italy practically every major artist was working in this technique. From the late 16th century onwards, mural decorations were executed predominantly on canvases. It was not until the 20th century in Mexico that extensive efforts were made to reintroduce the technique of painting on wet lime-plaster. From there, the interest in the ancient craft spread to the United States and had some currency during the two decades prior to World War II.

NAPHTHA is a general term for volatile distillates of petroleum and coal tar. See *V.M. and P. Naphtha.*

NAPHTHOL ITR CRIMSON and NAPHTHOL ITR RED are brilliant organic pigments of recent origin. Naphthol red is almost identical in color with the natural *Madder Lake*. Naphthol crimson approximates the aniline dye known as *Alizarin Crimson*, but it is considered to be more permanent. It is also more lightfast than naphthol red. Both colors have good *Tinting Strength*, but they are very slow *Dryers*. These pigments are chiefly used in alkaline mediums, such as acrylics, where a superior chemical resistance is required.

The general group of naphthol reds comprise a wide range of organic colors that are not sufficiently lightfast to be used as artists' colors. Hence, only those specified as Naphthol ITR are recommended. For all practical purposes, however, there seems to be no good reason for abandoning the now traditional alizarin crimson; but those who use madder lake may well consider replacing it with this superior modern product.

NAPLES YELLOW, when prepared from genuine pigment, is a lead antimoniate. More often, however, the tube color labeled "Naples yellow" is a mixture of white and ochre, with or without an addition of red. The *Hiding Power, Tinting Strength*, and drying properties of Naples yellow are good. Unlike other yellow

colors, it has the peculiar quality of seeming to recede into the picture's distant planes, that is, not to appear as a *Local Color*; hence, it is of great importance in landscape painting. Although it has been asserted that the pigment was used by the ancient Egyptians, and hence most likely by some of the old masters, no proof of this exists, and, consequently, the history of this pigment remains obscure.

NATURAL RESINS are exudates from coniferous trees. Among these are *Damar, Mastic*, and *Copal Resins*, used in painting and varnishing.

NEGATIVE SPACE in a composition refers to the space surrounding a solid object which, in this context, represents positive space.

NITRIC ACID is used as a mordant on copper and zinc plates in *Etching* and on limestone in *Lithography*. When concentrated this acid is highly corrosive. Its fumes are harmful if inhaled.

NYLON BRUSHES. Because of their wiry, inorganic, synthetic hair, they cannot be used as substitutes for the *Bristle Brushes* used for oil painting, nor are they a substitute for the softer, more flexible brushes required for watercolor painting. However, they are suitable for varnishing and for acrylic painting, where their durability by far exceeds that of *Sable* and even *Bristle Brushes*.

OCHRES. A group of natural earth colors consisting of silica, clay, and various hydrated forms of iron oxide. The pigments are found in deposits all over the world. The best quality ochres come from France. See *Brown Ochre; Gold Ochre; Red Ochre; Yellow Ochre.*

OIL ABSORPTION OF PIGMENTS. See *Grinding Pigments in Oil.*

OIL OF CLOVES, a chemically complex compound composed chiefly of eugenol, is obtained from the blossoms or branches of the clove tree. It can be used in very small quantities (1% to 5% of the combined weight of the paint and the painting medium) to retard drying of paint. (Only minute quantities should be used, because oil of cloves has a tendency to soften the underpainting.) It is not effective, however, when rapid-drying paints (*Burnt Umber, Burnt Siena, Prussian Blue*, and some of the *Mars Colors*) are used.

Oil of cloves must only be used when it is fresh; when it has become oxidized, it loses its efficiency. The synthetic product now on the market is not satisfactory.

OIL OF SPIKE OIL or OIL OF LAVENDER (different from the flower essence of the same name) is a product similar to *Turpentine*, but it dries more slowly, and, when exposed to air, it gums up considerably faster. It is now obsolete. Contrary to some

reports, it cannot be used as a *Solvent* for *Resins*. Because of its high content of brittle rosinous residue it possesses considerable stickiness. It is therefore useful as a medium for applying vitreous enamel material to metallic surfaces before the surface is subjected to firing (see *Enameling*).

OIL PAINTING. There are five general methods of painting in oils. These are (1) underpainting and overpainting on a panel, (2) alla prima painting on a panel, (3) underpainting and overpainting on canvas, (4) alla prima painting on canvas, and (5) improvised painting.

Underpainting. The word underpainting implies that one or more underlayers of paints precede the final painting. The purpose of these underlayers is to enhance the final appearance of the painting. Regardless of the nature of the support used, a specific group of colors should be chosen, and the choice should be governed by the nature of the body and color of the paints. Body refers to the consistency of the paint, which is due to the amount of the binder required to transform pigment into paint. The paint that has the best body for underpainting is the industrial *White Lead* paste. *Flake White* is usually not as dense and does not dry as well. Although flake white yellows less than white-lead paste, superior whiteness is not important in an underpainting. Since white lead can be mixed with practically every color that might be used for underpainting, a solid substratum of paint will be formed, provided that it remains undiluted by the painting medium.

When a high-keyed color is desired, the strongest color should be chosen for the mixture so that it does not become unduly reduced in tint by the addition of white. The following colors will yield the strongest tints when mixed with white: *Hansa Yellow, Venetian Red, Prussian Blue*, and, for green, a mixture of Hansa yellow and *Chromium Oxide Green Opaque*. The substratum of paint thus produced has a dual purpose: first, to ·create a homogenous surface upon which the final painting rests; second, to serve as a base in which textural effects can be made or on which they can be built up with several underpaintings, depending on the effect required.

Five different types of underpainting can be used: (1) toned ground, (2) grisaille, (3) underpainting in light colors, (4) un- 165

derpainting in dark colors, and (5) underpainting in contrasting colors.

Toned Ground. This is the simplest form of underpainting. Although it is simply a colored canvas, it facilitates the progress of painting, particularly in connection with the grisaille (see below) used in portraiture. A properly prepared toned ground should not be too light; its effect upon the final painting should differ significantly from that created by a white ground. A toned ground in a middle tone that resembles the value of the tone found in the raw linen is ideally suited for portrait painting. A dark ground would approximate the tone of Venetian red, burnt umber, or burnt siena, for example.

For middle tones in a toned ground, the simplest mixture is burnt or raw umber and white; this mixture was used by Gainsborough. If Prussian blue is added, the resulting color will be a cool, silvery gray, similar to that often used by the 18th-century school of Tiepolo. These tonalities represent a range of warm and cool grays, rather neutral, that is, low key in color. If one of the dark colors is chosen for the ground, it should also receive an admixture of white, but in lesser quantity to retain the dark tone. Darker grounds were used in Baroque paintings (in Italy in the 16th and 17th centuries and elsewhere in the 18th century) and in Goya's work (18th to 19th century).

Grisaille Underpainting. The word is derived from *gris,* the French word for gray, and refers to an underpainting executed solely in gray. The method is also called underpainting in dead colors or in monochrome. Grisaille, or dead coloring, uses a variety of grays, from the lightest to the darkest, obtained by mixing black and white, or preferably blue (Prussian or ultramarine) with brown (burnt umber) and flake white. These mixtures can be cool or warm, depending on the predominance of one or the other color, but they will always be grayish in tone.

Such grays are especially suited for underpainting a work that will use much flesh color. Starting with a light gray for the parts that will appear in light and progressing to a somewhat darker gray that is still a little lighter than the finished shaded areas will be, an excellent underpainting can be provided for flesh. This method gives the artist an opportunity to use transparent overpaintings in

the shadow parts. Moreover, the same dead coloring can be used for the underpainting of draperies, prior to glazing with *Alizarin Crimson*, for example. The method was used by the old masters in painting purple and crimson ecclesiastical garb. Grisaille can also be well utilized in painting rocks, backgrounds, etc.

Underpainting in Light Colors. This technique is used to achieve the greatest degree of luminosity. The underpainting is executed with the intention that a certain amount of glazing, or thin overpainting, will be carried out over it. Only thin overpainting will be influenced by a light underpainting. A high-keyed color will also have a radical effect when used in the underpainting. Thus, powerful polychromatic effects can be achieved by using colors in nearly full strength in the underpainting but, as usual, these colors should be mixed with some white lead to provide a solid substratum of paint.

Underpainting in Dark Colors serves as an underpainting for scumbles, which are essentially semi-opaque applications that are lighter than the underlying color.

Underpainting in Contrasting Colors offers perhaps the most interesting means of exploiting the value of color by contrasting complementary or strongly diverging colors. Examples might include a green underpainting with a red overpainting or vice versa; a blue underpainting with a yellow overpainting or vice versa; etc. There are numerous contrasting combinations. When the underlying color is not completely covered, but becomes visible in spots, the impact of the superimposed color will be greatly enhanced. Furthermore, the painter's own coloristic sensibility becomes sharpened as he tries to cope with strongly opposing color values.

Technology of Underpainting and Overpainting. Once the drawing is transferred to the canvas or the panel by means of *Transfer Paper*, the underpainting can proceed. The principle to remember is that no matter how many underpaintings are used, they should always be applied to a perfectly dry surface. However, once the final painting begins, the surface should be moistened first with painting medium. When this is done *Crawling* of paint sometimes occurs. To remedy this condition, turpentine should be

167

brushed onto the paint surface and allowed to evaporate.

In underpainting, it is important to soften or blend the contours of all objects. This allows more freedom in the execution of the finished painting because the artist is not obliged to follow the original concept meticulously. Moreover, once the contours become rigidly defined in the underpainting, it is extremely difficult to blend them later. On the other hand, if soft, indistinct outlines are used in the underpainting, they can either be firmly articulated later or they can be blended imperceptibly into the surrounding areas.

If resinous medium is used in the process of finishing a painting, the overpainting can proceed at any time—even on a semiwet or semidry surface—but the medium should always be brushed onto the surface in order to promote fluency of the brushstrokes and to integrate the superimposed paint layers. The following procedure will promote the incorporation of an overpainting applied on top of a well-dried surface. First the surface should be sandpapered lightly; then turpentine should be brushed on it. As the turpentine evaporates, rub some of the resinous painting medium into the surface prior to commencing the overpainting. Note also that an overpainting, unless applied to a perfectly dry, nonporous surface, will become dull upon drying and will need *Varnishing*. Lastly, depending on one's preference, the evidence or absence of brushstrokes in the underpainting should be considered, for these may interfere with the overpaints.

Underpainting on a Panel. When underpainting a *Gesso* panel or one that has received white-lead oil priming, the chief consideration should be to avoid leaving brushmarks. Therefore, the paint used for the underpainting should be more liquid. White-lead paste should first be mixed with enough painting medium to make it brushable, then it should be thinned further with *Copal Varnish* until the marks of flat sable brushes do not register. White paint prepared in this way is ready to be mixed with any color chosen for the underpainting. Once dry, the overpainting can proceed in the usual manner. However, the use of a *Painting Knife* on the rigid surface thus produced is quite limited, because this type of surface is not flexible enough to respond to the striking of a knife.

168 **Alla Prima Painting on a Panel.** The principles of this method,

which originated during the 15th century, are as follows. The gesso priming of the panel was given a thin, transparent veil of color called an imprimatura (oil paint reduced to the consistency of watercolor by a thinner usually copal varnish). Such a hard-resin varnish solidifies sufficiently in a day or two to resist being dissolved by the subsequently applied painting medium, which contains turpentine. No matter how old, the imprimatura prepared with a soft-resin varnish (such as damar) would be wiped away by the brush that applied the next paint layer. A medium containing linseed oil cannot very well be used for an imprimatura because it would create a slick, oil-saturated surface to which subsequent painting would not adequately adhere.

Any desirable color but white can be used for the imprimatura if sufficiently diluted by the varnish. However, some colors are especially adapted to this purpose. These colors are burnt and raw siena, burnt and raw umber, viridian green, and their combinations. Because the colors used for final painting are applied thinly—that is, diluted by the medium—it is quite important to increase their viscosity and add firmness to their substance. This is done best by mixing a little copal concentrate with every color used.

The characteristic features of a finished alla prima painting are its predominant transparency and the prevalence of its imprimatura. (In alla prima painting, the color of the imprimatura should not be completely obscured by the subsequent overpainting but should remain evident underneath the glazes and in areas that have not been completely covered up by the overpainting.) The prevalence of the imprimatura will give a consistent tonality to the painting and unify the entire color scheme. Before overpainting, some of the painting medium should be brushed onto the surface of the imprimatura.

As the term *alla prima* ("at first") indicates, the method is a one-phase operation. This means that the painting must be finished in one working period while the paint is still wet. Any subsequent overpainting would deprive the picture of its intrinsic character, although minor retouchings can be made after drying. Paint handled in this manner dries with the same gloss that it has at the moment of application, and the painting does not require varnishing.

Painting on Canvas presupposes the existence of sufficient tooth to hold one or more underpaintings. If executed primarily with brushes, the underpainting should be additionally pressed into the interstices of the canvas with a painting knife, unless a succession of heavy impasti is planned. When overpainting—that is, when aiming at the final effects—the color and texture of the underpainting should be taken into account, for its purpose is to enhance the color, as well as the texture, of the final picture. It is not always possible to visualize the painting in advance, however, and deviations from the original plan will occur. Examinations of the work of some of the old masters reveal that such deviations occurred frequently. Upon drying, the final painting will as a rule appear dull, due to the absorption of oil by the porous (i.e., not sufficiently dry) layers of paint. Hence it will require early *Varnishing.*

Painting Alla Prima on Canvas. This can be done in a number of different ways. If the texture of the canvas is very smooth—that is, practically toothless—the same technique can be employed as that used for painting on a gesso panel. Alla prima painting can also be executed on a toned ground instead of an imprimatura. In this instance, however, the character of the painting will be radically different, because the toned ground will not endow the paint with the same type of luminosity that is provided by an imprimatura. The most useful colors for such toned grounds are a pale yellow (ochre plus white) for landscape painting or floral motifs and a brownish color (burnt umber, burnt siena, and white) for portraiture. This type of ground is found in most portraits by Frans Hals, many of which are largely executed alla prima. Alla prima painting can also be executed directly on the white canvas priming; this technique was used by the Impressionists.

Improvised Painting. Painting without a definite plan, involving changes in the colors and designs as the work progresses, can be done without jeopardizing the permanence of the paint. The use of a hard-resin medium preferably copal, allows such a technique, which, of necessity, will rely mainly on scumbling and impasti. The advantage of this method of painting is that ''accidents'' may take precedence. When following momentary impulses, the painter's freedom may enable him to achieve effects that a con-

trolled procedure would not allow. The dominant character of paintings produced in such a spontaneous manner is their sketchiness and, therefore, suggestiveness. Improvisation, common in modern painting, can be seen in some Baroque painting and in the late work of Goya.

Glazing. This term refers to the use of an overpainting of highly transparent color, greatly diluted by painting medium and specifically to a darker color applied on top of lighter surface. To produce the effect of a glaze, the underlying surface (whether it is one of the types of underpainting or a white priming) must be dry. When the paint has sufficient *Viscosity*, glazing can even be carried out to a very limited extent wet-on-wet.

The chromatic effect of a glazed surface depends to a great extent on the key of the underlying color. The stronger and lighter the color of the underpainting, the more luminous the effect of the glaze. Yellow provides the highest key and gray the lowest. Strong underlying colors can influence the superimposed glazes to such an extent that the various colors lose their coloristic identity; together the layers of color create an entirely new coloristic sensation which cannot be achieved by any other means.

Glazes are the first paint layers to be affected when a painting is cleaned with strong solvents (see *Restoration of Paintings*). Thus, the sooner a glaze is applied to a dry surface, the stronger will be its incorporation into the body of paint.

Scumbling is just the reverse of glazing. Here, a lighter color is applied to a darker underpainting in a semitransparent fashion. Scumbling can be undertaken in three different ways; on a dry surface; on a wet, glazed surface; or on a surface that carries a solid, wet film of color. Scumbling on a dry surface will have the least effect on color and texture. Scumbling into a wet glaze or a wet solid layer of paint can be done with brushes as well as with a painting knife. Even more than in glazing, high paint viscosity is imperative. Therefore, all paint should receive an addition of copal concentrate.

The darker the underlying surface and the lighter the scumble, the more powerful will be the effect. Contrasting colors will also contribute greatly toward the brilliance of a scumble. Light and brilliant colors such as Naples yellow, yellow ochre, cadmium

171

yellow and red, and Venetian red can be used straight. Darker and transparent colors must be mixed with white to be effective.

OIL PAINTING MEDIUM is used for thinning tube oil color to the required consistency. Modern tube paint is short because a *Stabilizer* (aluminum sterate) is used in the manufacture of the tube paint and because while kept in a tightly closed container (the tube) the paint will not polymerize (see *Polymerization*). Hence, today's paint does not possess the requisite viscosity for *Glazes* and *Scumbles*. Certain other painting techniques, however, such as those used by most of the Impressionists and some of the post-Impressionists, did not employ thinned tube paint. In these techniques, the paint is used straight from the tube.

Linseed oil, the best vehicle (i.e., binder) for pigments, is not an ideal thinner for oil paints. Considerable dilution of the paint by this vehicle will contribute to the yellowing of many colors (see *Yellowing of Oil Paints*). Another inappropriate paint diluent is *Turpentine*, a solvent which reduces the binding property of the vehicle and thus renders the paint film weak; it also destroys the inherent depth of the color. Mixtures of linseed oil and turpentine merely combine the deficiencies of both these mediums. Other diluents that are not considered desirable are *Poppyseed Oil* and *Walnut Oil.*

Combinations of oil and a *Resin* such as *Damar* or *Mastic* also render a paint film impermanent. Films that contain one of the soft resins cannot be cleaned because they are easily dissolved even by the mildest of solvents. It must be understood that after a certain period of time, the surfaces of all oil paintings must be subjected to the cleaning action of solvents which are often very strong.

A more acceptable medium than untreated linseed oil is *Stand Oil*. Its yellowing is minimal, and, depending on the degree of its polymerization, it renders the paint more or less viscous. Working with stand oil, however, imposes certain limitations upon the painter. On its slick *Linoxyn* surface overpainting becomes difficult because an insufficient bond is created between the strata. Also, paint applications of semiliquid or liquid consistency are not feasible because paint extensively diluted with stand oil will drip down and lower the paint level on an upright standing canvas. In the paintings of the early Flemish masters, where such heavy,

172

semiliquid paint applications are found, no evidence of lowered paint level can be observed. Hence, it must be assumed that a hard resin was combined with the medium.

When a hard-resin varnish is added in sufficient quantity to stand oil, the medium will show an increase in the viscosity and hence will impart to paint an improved capacity to fuse and to blend. The viscosity and cohesion of the medium will allow repeated overpaintings in quick succession and will also strengthen the quality of the *Linoxyn*. With the increase in viscosity, the paint changes from short to long (see *Long Paint*). Paint layers may be superimposed wet-in-wet without undue disturbance of the underlying paint strata, and the execution of glazes and scumbles is also greatly enhanced. Moreover, the resinous painting medium, even when used in excessive quantities in relation to the paint, will not cause yellowing. It will also increase the bond between the paint layers, allow the painting to dry faster, and will form a film that is smoother, less porous and more resistant to atmospheric attacks than that formed by paint compounded with linseed oil alone. See also *Copal Painting Medium.*

OIL PASTELS are prepared from material that dissolves in turpentine. Hence, colors applied to the support in the manner of crayons can be blended with a turpentine-moistened brush.

OIL TEMPERA is a term denoting that the *Emulsion* contains *Linseed Oil* (or *Stand Oil*) as one of its ingredients. In contrast to the pure *Egg Tempera*, oil tempera permits a certain amount of glazing; the capacity to *Glaze* increases with the increase of oil.

OPACITY designates the ability of a paint surface to obscure the color of any underlying surface. Opacity of the painting material, be it oil, tempera, watercolor, or acrylic, decreases with an increase in the amount of the particular *Vehicle* that serves to bind the pigment. Opacity is particularly important when transparent or semitransparent applications of color over an underpainting are planned. In the first paint layers of an *Oil Painting* opacity is mandatory, because a color lacking opacity would indicate that it contains excessive amounts of the vehicle, i.e., is too "fat" (see

173

Fat Over Lean). In other words, a transparent color is not "solid" enough to carry overpaints—except for further corrective glazes.

OPAQUE WATERCOLORS. See *Gouache.*

OPEN COLOR PAINTING is a term denoting that the color or colors do not terminate at the contours of objects painted, but go beyond them. In contradistinction, a closed color is precisely contained within the contours of the object to which it belongs.

ORANGE SHELLAC. See *Shellac.*

ORGANIC COLORS derive their origin from formerly living organisms (animal or plant). Examples are *Alizarin Crimson*, the phthalocyanine colors, and *Ivory Black*. They are called "organic" to differentiate them from colors of mineral origin, such as the *Iron Oxide Colors.*

ORPIMENT (King's yellow) is an obsolete color, once made from a poisonous sulphide of mercury found in various natural deposits, particularly in the Middle and Far East. It has been superseded by *Hansa Yellow.*

OVERPAINTING. The term refers to a film of paint that has been preceded by another paint layer. Overpainting is employed as a corrective measure as well as a final application of paint.

OXHAIR BRUSHES. See *Sabeline Brushes.*

PAINT QUALITY refers to the visual and tactile character of the brushwork and surface effects in a painting. This term is used to describe the technical virtuosity displayed in a painting by such means as a skillful handling of paint, for example.

PAINT REMOVER is sold under various trade names, and each brand is of a similar formulation. The fluid is used to remove old paint layers and oil-varnish films. The principal ingredients used in paint removers are *Acetone, Alcohol*, hydrocarbon solvents and paraffin. The paraffin, a form of wax, slows down evaporation by forming a thin film on the surface of the fluid.

PAINT THINNER is a volatile or oily liquid capable of reducing a normally dense oil-paint material to a more fluid consistency. The volatile thinners (generally used for industrial oil paints) that allow a normal manipulation of paint must have a *Flash Point* between about 110°F. and 140°F. (such as *Turpentine*, 115°F.; *V.M. and P. Naphtha*, 120° F.; *Mineral Spirits*, 140° F.). If the flash point is any lower the liquid will evaporate from the oil-paint compound too rapidly and thus impair its brushability. *Benzene* and *Toluene*, highly volatile solvents, are also used as paint thinners, but only in industrial paints.

PAINTERLY. This expression is used to describe paintings which avoid linear definitions and linear emphasis so that the total effect is a soft focus. Painterly art is in contrast to *Graphic* or *Linear* painting, in which all objects are clearly defined. Thus, 175

Botticelli is a linear painter, while Rembrandt's work would be considered painterly.

PAINTING, CLEANING. See *Restoration of Paintings.*

PAINTING KNIVES, incorrectly referred to as palette knives, are made from straight or trowel-shaped flexible steel blades of all sizes set in handles. The straight blade knife is widely employed because it can be used, in a sense, as an elongation of one's fingers; it allows the fingers' impulses to register directly on the working surface. A trowel-shaped knife cannot be used in the same way; here the operation moves, as it were, over a gear. Although at least half-a-dozen knives of various shapes, measuring between 3" and 6" in length, are useful in painting, there are three basic types: the underpainting knife, the painting knife, and the blender.

The underpainting knife should be somewhat less flexible than the painting knife, because in underpainting more pressure is needed to force undiluted paint into the interstices of the canvas. For small and medium size paintings, a 4" blade is the most practical for larger surfaces, the blade may measure up to about 8". The painting knife should have a blade that tapers off, because it is used for more intricate manipulations of the paint. Moreover, the blade should have the right degree of elasticity. If it is too weak, it will not distribute the paint sufficiently. A stiff blade, on the other hand, will require too much pressure, which makes the paint slide from under it instead of being deposited in the desired place. (However, a short—about 3"—blade that tapers off to a narrow point, even when relatively stiff, can be useful for rendering small details and working over an *Impasto* underpainting.)

The so-called blender is a straight-blade knife which is at least 5" long and quite flexible. Such a knife is indispensable for blending colors and for smoothing impasti and brushmarks. The trowel-shaped knife, often called a *Spatula*, is useful (providing that its blade is stiff enough) for grinding pigments and for scraping paint off the palette. The one with a longer, more elastic blade will serve for sizing the canvas with *Glue–Gel* and for *Priming.* The small spatulas are too elastic.

Knives should be completely free from dried paint because every imperfection on their surface will mar the paint film. The blades should always be wiped clean after use. The blades do not usually become rusty because a trace of oil remains on their surface.

After frequent use, the edge of the blade may become almost razor sharp. When a knife becomes so sharp that it may even cut into the canvas, the edge of the blade should be rubbed with fine *Carborundum Paper* until it becomes dull. The *Burr* that forms on both sides of the edge of the blade may also be removed with the carborundum paper. If the metal becomes indented at the edge, a

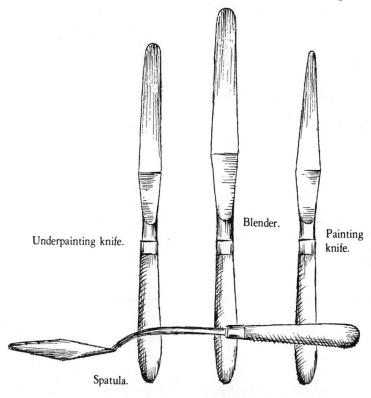

Underpainting knife.

Blender.

Painting knife.

Spatula.

fine, flat file should be used to even and smooth the side. The length of the file should be placed on the length of the blade edge, and the file should be moved until the edge becomes straight again. The burr formed on the edge of a blade may be quite strong, so a file is also frequently required for its removal.

177

The elasticity of a blade is due not to the nature of the metal, but to its thickness. Thick blades can be thinned on a slowly rotating grinding stone. The standard dynamo-propelled stones work too fast; usually they "burn" the blade and cannot be controlled enough to produce a uniform thickness. The uniform thickness of a blade should always start about ¾" from the handle. Blades that possess the same degree of elasticity from the handle to the tip are useless; it is impossible to control their operation.

A knife is unnecessary for priming rigid surfaces (panels) because a brush distributes the *Gesso* more efficiently and smoothly. However, a knife must be used for sizing a canvas with glue gel (see *Size*). In priming, a knife is indispensable because it forces the priming into the grain of the fabric. The brush, in contrast, only deposits the material in equal quantities on top of the grain and in the interstices. The surface appearance of the early paintings done on canvas definitely confirms the assumption that priming was done by means of a knife.

PAINTING MEDIUMS. Watercolors can, obviously, only be diluted with water; the same is true for casein and poster paints. In *Acrylic Painting*, acrylic painting medium can be used as well as water. For *Tempera Painting* an emulsion prepared from egg-oil and water is appropriate. The medium used in encaustic painting is a mixture of a soft-resin varnish (such as *Damar* varnish dissolved in *Turpentine*), *Wax*, and *Linseed Oil*. For mediums used in *Oil Painting*, see *Linseed Oil*, *Stand Oil*, and *Copal Painting Medium*.

PALETTE is the surface on which the colors are arranged and then mixed by the painter. Traditionally, oil colors are arranged on both sides of white: to the left, the warm colors, starting with the lightest (yellows, reds, browns) and ending with black; to the right, the cold colors—the greens and blues. The oil cup is generally placed at the right-hand corner if the palette is rectangular. Through the ages the shape of the palette has changed, but the palette for oil painting has always been made of wood. This is still the best material for this purpose. When it becomes impregnated with *Linseed Oil* derived from the paints and the painting medium, the wood surface attains a high polish. This allows the paints to be mixed easily and makes paint removal

Oil painting palettes.

effortless. The dark color of wood is also a great advantage because once the white of the canvas disappears under the initial painting the tonality of both canvas and palette become related. For unhindered work a palette for oil painting should not be smaller than 10'' x 14'', and should preferably be at least 15'' x 20''.

A palette for *Watercolor Painting* should be impervious to water; it should be made of enameled metal, of plastic, or of glass. A palette for *Acrylic Painting* should allow for the use of a paint remover to eliminate dried paint. An enameled surface is best for this purpose. The palette used for *Mural Painting* should be white.

PALETTE KNIFE. An older term for a *Painting Knife,* derived from the fact that a knife is used to scrape paint from the palette.

PANEL refers to almost any inelastic, movable support for painting; these can be divided into the following groups.

(1) Waste-paper or wood-pulp panels, known under the trade names of Beaver Board, Upson Board, etc., and generally referred to as wallboards. If they are already prepared for use in painting, these panels are known as Academy Boards or Mill Boards. Although in use since about the middle of the 19th century, they are unsatisfactory as supports, as are the cellular boards such as Celotex, Homasote, and Vehisote.

(2) Fiberboards, such as *Masonite*, should be the painter's choice for a rigid support because of their excellent qualities.

179

(3) *Wood Panels* do not compare favorably with Masonite, although the best quality plywood panels can be considered if such material appears desirable. However, the wood panels do not possess the hardness of the Masonite surface or its relative imperviousness to atmospheric moisture.

(4) Metals (aluminum, copper) are occasionally used as supports for painting. *Acrylic Gesso* should be used for their preparation because its adhesion to a smooth surface is far stronger than that of oil paints. Highly polished surfaces, however, must be first treated with a fine *Carborundum Paper* or with *Iron Chloride* or *Nitric Acid* to give the surface some tooth.

(5) Lastly, so-called canvas boards are on the market. These possess neither the advantages of a stretched canvas nor those of a panel. In fact, their use entails so many technical disadvantages (rigidity combined with coarseness of surface) that they should not be considered for any purpose.

The traditional method of preparing a panel involves a *Gesso* priming. If a wood panel is used, it should first be sized, then gessoed. Masonite does not require the initial sizing.

Only the untempered quality of Masonite should be used, and the smooth side should be gessoed. The reason for this is that the mechanical texture of the screen pattern on the rough side will adversely influence the paint texture—unless unusually heavy impasti conceal it.

Upon drying, the gesso can be sanded to perfect smoothness. But before using this ground for oil painting, the gesso must be isolated with *Size* to make it largely nonabsorbent. Ancient formulas call for many layers of gesso. However, when *Titanium White* is used in the mixture of the white pigments, two layers should provide an opaque, perfectly white ground. The priming should be done with a wide *Utility Brush.*

Priming with acrylic gesso is simpler and, according to current evidence, more desirable. This is because of the greater adhesion of the acrylic material and its water-insolubility upon drying. However, the gesso must be well thinned with water as it comes from the can, or it will leave brushmarks which cannot be sanded easily when dry. Depending on the thinness of the gesso, two to three primings will be needed. These may follow each other in

quick succession, for they dry rapidly. Sanding is never required when the gesso is applied thinly.

PAPER. Three general categories of paper are available. The first type is made entirely of linen or cotton rags, hence the name "rag paper." The cotton paper is produced exclusively in the United States, whereas the paper made from linen comes from Europe. In regard to quality, no distinction can be made between the two. Secondly, there are papers that contain wood pulp in addition to linen or cotton fibers. The proportion of wood pulp in the sheet varies from 10% to 90%, and the quality of the paper is lowered as the proportion of wood pulp increases. As a general rule, papers containing about 50% rag and 50% wood pulp are of acceptable quality. The third kind of paper is made entirely of wood pulp and is inferior in strength and color retention. In addition, there are "exotic" papers on the market, mostly referred to as "Chinese," but generally of Japanese manufacture. These contain fibrous substances such as those derived from the paper mulberry tree, bamboo, and rice.

Manufacturing Process. The fibrous cellulose is reduced to a pulp from which the paper is made. As a rule, various substances that constitute a *Size*, such as starch, *Glue*, or *Rosin*, and, lately, synthetic resins, are added to the pulp. The size is used to impart strength to the sheets and to reduce their absorbency. Starch and glue are apt to increase the tendency of the paper to become damaged by mold and microorganisms if it is stored under conditions of high humidity (above 65%). Rosin will cause serious deterioration in a short time by making the paper yellow and brittle. At present, it appears that sizing with synthetic resins produces the best results.

If the paper is not of the highest quality, it will become discolored when subjected to strong light, even after only a few years. Brown spots on pure rag paper less than a century old (a discoloration referred to as "foxing" and often visible on old book pages and prints) are considered to be due to mold. Red spots are thought to be due to oxidation of minute particles of iron left in the paper by the roller used in manufacture.

Better grades of paper (prepared either by hand or by machine) first receive a sizing bath to reduce their absorbency and then are

pressed by rollers to give them their characteristic surface appearance. This rolling process can be done while the paper is cold, in which case we speak of cold-pressed paper. As such, it carries the designation C.P. and retains some degree of absorbency. The paper can also be hot-pressed (H.P.), a process which makes it denser and less absorbent. The rag content is often indicated in watermarks that become clearly visible when the paper is held against the light. Handmade papers always carry watermarks, stating the name, seal, or initials of the manufacturer. The best known pure rag papers carry such names as Strathmore, Whatman, Montgolfier, D'Arches, and Fabriano.

The thickness of paper is expressed by its weight; for use in the fine arts, a quantity of 1000 sheets may range in weight from 30 lb. to 400 lb. or more.

Uses in Fine Arts. Tracing or *Transfer Paper* is a thin, translucent or semitransparent material used for the purposes indicated by the names and also for sketching. It comes in pads of various sizes and in rolls.

For studies made with charcoal, where permanence is of no account, pads made of newsprint (newspaper stock) can be used. This is the cheapest and most inferior of all papers.

A paper designated as ''bond'' with varied rag content, is thin, finely textured, and suitable for pencil, crayon, or charcoal *Drawing.* Such a thin paper is not suitable for *Watercolor Painting,* because the sheet will wrinkle. If the surface of the paper is slick and lacking in tooth, it will be unsuitable for work with vine charcoal, but it will take a soft carbon pencil or carbon charcoal.

An almost toothless paper coated with a mixture of size and chalk is suitable for *Silverpoint* drawing. In this case, the grain of the white pigment serves as an abrasive for the silver stylus. A thin charcoal paper, in use for more than a century, with a characteristic screen impressed on its surface, is still best for charcoal drawing. It comes in white and in a variety of light, pastel hues.

In drawing with pencil, the harder the pencil, the smoother the texture of the paper must be. Coarse surfaces are suitable only for very soft pencils or for crayons. If the drawing material can be easily erased, the texture of the paper surface is immaterial.

Pen-and-ink techniques will require fairly smooth paper, heavy enough not to wrinkle around the ink marks and ink washes.

Coarse paper surfaces are inappropriate for pen-and-ink work; their tooth impedes the movement of the pen point, and the marks, lost in the grain, do not register well. To delete pen marks, a hard *Eraser* is required, but, if it is applied to a soft, cold-pressed surface, unsightly injuries to the paper will result.

For work with soft points (felt points, reed pens, and soft hair brushes), a soft, loosely pressed material, such as Chinese paper, can be used in spite of its thinness and great absorbency.

In watercolor painting, the weight of the paper should be no less than 72 lbs. As a rule, the surface of the heavy paper has a strongly pronounced texture, quite different from that of any of the drawing papers. Its thickness and preparation prevent it from wrinkling and buckling when wet.

Paper used in printing from metal plates (see *Etching*) is generally heavy and possesses a marked texture. However, a thin paper can also be used for this purpose if it is made solely of rag. Very thin Japanese papers, made of various plant fibers, can be used in printing *Woodcuts and Wood Engravings.*

For printing lithographs, the paper should be fairly smooth and either lightweight or medium heavy (see *Lithography*).

For *Pastels*, paper must have a good tooth. Papers made especially for this purpose, which are usually colored and often have a sandy tooth, are generally available.

Paper can also be used in *Oil Painting*. It must be sized first to make it nonabsorbent. Glue or gelatin, once recommended for this purpose, has become obsolete. *Acrylic Polymer Emulsion* is a much more suitable material. Depending on the quality of the paper, the emulsion can be used full strength or diluted with water up to 1:2. Since the purpose of sizing is to make the paper largely nonabsorbent, some painting medium should be rubbed onto a sample of the sized paper. If the oil penetrates to the reverse side of the paper or disappears rapidly from its surface, the isolation is insufficient, and the size should be strengthened.

History. In Egypt, paper was produced from the papyrus plant more than 5,000 years ago. In China, it was first made in the 2nd century A.D. from fibers of various plants. In the Western world, paper has been used since the 8th century, when it was first introduced and made by the Arabs. Linen and cotton were the exclusive materials used in paper at that time. A few centuries later,

all the principal European nations had paper factories. Toward the end of the 18th century, wood pulp entered into the composition of paper, but extensive use of this material dates only from about the middle of the 19th century.

PARIS BLUE is another term for *Prussian Blue.*

PASTEL. The technique of working with colored chalks derives certain features from painting and other features from *Drawing.* Because pastel involves the use of color, it is akin to painting; but the manipulation of the chalk involved in its execution is that employed in drawing.

Paper. White *Paper* like that used for drawing (especially charcoal drawing), is suitable for pastels. The white ground contributes toward brilliance of color. However, a toned ground is preferred by most pastellists because it unifies the tonality of the picture. The toned paper can be what is generally referred to as pastel in hue—that is, a rather light shade. Deep tones can also be used successfully.

Pastel paper (or velour canvas) can be obtained in a great variety of textures and shades. A variety of paper boards are also prepared with a coating of marble dust or pumice; these possess a highly abrasive quality. Hence, the surfaces available range from relatively smooth to very toothy. Each will impart a particular character to the pastel stroke.

Materials. Pastels come in soft, semisoft, and half-hard sticks and in pencil form. The sticks are prepared with pigment, chalk (which extends and reduces the colored substance to "pastel hues"), and gum tragacanth, which is the binder (see *Glues*). These are obtainable in a bewildering array of several hundred colors. Many of these are of dubious permanence. For all practical purposes, however, a box of forty or fifty colors should suffice. The reason for the great number of colors is that chalks cannot be intermixed like liquid paint. To produce the desired effects, colors must be superimposed.

The other materials needed for pastel work are *Stomps*, used for blending colors; *Fixative*; a stiff *Bristle Brush*, (employed for

corrections and for brushing off accumulations of pastel dust); and a hard, soft, and kneaded *Eraser.*

Pastel Technique. This parallels that of *Alla Prima Painting.* A toned surface is highly desirable. There is no *Underpainting* as we know it in oil painting. Coloring generally proceeds from dark to light, in just the same way as in an oil painting.

Pastels can be used only for opaque or semi-opaque applications, although thin passages may have a certain transparency. Colors can be blended by means of *Hatching* or *Crosshatching* with a finger or with the stomp. If the accumulation of the pastel dust becomes too heavy, it can be eliminated from the paper with a stiff bristle brush.

Mixed Techniques. One advantage pastel offers is its adaptability to combinations with crayon, charcoal, gouache, casein, acrylic, and watercolor. Such mixed techniques are best executed on a white ground. Black linear definitions can serve for the outlines and strongest accents. Watercolor and other paints may be used for painting solid background colors or as an underpainting.

Preservation. No matter what its formulation, fixative cannot make the marks of pastels indelible. The best that can be achieved is partial solidification of the powdery surface. If a fixative is used excessively and sprayed from a short distance, considerable darkening of the colors will occur. Fixative (normally manufactured from acrylic or natural resins) should be used economically.

When kept in portfolios, the surfaces of the papers should be protected by sheets of acetate, and heavy pressure during storage should be avoided. The best protection for pastels is to keep them framed under glass. A heavy *Mat* should be used to prevent the paper from being pressed against the glass.

Hard Pastels. These are not as powdery as the soft variety, and they can be used on a smooth paper.

Pastel Pencils are excellent for fine delineations but cannot be used for a broad application of color; they are suitable for hatching and cross-hatching technique only. A water-soluble variety of pencils is also on the market. Drawings made with this material can be turned wholly or partially into watercolors.

Oil Chalks. (These are never used in combination with pastels.) They can be used with impasto on broad surfaces and also for linear effects. The marks can be dissolved by brushing them with turpentine.

PEACH BLACK. An ancient color, now obsolete, prepared by charring peach stones in closed retorts. *Ivory Black* is the nearest equivalent.

PEN AND INK DRAWING. See *Drawing.*

PENCIL. Known by the general name "lead pencil" (because lead was originally used in its manufacture), the standard drawing pencil now contains graphite compressed with a very finely divided clay. See *Drawing.*

PERMANENT GREEN is the name used to designate a mixture of *Prussian Blue* and a yellow such as cadmium yellow (see *Cadmium Colors*). The opacity and *Tinting Strength* of permanent green are considerable. When it is made from these components (the same tint can also be obtained by mixing other colors), its permanence is excellent.

PERMANENT WHITE. See *Barium White.*

PETROLEUM DERIVATIVES are hydrocarbons obtained from the distillation of crude petroleum. They are commonly known as *Naphtha, Mineral Spirits, Benzene,* and gasoline.

PETROLEUM SOLVENTS are volatile liquids derived from the distillation of petroleum or coal tar.

PHENOL (carbolic acid) is an effective germicide. It is composed of a white crystalline compound produced from coal tar and is available in a 10% solution in drug stores. When added in the amount of about 1% (2 drops to a teaspoonful) to a glutinous liquid (glue *Size, Gum Arabic*), it will prevent the liquid's decomposition.

PHTHALOCYANINE BLUE; PHTHALOCYANINE GREEN. These are organic dyes (first introduced in 1935) precipitated on an aluminum-hydrate base. Their tinting strength is great—both are among the artist's strongest colors. In oil painting, they have weak body, great transparency, and poor drying capacity. Phthalo blue, as it is generally called, is the only blue developed since the discovery of *Prussian Blue* (in 1704) and *Ultramarine Blue* (in 1824), but, because of its particular color value, it is not considered a substitute for them. Similarly, phthalo green does not replace *Viridian Green*. Where a strong color is desirable, phthalo colors would be the logical choice. The special quality of phthalo blue is its "natural" hue; in mixtures with white, it yields neither a purplish tint as does ultramarine, nor a greenish one as does Prussian blue. Because of their strength and transparency, the two phthalos are important in all water-based painting mediums.

PIGMENT. A dry coloring matter of mineral, vegetable, or animal origin in the form of a more or less fine powder possessing a specific color. The term should be distinguished from the word paint, which refers to coloring matter dispersed in a liquid binder. In powder form, pigment is not soluble in its *Vehicle*. To produce paint from pigment, pigment must first be combined with a *Binder* such as a drying oil. (See *Grinding Pigments in Aqueous Binders; Grinding Pigments in Oil*.)

The pigments used by the painter either are natural materials (these are referred to as *Earth Colors*) or are artificially produced chemical compounds.

A dye, in contrast to pigment, is a colored substance that dissolves in such liquids as water, alcohol, hydrocarbons, and oil, thereby losing its own body. When used as an oil color, a dye is precipitated on a substratum of *Aluminum Hydrate*, a white, extremely light, transparent powder. *Alizarin Crimson* and *Hansa Yellow* are both dyes.

PLASTER OF PARIS is calcium sulfate (*Gypsum*) roasted at high temperatures, which results in the loss of three-fourths of its water content. When mixed with water to a heavy consistency, it hardens quickly and cannot be dissolved again. If a weak *Glue Size*

is used instead of water, the drying process is delayed, and the plaster's toughness is increased. Drying can also be delayed and hardness increased if the dry powder is mixed with *Acrylic Polymer Emulsion*. Plaster of Paris was used as a pigment for gesso grounds in the 14th century but today *Whiting* has replaced this material. It is also used for stucco (in mixtures with marble dust) because it sets quickly in a dry atmosphere and does not shrink.

PLASTICIZER. This is a general term used for a substance that improves the brushability, elasticity, body, and adhesive properties of certain paints. *Wax, Aluminum Stearate*, and polymerized oil (see *Polymerization*) are plasticizers. For example, *Viridian Green*, a transparent glazing color that tends to be brittle when used with *Impasto*, can be used with some impasto when combined with a little wax. Aluminum stearate, when used in excess of 2% (to the weight of the pigment), would considerably increase the bulk of a color like viridian green and would constitute an adulteration. A polymerized oil or oil-resin compound will increase the adhesion and fusability of any paint.

In *Watercolor Painting* the plasticizer used is *Glycerin*, which also acts as a drying retarder.

The formulas for acrylic plasticizers are the property of their various manufacturers.

PLEIN-AIR painting refers to painting outdoors in order to capture the fleeting effects of outdoor light and atmosphere. The term is also used to designate the school of French Impressionists who originated this type of painting.

PLYWOOD PANELS, ⅛" thick, are suitable for painting if first primed with *Gesso* (see *Panels*).

POLYCHROME; POLYCHROMY. A polychrome painting is one executed in several different colors. Polychromy refers to the multicolored appearance of a painting.

POLYMER. A compound formed by the combination of molecules of the same substance to produce chemically identical

substance that has a higher molecular weight as, for example, in *Acrylic Polymer Emulsion.*

POLYMER MEDIUM is another name for the *Acrylic Polymer Emulsion*, the vehicle for *Acrylic Paints.*

POLYMERIZATION denotes that a number of small molecules have been chemically joined into a single large molecule of greatly enhanced strength and stability.

POLYVINYL ACETATE is a synthetic resin used for adhesive purposes and also in some protective sprays (see *Fixative*).

POPPYSEED OIL is obtained from the seeds of the opium poppy. The cold-pressed variety yields a pale, yellowish liquid. When hot-pressed (see *Linseed Oil*) it is reddish in color. It tends to become rancid and forms weaker, softer films than those produced by linseed oil. Although at one time it was highly praised because of its non-yellowing and slow-drying properties, these qualities cannot be verified in the present-day American product. When thickened (*Polymerized*) under the action of the sun, it shows improved characteristics. However, there are no valid reasons for today's painter to use it, either as a vehicle or as a diluent.

PORTLAND CEMENT. See *Cement, Portland.*

POSTER COLORS. With the advent of *Acrylic Paints*, these colors became obsolete as a painting material. Poster colors are essentially water-based colors. They are sold in jars and contain colored pigments cut with an inert white pigment and bound with a solution of gum arabic (see *Gums*).

PRECIPITATED CHALK. See *Whiting.*

PRIMING. The application of a finish, usually white, to a surface upon which painting is to be done. Depending on the nature of the support, the primer is applied either directly on the surface or over one or more coats of *Size.*

PRINTER'S INKS are used in printing *Etchings, Lithographs,* and *Woodcut and Wood Engraving.* They are most often oil colors of great density and high viscosity. Water-based inks can also be used in printing woodcuts. See *Inks.*

PRUSSIAN BLUE (which is often labeled Berlin blue or Paris blue by European manufacturers) is one of the most stable and universally useful synthetic colors. Technically the pigment is a ferric ferrocyanide, so finely divided that it resembles a *Dye.* It was introduced as an artist's color during the first part of the 18th century. It is the darkest of all the blues and possesses a greenish cast. Although *Prussian Blue* is quite transparent, its *Tinting Strength* exceeds that of every other color on the palette except for *Phthalocyanine Blue and Phthalocyanine Green.* Its drying capacity is also excellent. In fact, when mixed with other oil colors, it materially accelerates their drying time. When heaped up on the palette, a horny film will form on top of this paint. It should not be used in impasto techniques. Prussian Blue is also useful as a watercolor, but in *Acrylic Painting* it has been replaced by the modern phthalo blue.

QUILL PEN. The traditional quill was made of a goose or turkey feather. It was the sole writing and drawing tool prior to the advent of the metal pen in the 19th century. The quill's flexible point permits strokes of great delicacy as well as strength.

A quill should be cut in three stages using a knife with a razor-sharp thin blade. The first cut should be about 1'' long. Next the split in the middle is cut to a length of about ¼''. Then the nib should be pin pointed on both ends.

Cutting a quill.

RABBIT SKIN GLUE. The best quality of animal *Glue*, obtained from clippings of rabbit skins.

RAW SIENA is a pigment that closely resembles *Yellow Ochre*. Both colors consist of hydrated ferric (iron) oxide and alumina and silica. However, siena's tint is more brownish and its key is lower than that of yellow ochre. It is also more transparent and, because of its small *Manganese Dioxide* content, its drying capacity is better. Raw siena is in no way a substitute for yellow ochre. If it is not to be mixed with other colors, it should be used chiefly for glazing (see *Glaze*). The best quality of this mineral is found in deposits near the Tuscan city of Siena, but there are also deposits in Germany and America. See also *Burnt Siena.*

RAW UMBER is an *Earth Color* of great permanence; it belongs in the same family as the ochres and sienas. Its color is a fairly opaque dull, dark brown which has a rather cool tonality (in contrast to the warm tone of *Burnt Umber*). Because it possesses a large content of *Manganese Dioxide* (ranging from 8% to 16%), it possesses an enormous drying capacity (see *Drying of Paints*). The slightest admixture of this color will considerably accelerate the drying of other slow-drying colors. Deposits of the best qualities of umber are found on the island of Cyprus, but the mineral is also widely distributed in other parts of Europe and in America.

RED BOLE is another term for colored clay. Its composition is

similar to ochre, but because it contains aluminum silicate it is softer and more plastic than ochre, which makes it suitable as a foundation coat for gold leaf (see *Gilding and Silvering*). In order to burnish gold leaf to a high gloss, it must be laid on an unctuous material.

RED IRON OXIDE is red earth color. The name is virtually synonymous with light red, Venetian red, terra di Pozzuoli, terra rosa, English red, and Mars red. (The last is produced artificially and is a nearly pure iron oxide, whereas the other red pigments contain various amounts of clay and silica.)

RED LEAD is produced by various methods of roasting white lead. This color was known in antiquity under the name of "minium," a paint of great opacity and rapid-drying capacity. Its orange-red color was not always stable; it bleached to a light pink in the sun or turned brownish. Hence as an artists' color it does not appear any longer on manufacturers' lists. The color can be easily matched, however, by adding a little cadmium yellow (see *Cadmium Colors*) to *Venetian Red*. Prior to the invention of more reliable anticorrosives, red lead was used as a primer on structured steel (bridges, fences) and on other objects made of iron that were exposed to outdoor conditions.

RED OCHRE is identical to *Yellow Ochre* except that it contains anhydrous iron oxide as its coloring matter.

RED OXIDE is the popular name for the red *Earth Colors* usually containing silica, alumina, amounts of iron oxide ranging from 45% to 85% (100% in the pure Mars red). If the pigment contains a smaller amount of iron oxide, it has a weaker *Tinting Power*, which is sometimes desirable in portraiture, for example. All red oxides are opaque, dry moderately well, and possess great permanence.

REED PEN. The so-called reed pen is cut from a bamboo twig. It is impractical to make it oneself. (See *Drawing*.)

RELIEF ETCHING is a term used when large areas of the plate

are etched out with acid, leaving the design standing high and isolated on the plate. In relief etching the raised areas are inked and printed as opposed to the procedure in regular *Etching* of inking the incisions.

RELIEF PRINTING is the process of printing from the raised areas of a carved block or plank of wood, linoleum, or other suitable material. See *Woodcut and Wood Engraving.*

RELINING PAINTINGS refers to mounting old canvases on new ones. See *Restoration of Paintings.*

REPAIRING DAMAGED PAINTINGS. See *Restoration of Paintings.*

RESINOUS PAINTING MEDIUMS are oil-resin mixtures. See *Oil Painting Medium.*

RESINS are exudates of coniferous trees. Those resins obtained from living trees are known as soft resins and those obtained from trees now extinct are known as hard resins. The latter are found in underground deposits. Soft resins such as *Mastic* and *Damar*, are soluble in a variety of coal-tar and petroleum derivatives and are used in the preparation of *Varnishes* for paintings. Hard resins such as Congo *Copal* have to be thermally processed to make them soluble in commonly used solvents.

RESIN-WAX. A *Resin* varnish in which *Wax* has been dissolved. It combines the properties of both ingredients.

RESTORATION OF PAINTINGS. Much has been written on this subject, but this author's experience has been that the procedures generally advocated are so cumbersome and impractical that they are of little value to the painter. If a painter has not received direct training in a restorer's shop and has no specialized equipment, he is not in a position to follow involved directions or to handle fantastically complex chemical formulas. The instructions given in many manuals seem to compound the "mysteries" of picture restoration, instead of simplifying the

manipulations involved. Moreover, the practicing painter is concerned mainly with rectifying damage in his own paintings, and he would seldom handle masterpieces from the past, paintings that demand restoration involving a great deal of experience and skill. The following instructions are intended for the practicing painter whose main interest is in restoring and preserving his own work.

Cleaning of Superficial Dirt. The accumulated dust on the surface of a painting should be removed first with a soft cloth. After the loose dust has been wiped off, the more tenacious dirt can be removed by rubbing the paint surface with one's fingers. Repeated ''massaging'' (with periodic hand-washing) will elicit most, and sometimes all, of the clinging dirt from the paint texture.

Next, a wad of cheesecloth should be saturated with *Damar Picture Varnish* or *Copal Varnish* and gently rubbed over the surface. This will clean as well as varnish the painting. One should remember, however, that *Turpentine* is a strong solvent, and a picture that is only several years old may be affected by harsh and prolonged rubbing with varnishes containing this solvent. (A piece of surgical cotton moistened with the varnish will exert less pressure on the surface of the painting than will cheesecloth.) Paint that is not completely bound by the *Vehicle* or the painting medium will come off easily at its top surface. How much paint is coming off will become evident by the discoloration of the cheesecloth or cotton used in cleaning. Paint surfaces that are powdery or brittle should not be treated in this manner.

A powdery paint surface indicates a lack of cohesion of the pigment particles, caused by a loss of the *Binder*. For varnishing such surfaces, *Copal Painting Medium* should be applied with a soft hair brush or, still better, be rubbed into the paint film with one's finger. Brittle surfaces should also be treated with this medium. Varnishing in this manner will not make the paint film more elastic, but, unlike a volatile varnish, it will not penetrate into the reverse of the canvas and thus deprive the paint film of requisite protection.

Some paintings may require a more thorough cleaning. If the paint film is in good condition, it may be subjected to treatment

195

with a mild soap and water. "Good condition" implies that the paint surface does not show cracks or open interstices through which water could seep. If the water seeps through, it will cause the canvas to swell and then, upon drying, to shrink. The fabric will thus be subjected to considerable movement which the dried paint strata may not be able to follow. A relatively fresh paint film—that is, one several years old (or sometimes even much older)—does not usually react in this way. However, when the paint film does become desiccated, it will develop a network of cracks or, because of the softening of glue in the sizing, may flake off in spots. When cleaning a painting of this kind, water should be used sparingly. A moist—not wet—cloth should be used for lathering. Every trace of the soap should always be carefully removed with a clean, damp cloth. This is quite important because soap is highly *Hygroscopic* and should not be left imbedded in the paint's texture.

Cleaning Oil Paintings with Strong Solvents. A stronger solvent than soap is *Saponin.* Like soap, it will not remove a varnish film, but some airborne substances deposited on the painting, such as tobacco smoke and kitchen fumes, usually yield when exposed to the action of saponin, even when they resist soap. A teaspoonful of the powder should be dissolved in about 4 oz. of water. A small addition of ammonia will considerably strengthen its action; therefore this mixture should be used with great care.

The removal of varnish from a fairly recent painting poses no problems whatever. All of the following solvents, at least one of which should be on the painter's shelf, can be used for this purpose. (1) Turpentine is a strong solvent for varnishes (and also paints) and should not therefore be used on fresh or relatively fresh paintings. (2) *Mineral Spirits* is a milder solvent; its evaporation rate is like that of turpentine. (3) Xylene (xylol) is stronger than mineral spirits and evaporates more quickly. (4) Toluene (toluol) has considerable dissolving action on varnishes but also on paint films that have not solidified completely. (5) Acetone is still more volatile and stronger than any of the preceding solvents. (6) Alcohol (methanol, ethanol) possesses very strong dissolving properties, even on hardened (but not ancient) paint films; it can also be mixed with toluene. (7) Diaceton alcohol has a lower

evaporation rate and slower dissolving action on some soft resins (not damar); its action on shellac seems to correspond to that of alcohol. Unlike methanol, it possesses the ability to coalesce certain old varnish films. (8) Equal parts of alcohol and toluene, with a small addition of acetone, should be used only on very old paintings.

Here are some typical examples of how the author has cleaned paintings.

A painting several years old became covered by dust while in storage. It was dusted with a cloth, rubbed with fingertips, and revarnished with a wad of cheesecloth.

A twelve-year-old painting, quite grimy, was treated with mild soap and water. Upon thoroughly drying, it was revarnished as above.

A twenty-year-old painting, obscured by a yellow film evidently due to tobacco smoke and kitchen fumes, was treated with saponin and xylol, then revarnished with a brush.

A thirty-year-old painting, obscured by dirt, had been evidently executed with a soft-resin medium. Xylol was used with little effect, but diaceton alcohol, applied with cheesecloth, cleaned the dirt off and made the paint film coalesce. This was a very delicate operation.

A 19th-century painting that was very dark and probably covered by a discolored oil-resin varnish, was cleaned with toluol, which made some improvement. Acetone was much more effective.

An 18th-century painting that was very brown, with all its details obscured, was cleaned with anhydrous alcohol. This removed what was probably an aged orange-shellac film. No other cleaning agents were necessary.

On a completely darkened, deep brown 18th-century painting, acetone, the strongest solvent, was tried without the slightest effect. Next, the surface was subjected to the action of saponin with a little concentrated ammonia added. The solvent speedily and completely freed the paint surface from what was evidently an accumulation of grime, tobacco smoke, and other impurities.

The examples outlined above are typical cleaning problems, although, of course, this does not preclude the rare possibility that an ancient (or perhaps not so ancient) painting may prove to be

197

atypical and require a complex and unusual cleaning procedure.

Cleaning Procedures. Before using strong solvents—this will rarely be the case if a painting is less than about thirty years old—a test should be made at the edge of the painting to ascertain what effect it will have. Its action may be too strong or not strong enough. After finding out which solvent is best, a wad of surgical cotton (the nap of cheesecloth may be too abrasive) should be moistened with the fluid. When the cotton is rubbed on the painting's surface, the wad should be examined from time to time to see whether it has picked up the dirt and or the color. Should the paint start to come off conspicuously, the applied solvent should be neutralized at once with a restraining agent. The action of acetone and saponin can be stopped with water, that of alcohol with toluene, turpentine, or mineral spirits. A wad of cotton moistened with the restrainer should always be at hand when working with a strong solvent.

Repairing Bulges. The most common damage to canvases are bulges caused by an object pressing against the picture. On a relatively fresh painting, even a major bulge (providing it does not occur in an area of a considerable *Impasto*) will not create a break in the paint strata. To rectify such damage, the reverse side of the canvas should be slightly moistened (not made wet) and the stretchers should be tightened, by lightly hammering the keys, to make the fabric taut (see *Canvas*).

In severe cases where minor fissures appear in the area of the bulge, the picture should be placed face down on a Masonite panel or any appropriate flat support. Next, after moistening the reverse side of the effected part of the canvas, a few sheets of blotting paper should be placed on it and weighted down. (A stack of books or a cinderblock can be used for this purpose.) The canvas should remain under pressure for at least twelve hours. This is done to prevent the fissures from becoming conspicuous.

Creases. On a relatively fresh painting creases caused by the pressure of the underlying stretcher bars, unless superficial, may resist a simple moistening of the canvas. Should this be the case, the stretcher bar or bars responsible should be removed. The entire area of the crease, reaching to the edge of the picture, should be moistened. Next, the canvas should be nailed again to

the stretcher bar and made taut. Such creases often cannot be eliminated by a simple moistening of the canvas, however; they must be pressed out by a warm (not hot) laundry iron. Heavy breaks in the paint strata along the edge of the stretcher bar will have to be repaired by relining (see below).

Cracks. If cracks are not the result of faulty technique or inadequate materials, they must be treated by more radical methods than those described above. Even if they disappear after having been pressed out with a warm laundry iron, they will reappear quickly. Also, *Overpainting* the cracks, no matter how heavily, will prove to be ineffectual. The type of crack that involves all the paint strata, and frequently the priming as well, occurs when a heavy, well-dried painting is subjected to stress. A heavy, desiccated impasto will crack when the canvas is bent or pressed, even with only moderate force. A canvas that was stretched taut at a time when a high humidity prevailed (60% and up) and then subjected to low humidity and high temperatures will develop large diagonal cracks at the corners. These conditions often occur when a picture is stored in winter near a furnace in a cellar, for example, or when it is exposed to desert heat.

Three principal measures can be taken to remedy the situation: (1) removing the affected part; (2) patching up the area; (3) relining the entire canvas.

If one's own painting is involved, there need be little hesitation in removing the damaged part, providing that it is not too large. The removal, it must be understood, should be complete; the paint film, the priming, and in most cases the sizing as well must be eliminated. If this is not done, the creases (if not the cracks) will reappear, even when the area has received a heavy overpainting. Such a radical operation can be done best with a combination of strong solvents, such as acetone and alcohol. If xylene is added, the evaporation of the solvents will be retarded. The paint should be removed with a *Scraper,* which can be safely used on a canvas without danger of injuring it. After the priming is gone, the glue size should be softened by brushing hot water on it and then be rubbed off with a rag. If a commercial *Paint Remover* is used, care should be taken to eliminate the residue of paraffin with turpentine or mineral spirits.

To repair the damage, proceed as follows. Size the bare canvas

with *Acrylic Polymer Emulsion*. When the canvas is dry, reestablish the priming with *White Lead* paste mixed with umber. This is a quick-drying priming which can receive an underpainting in two or three days, whereupon the final overpainting can be executed.

Relining Damaged Paintings. All the manuals on picture restoration are replete with formulas and directions concerning the relining of canvases—mounting a damaged canvas on a fresh support. But no matter how sound the advice may be, the manuals all have one failing. The painter, without specialized skill and training, cannot follow the complicated formulations and procedures. The instructions which follow include only those which will be of practical value to the painter.

As mentioned before, heavy cracks involving all the paint strata cannot be corrected unless one of the three following measures is taken: entire removal of the affected area, complete relining, or partial relining. Partial relining is referred to as patching up; instead of the entire canvas, only the affected area is provided with an additional canvas support.

The simplest operation is pasting the canvas to a rigid support, such as ⅛" thick untempered *Masonite*. When doing this, the edges of the canvas can be first cut off or they may be left unattached. However, the use of the panel support limits the size of a painting to about 12" x 14". Also note that a picture on a canvas looks different from one mounted on a rigid support. When a larger canvas is transferred in such a manner, it does falsify its original appearance; this does not seem to be the case with small paintings, where the rigidity of the panel does not become conspicuous. The advantage of a Masonite support is that a painting attached to it remains safe from any of the future injuries that can befall a stretched canvas. But, before the attachment, the reverse side of the canvas should be sandpapered to a perfect smoothness or its texture will become unpleasantly conspicuous.

To attach the canvas, the standard *White Glue* sold under various trade names may be used. A fine-textured canvas can be pasted onto the smooth side of the Masonite; rough fabrics will have a firmer bond on the side with the wire screen marks. When pasting up fine fabrics, the adhesive should be applied only to the panel. In the case of a coarse canvas, both the panel and the fabric

should receive the adhesive. It is best to use a *Spatula* rather than a brush for this application. Instead of white glue, *Acrylic Gel Medium* (which is equally strong) or plain acrylic medium can be used. The latter is not as strong an adhesive as the former, but it is quite adequate, especially when both the panel and the canvas are treated with it.

If a canvas that does not show deep cracks has been mounted as described above, it need only be covered with sheets of soft paper upon which another Masonite panel should be placed; the whole "sandwich" is then weighted down with cinderblocks of 30 lbs. each (or equally heavy objects) and left under pressure for 24 hours. A badly creased canvas will require pressing with a warm (again, not hot!) iron before placing it in the cinderblock press. Some panels treated in this manner may show a slight bend, others will not; it is impossible to predict. In most cases, when the painting is arrested in the rabbet of a frame, the bend does not show. However, the tendency of the Masonite to warp can be overcome by pasting a canvas on its reverse side to equalize the stress. This should be done at the same time that the picture is attached.

Relining a Canvas. This has always offered the greatest difficulty to the painter because of the complex manipulations involved and because the recommended adhesives and materials are difficult to handle. These adhesives usually include pastes composed of glue, dextrin, and *Venice Turpentine;* glue and *Rosin;* damar resin and wax; and other similar combinations. With the introduction of acrylic compounds, however, the entire procedure has become greatly simplified.

The materials required for relining are a Masonite panel or a table on which the work is done; another panel and cinderblocks or other heavy objects to serve as a press; raw canvas; and acrylic gel medium to serve as paste. The paste is prepared simply by mixing the gel with chalk to a rather thin consistency. The chalk in the compound functions as a *Plasticizer,* or bodying agent. The canvas used for relining should be more densely woven and heavier than that of the picture. It should also be a few inches larger. The edges of the picture that were originally nailed to the stretcher bars can be retained, or they can be trimmed off.

The surface of the table or the Masonite panel should be covered

with many sheets of soft paper and topped with a sheet of kraft paper, all several inches larger than the painting. This provides a cushion for the painting which will rest on the top of it, face down. The softness of this surface is important when the painting shows impasti because these, as well as minor protuberances of paint, can become pressed and distorted by the warm laundry iron. If there are only a few textural protuberances on the paint surface, they can be protected separately by pasting layers of soft tissue paper over them. This can be done with *Gum Arabic* which is easily softened by moistening with water when the tissue patches have to be removed. The kraft paper should always be the top layer of the working surface.

When the picture has been placed face down on the paper cushion, the canvas should be covered with a generous layer of the adhesive, applied with a spatula. Immediately after this, the new canvas, several inches larger than the picture, should receive the adhesive, but sparingly so that the gel does not penetrate to the reverse side of the fabric. (Such penetration would only make the paper attach itself to the fabric in spots; its removal is simple but annoying.)

The two canvases are joined together. The new canvas, on which the ironing is done, should be on top, covered by a sheet of paper. This prevents the iron from sticking to any adhesive that may have penetrated the canvas. Next, a laundry iron should be used for the important job of pressing out the creases, breaks, and cracks in the painting. This is facilitated by the heat of the iron, which should be just enough to slightly soften the layers of paint. After the ironing, all traces of the adhesive that do actually penetrate to the picture's surface should be carefully wiped off. Now, a Masonite panel, several inches larger than the picture, should be placed on top of the new canvas (still covered by the protecting paper) and weighted down with a row of cinderblocks extending beyond it.

The painting should be left in this press for at least 24 hours; immediately after this, it should be attached to the stretchers. For paintings up to about 25'' x 30'', the standard stretcher may be used. Larger sizes will require stretcher strips 3'' wide or wider, reinforced by crossbars, since the pull of the relined canvas might twist a weaker framework.

Small cracked areas or tears can be treated with separate patches of canvas, which may measure 2'' square or larger. The adhesive used for this purpose is the same one described above. A frequent disadvantage in using a patch is that its outer edges impress themselves on the picture's surface, and create a slight bulge which becomes visible when the picture is in direct light and one looks at it from an angle. To avoid this, a small margin should be left free from adhesive all around the patch; thus only the central part of the patch is attached to the damaged area of the picture.

Repairing Scratches and Cleavages. To make these repairs on panels requires that the damaged area must first be filled with a material which will bring it flush with the paint surface. Because of the rigidity of the support, the filler need not be elastic. *Acrylic Modeling Paste* can be used for this purpose. The white paste should be mixed with a pigment that will tint it to approximate the color of the cleavage or scratch. This simplifies the overpainting or retouching of the filled-in indentation. The paste should be applied with a small painting knife and, depending on the depth of the cleavage, one or more separate filling-in operations will be required. Each filling-in should be done after the underlying paste has dried. Because of the rapid drying of the acrylic material, however, several consecutive applications can be made within less than an hour. Some copal varnish should be brushed onto the filled-in area so that it will be less absorbent when overpainted.

Similar damage to canvas can be treated in the same manner, except that a putty prepared from white-lead paste mixed with an appropriate oil color should be used, instead of the inelastic acrylic paste. To accelerate the drying of this putty, some umber oil color should be added to the mixture.

Tears in the canvas may be so severe or jagged that a simple patch on the reverse side of the canvas, and then a filling-in with picture putty may not be sufficient. The loose threads may have to be rejoined, and actual weaving will be required. As a rule, this can be done only by a professional. Once the mending job has been accomplished, the fabric should be sized with acrylic medium, which is preferable to glue size because it does not exert the type of pull on the fabric that might bring up radiating folds around the repaired area. Priming with oil paint, underpainting, and painting should then proceed in the usual manner.

203

Yellowing. Oil paintings that are kept in the dark or exposed to sulfurated air will darken and acquire a yellowish cast. This will be noticeable in areas where *Flake White* was used. Such a condition can be easily rectified by exposing the painting to strong daylight or to direct sunlight, which will have a much faster action. Direct exposure to excessive heat, however, should be avoided. The painting should be placed at a slant to minimize the impact of the sunrays. Usually an exposure of 5 to 10 hours will bring about the desired result.

Mold. In areas of high or tropical temperatures and prolonged humidity of about 70%, mold can affect the glue sizing of a canvas. The usual remedy for this condition is to spray the reverse side of the canvas with a 5% *Thymol Solution.* Repeated applications are often necessary.

Cleaning Tempera Paintings. Paintings executed with egg tempera emulsion are waterproof; hence they can be cleaned with mild soap and water. However, if the gesso panel has been prepared with glue, this operation may be hazardous; traces of water, seeping through the minute openings in the paint surface, will soften the gesso and make it swell. In preparing tempera panels, it is best to use acrylic gesso which is water insoluble. Old and soiled varnish can be removed with any varnish solvent of the mineral-spirits group.

Cleaning Acrylic Paintings. Because the film formed by acrylic paints is nonporous, atmospheric dirt does not become firmly attached to it. Any dirt can easily be removed from the waterproof surface with mild soap and water. However, acrylic paint films are *not* resistant to turpentine and other hydrocarbon solvents; avoid these.

RETARDATION OF PAINT DRYING is sometimes necessary in the execution of very large paintings or in the use of special techniques.

Oil Painting. The following measures should be taken in order to delay drying in oil painting. First, avoid such quick-drying paints as *Raw Umber, Burnt Umber, Burnt Siena,* and the *Mars Colors;* also avoid the moderately quick-drying paints (*Flake White,*

Viridian Green, Raw Siena, Prussian Blue). Use instead *Zinc White* or *Titanium White; Ivory Black* mixed with dark *Ochre* for browns; and ivory black mixed with *Venetian Red* for burnt siena effects. It is also a good idea to grind your own pigments in raw *Linseed Oil*, because it is common practice among some paint manufacturers to add a drying agent to certain colors to insure their accelerated, uniform drying. Resinous painting mediums, absorbent or semiabsorbent painting grounds, and exposure of the wet painting to heat and dry air should also be avoided. A temperature of 70°F. will accelerate drying of paint much faster than a temperature of 50°F., and comparable increase in drying time will occur when the relative atmospheric humidity is 20% rather than 60% or over.

Watercolor and Acrylics. Watercolor grinds containing glycerin have the tendency to remain moist for a longer period if they are used on relatively nonabsorbent paper. So far, chemistry has not revealed a satisfactory ingredient for retarding the drying of *Acrylic Paint.*

RETOUCHING VARNISH is a preliminary *Varnish* which is used before the application of the final varnish.

ROSE MADDER is natural dyestuff obtained from the roots of the madder plant. It has been superseded by the more permanent dye obtained from coal tar that is known as *Alizarin Crimson.*

ROSIN (Colophony) is the residue left after the distillation of *Turpentine.* Because of its weaknesses—easy solubility and deterioration of the film under the influence of moisture—it is worthless for use in painting. It is sometimes employed as an adulterant in the preparation of varnishes, as a substitute for a higher-grade resin such as *Copal.* Its presence in products labeled *Copal Varnish* can be detected easily by submerging in water a glass slide that carries a dried film of the varnish. Whitening or clouding of the film will indicate substitution of colophony. In an *Emulsion* with glue, it can be used successfully for relining canvases (see *Restoration of Paintings*). It is also used as a ground in aquatint (see *Etching*). 205

ROULETTE. This is a notched metal wheel, set in a handle, that allows the wheel to turn freely when rolled across a flat surface. Such tools are used for marking copperplates for various types of *Etching*.

RUNNING is a term denoting the thermal processing of *Copal Resin*.

SABELINE BRUSHES are substitutes for sable brushes. They are made of oxhair, dyed to a color that approximates that of sable hair. Because of their low cost (they are considerably cheaper than genuine sable brushes) they have become quite popular. When used for blending oil colors or for laying down washes of watercolor or acrylic, the flat sabeline brush is no less effective than the sable brush. In large sizes (exceeding that of the largest standard sable brush, No. 12), sabeline brushes are also very useful. Because sabeline hair is thicker and its texture coarser than sable hair, sabelines are not well suited to work that requires precision.

SABLE BRUSHES possess soft, but resilient hairs and are used in all painting techniques when a smooth, fluid stroke is required. Because of the softness of the hair, the brush leaves very little indentation on the surface of an oil painting and is therefore used for blending and for thin passages of fluid paint. Sables are standard painting tools for all water-based mediums—watercolor, acrylic, casein, gouache, etc.—which require large, thin passages of fluid color.

Sable brushes come in a variety of shapes: flat and round, as well as in such special designs as the *Striper* and *Scriptliner.* Brushes designed for *Oil Painting* have long handles, generally the same length as those of *Bristle Brushes* (see also *Oxhair*). Those designed for watercolor and other aqueous media have shorter handles, approximately the length of a drawing pencil. The best brushes of this type are called *Kolinsky Sables.*

Sable brushes can be used with India ink (see *Lithography*). 207

SAFFLOWER OIL is derived from seeds of certain plants (Carthamus tinctorius) that were cultivated in India for many centuries. Often considered a good substitute for *Linseed Oil,* it dries more slowly and yellows less, which may be looked upon as an advantage in the preparation of *Flake White* oil color. Lately it has been used as a grinding oil by some American manufacturers of artists' colors.

SAFFRON is a golden yellow dye derived from a certain part of the crocus flower. It was known in antiquity and was used chiefly in the painting of illuminated manuscripts. It is also a condiment for food. It is no longer on the market as an artist's color.

SANGUINE. A brownish-red pastel-crayon.

SAPONIN is a white powder obtained from certain plants, among them soapwort. It is soluble in water, in which it foams like soap, and is used to clean paintings on specific occasions (see *Restoration of Paintings*).

SCHWEINFURTER GREEN. See *Emerald Green.*

SCRAPER. This tool is used to correct undesirable marks or roughness on a metal plate (see *Etching*). It is also a knife specially designed to scrape off dried impasti from a canvas or panel.

SCREEN PRINTING. See *Silk Screen Printing.*

SCRIPTLINER is a round sable brush possessing extra long hair that terminates in a fine point (see *Brushes*).

SCUMBLE. This is a lighter semitransparent color resting on top of a darker color. See *Oil Painting.*

SEPIA is a black or brown-black secretion of enormous *Tinting Strength* from the ''ink bag'' of the common cuttlefish or squid. It was never used as an oil color, but it served as an ink in antiquity. During the latter part of the 18th century, it became popular as a medium for ink drawings and as a watercolor. The present

watercolor designated as "sepia" is a *Dye,* and is more permanent than the original ink, which often fades in strong light.

SERIGRAPHY. Another name for *Silk Screen Printing.*

SGRAFFITO. See *Graffito.*

SHEELE'S GREEN, named after its inventor, is an inferior version of the color known as *Emerald Green.* It is a copper aceto arsenite, and as such it is quite poisonous. It is rarely used today because of its instability in mixtures with other colors. The original color had moderate *Hiding Power* and *Tinting Strength* and dried slowly. Its tint can be approximated by a mixture of *Phthalocyanine Green, Cobalt Blue,* and white.

SHELLAC is a resinous secretion of the lac insect gathered from certain trees in India and Indochina. In its natural state shellac is composed of orange-colored thin transparent flakes. The bleached variety comes in small, irregular lumps. Both these qualities of shellac are soluble in denatured alcohol (shellac solvent). A solution of 1 part shellac to 12 parts alcohol (the first by weight, the second by volume) can be used as a *Fixative* for drawings, but it has now been replaced by acrylic resins commercially available in aerosol cans. The standard commercial quality of shellac, when thinned with alcohol in the proportion of 1:1 or 1:2, can serve for the isolation of such absorbent surfaces as plaster. Nevertheless, its use for this purpose is now very limited because of the more effective acrylic substitutes. In woodworking and *Gilding,* however, white and orange shellac are indispensable. White shellac is used as a sealer on wood that is to be painted to prevent the show-through of knots. Orange shellac can be used to endow wood with a deep warm tonality. Furthermore, shellac produces a very high degree of gloss on wood. In gilding, shellac serves as a protective coating, and the orange variety not only enhances the color of gold but also gives it an antique appearance. When brushed over silver leaf several applications of orange shellac will produce a close approximation of gold.

SHORT PAINT refers to oil paint which tends to be stiff rather

than fluid in its brushing quality. Such paint does not fuse or blend well but it can be used to create sharp impasti and textural passages. Modern tube paint tends to be short because stabilizers are added to it and because paint does not polymerize in closed containers (see *Polymerization*). Also see *Long Paint*.

SICCATIVES, such as *Cobalt Dryers, Manganese Dryers,* and *Lead Dryers,* are metallic agents in solution, used to promote the drying of oil paints.

SIENA is related to *Ochre,* but the sienas are darker and more transparent. The colors derive their name from the Tuscan city from where the best qualities of the pigment were originally found. Although *Raw Siena* and *Burnt Siena* are made from an identical pigment, their colors are quite dissimilar. Raw siena is a dull yellowish-brown, having only moderate *Hiding Power.* When roasted, it takes on a warm, deep reddish-brown color (burnt siena), which, unless thinned by an oil-painting medium to a glaze, is quite opaque. When burnt siena is used as a glaze, its tonality becomes warmer and deeper; it is one of the most important transparent colors. The drying capacity of burnt siena is excellent, and both varieties are of greatest permanence.

SIERRA LEONE COPAL is a very hard quality of *Copal* found in Africa in Sierra Leone. It is no longer readily available.

SILICOIL is a recently developed hydrocarbon brush cleaner, practical for painters whose *Brushes* are in daily use, because the brushes can be left from day to day in the tank containing the solvent. A special tank, containing a coil against which the brushes may be rubbed, is also available.

SILK SCREEN PRINTING, also referred to as serigraphy, represents the simplest technique of making reproductions in a large quantity. It has been used for centuries to pattern textiles and paper; in the more recent past, printing by stencil came into commercial use. As a fine-arts medium, it was adopted less than fifty years ago. The term silk screen printing indicates the material originally used for stenciling, but other fabrics are also now in widespread use.

Silk, nylon, or a similar finely woven fabric is stretched on a wooden frame called the screen. When paint is applied over the screen, the liquid color penetrates its open mesh, except for the areas where the fabric has been masked, and deposits a design on paper or fabric beneath the screen. The stopped-out areas on the screen can be created with cut stencils made of a variety of papers, especially prepared film, or various liquid "resists." Inks and paints for screen printing can be oil-based or water-based.

Materials and Equipment. A printing unit can be ready-made. It consists of a rectangular frame with the silk or other fabric stretched on it, and a baseboard on which the paper or fabric to be printed is placed. The silk is classified according to its mesh, generally ranging from #8 to #16. These figures indicate the number of meshes to the linear inch. The finer the mesh, the sharper the printed image. Mesh #12 is considered suitable for most commonly used techniques.

Screen printing frame
and baseboard.

The mesh of the screen will always leave a somewhat "toothy" edge, which can be undesirable when the design involves fine lines, as in the tusche method. To avoid this, the screen can be sized with a water-soluble filler that temporarily blocks out the open areas of the screen. The filler is obtainable ready-made and is simply brushed on top of the screen before drawing on it. When the drawing is finished, the size can be removed easily with a sponge and warm water, leaving the drawing intact with precise edges.

To push liquid color across the screen an instrument called a squeegee is used. A squeegee consists of a wooden handle into which a thick rubber blade is inserted; the blade should be almost as long as the inside width of the screen frame. To obtain an even, thin spread of color the edge of the rubber should always be sharp and free from dried paint residue. If the rubber blade becomes worn, it should be sharpened again by moving it horizontally on a strip of sandpaper.

Squeegee.

The stencil is cut from transparent material. A heavy oiled paper can be used for this purpose; a specially made film suitable for producing precise and sharp images, if these are desired, is also available. For cutting, one can use either a special stencil knife or an X-acto knife with a semicircular blade.

Other necessary materials and utensils include silk screen glue in liquid form and *Lithographic Tusche* (both for preparing glue-resist screens); *Lithographic Crayons; Bristle Brushes* and *Sable Brushes;* a sponge; *Turpentine, Kerosene,* and *Mineral Spirits* or *Turpentine.* Common clothespins serve for hanging the prints while drying.

X-acto knife.

Screen process colors especially formulated for this purpose come in cans, the smallest containing half a pint. The colors can be thinned with mineral spirits. The designation of colors by various manufacturers does not always correspond to the standard nomenclature used for oil-painting colors. To achieve transparency of color, a salve-like substance known as transparent base can be added.

The paper for printing should be neither too smooth nor too rough. It should be non-glossy and slightly absorbent, and its weight can range between 140 lbs. and 280 lbs.

Paper Stencil Method. The frame with the screen should be removed and the original drawing centered on the baseboard. Register tabs (two at the bottom, one at the side) should be stuck on with rubber cement to maintain an identical position for each print that will be made. The stencil paper is placed over the original drawing and stuck down with pieces of masking tape at the corners. The outlines of the drawing, visible through the transparent paper, are now cut with the stencil knife, but the excess parts are not yet stripped away.

At this point, without disturbing the position of the stencil paper, the masking tape that held it firmly in place should be removed. Then the screen frame should be rehinged and pressed down on the underlying stencil paper. To make the stencil adhere to the screen some paint should be poured along the narrow edge of the frame and pressed through with the squeegee; the color penetrates and forms a sticky bond between stencil and fabric. The frame is lifted (with the stencil now firmly attached to the screen), and the original drawing can be removed from the baseboard and the stencil stripped.

The paper for printing will now replace the original drawing on the baseboard and be accurately positioned by the register tabs. The screen frame is pressed down, color is squeegeed across the screen, and the exposed areas of the stencil allow the color to penetrate to the paper. After printing as many copies as required, clean the screen thoroughly with kerosene to remove the imbedded paint. Additional stencils can be used to print additional colors on the papers. The finished prints are hung up to dry with clothespins.

When the stencil is made from the product called cut film, it is adhered to the screen with water, which softens the film. The film can also be removed with water. Film stencils produce perfectly sharp edges, even on coarse-mesh silk.

Tusche Process. This is a more direct process than the paper-stencil method. In fact, this technique differs very little from *Lithography,* because the character of the artist's original drawing remains preserved. The initial drawing is placed under the screen to serve as a guide for the tracing made on the fabric. This tracing is executed either with a brush and liquid lithographic tusche or with lithographic crayon. Next, the entire screen is gone over with the liquid glue, which serves as a resist, blocking out all portions that are not covered with the greasy tusche or crayon.

The marks made with the drawing materials are then washed away with kerosene and mineral spirits. The best way to do this is to place kerosene-soaked blotting paper on the reverse side of the screen in the area of the lithographic marks until the dried marks become soft. Mineral spirits can then be used. The glue film on top of the tusche flakes off, but the glue on the rest of the screen is unaffected by the solvents and remains intact. Cleansed of the tusche and the glue, the design now can be printed with the squeegee in the usual manner. If the silk is given an initial sizing, fine, sharp lines, *Crosshatching,* and a variety of textural effects that are produced with drawing tools and bristle brushes will be accurately rendered in print.

Glue-Stencil Method. In contrast to the former method, which employs direct drawing, this calls for the creation of a negative image. The liquid glue is painted on just those parts of the screen which are not intended to print. For this purpose, 1 part of liquid glue should be thinned with 3 parts water. Because the colorless liquid will not make visible marks on the white silk, a little writing ink should be added to the solution.

The drawing is traced first with a pencil directly on the screen. The design areas will remain untouched by the glue resist, allowing the paint to pass through its unblocked mesh. Only the areas outside the design proper are painted with the glue.

This technique enables the artist to incorporate a wide variety of textures, such as *Drybrush Effects* and *Stippling.* To produce

mottled effects on the surface outside the design, the glue resist film can be manipulated in various ways; it can be partially softened with water, sponged out in places, or scraped into with a *Stylus,* thus allowing some of the printing color to penetrate through to the paper.

Multicolor Printing. The technique involved does not really differ in principle from single-color printing, but a different stencil has to be made for every color used. The screen can remain the same. When printing a given number of sheets, all will receive one color and then be allowed to dry. The stencil used for that color is then removed from the screen, the screen is cleaned, and the second stencil for the second color is created and adhered. Then all the dried sheets receive the second color. This procedure is repeated for each new color.

The crucial part of multicolor painting is keeping all the stencils in perfect register. Besides the guide tabs placed on the baseboard, the common practice in color printing is to mark the four corners of every print's margin with small crosses and to do the same on each stencil used for the different colors. In printing, these marks must be lined up accurately; otherwise, the colors will be out of register.

Although it depends on the subject matter, it is often practical to start with the black color that delineates the salient part of the design and then to proceed with the other colors.

The opacity of the process colors is such that any one will completely cover an underlying color. Hence, it is immaterial whether one starts with light or dark colors. If a color as it comes from the can is too thick for each manipulation, some mineral spirits should be added, but care must be taken not to make it too runny. Transparent colors can be obtained by adding transparent base to the process colors.

SILVERING. See *Gilding and Silvering.*

SILVERPOINT is a *Stylus* made of silver. A silver wire with a fine dull point can also be set in a lead-pencil holder. A sized or gesso-coated drawing surface has the necessary *Tooth* to grip the granules of silver. See *Drawing.*

SIZE is a solution of *Acrylic Resin,* animal *Glue, Casein Glue,* or *Gum Arabic* in water. Size protects the fibers of textiles (see *Canvas*), wood and Masonite (see *Panels*), and *Paper* from penetration by oil colors. See also *Acrylic Gesso.*

SMALT, an ancient, obsolete blue, was a potash silicate colored by cobalt oxide. Its color approximates that of cobalt blue, which, however, is more opaque and as pigment is more finely divided.

SOFT-GROUND ETCHING. See *Etching.*

SOFT-HAIR BRUSHES include those made of *Sable, Oxhair, Fitch,* and *Squirrel.* See *Brushes.*

SOLVENTS are materials used to dissolve other materials. The ones most useful to the painter are organic compounds of carbon. Some are natural products such as turpentine, a greater number are now manufactured synthetically. Coal-tar hydrocarbons, another class of solvents, are derived from the destructive distillation of coal tar, a by-product of coke and coal gas (see *Coal-Tar Derivatives*). Depending on their nature, solvents are employed to dissolve *Resins;* they are also used to clean paintings (see *Restoration of Paintings*) and to soften paint-hardened brushes. The following solvents are useful to the painter: *Acetone, Alcohol* (methanol, ethanol), *Ammonia Water, Diaceton Alcohol, Kerosene, Mineral Spirits, Paint Remover, Saponin, Toluene, Turpentine,* and *Xylene.*

SOYA BEAN OIL is slow-drying and forms weak films. It is not recommended for the artist's purposes.

SPATULA. A knife (also called a trowel) similar to those used in painting (see *Painting Knives*) but with a short trowel-shaped blade. It is not very elastic and allows vigorous operation when dispersing pigment in its vehicle (see *Grinding Pigments in Oil*). The term also describes a larger trowel-shaped instrument used for the same purpose.

SPLIT. See *Flag.*

SQUIRREL-HAIR BRUSHES are soft hair brushes used mainly as blenders (see *Brushes*).

STABILIZER. An ingredient used to promote the suspension of pigments in oil. See *Aluminum Stearate; Green Earth; Waxes.*

STAND OIL is *Linseed Oil* thickened by heat in the absence of oxygen. See also *Blown Oil.*

STEEL FACING is a method of coating a copper plate with steel to make the surface of an *Etching* more durable for prolonged printing.

STIPPLING is a method of producing a paint surface made up of small dots; paint is applied with a bristle brush or a painting knife, employed in a perpendicular, up-and-down motion.

STOMP, often called a tortillon stomp, is a tightly rolled piece of soft paper, formed into a small stick and tapered at one or both ends. It is used to produce fine tonal transitions in *Drawings* made with charcoal, crayon, and pencil.

STORING PAINTINGS. Oil paintings should never be removed from their stretchers unless necessary. Should it be necessary to remove a canvas from its stretcher (because of storage space, for example), it should be kept flat between sheets of corrugated boards. Unless a picture was painted very thinly on a thin, elastic priming and is still in a relatively fresh condition (not older than 10 or 15 years), it can be rolled up (face outside) for a short time only. The back of paintings to be stored intact should have a corrugated board affixed to the stretcher boards, but not nailed down. (The hammering of nails may jolt an older canvas on which the paint may have become brittle. In fact, screws and washers are preferable even to staples.) A few openings should be cut in the corrugated board to allow a free circulation of air; these need not be larger than about one square inch. The face of a painting should always be turned toward the wall, with the corrugated board outside.

Paintings should not be stored in basements accommodating a

furnace; the relative humidity there during the winter months may register zero. The optimum atmospheric humidity for paintings is 45%. When over 60%, the danger of mold developing on canvases carrying a glue size becomes acute. Properly equipped storage rooms should possess a hygrometer for registering the prevailing atmospheric condition and both a humidifier and a dehumidifier. Varnishing paintings prior to their storage is mandatory.

Drawings and watercolors are sufficiently protected from dirt when framed under glass. If the rag content of the paper is low, however, it remains vulnerable to light, heat, and humidity. Hence excessive exposure to such conditions should be avoided. The safest way to store work done on paper is to keep it in a portfolio between sheets of tissue paper.

STRETCHER BARS are made of wooden strips 1½" wide and ¾" thick on the outside, tapering to ⅛" on the inside. The canvas, mounted on the rectangular frame formed by the bars, rests only on the outer edges of the bars. Stretcher bars are made with mortised and tenoned corners, ready for assembly, and with groves into which wooden keys are hammered to stretch the canvas taut. See *Canvas.*

STRETCHER KEYS. See *Keys.*

STRETCHER STRIPS. See *Stretcher Bars.*

STRIPER. A brush made of very long sable hair, terminating in a chisel-shape tip (see *Brushes*).

STRONTIUM YELLOW (sometimes labeled lemon yellow) is strontium chromate, a color rather weak in *Tinting Strength* and *Hiding Power.* It dries slowly in oils and does not seem to solidify very well. All these qualities are greatly improved by mixing it with *Copal Concentrate.* In fact, some of its original *Vehicle* should be eliminated before using it by placing the paint on an absorbent paper, and the liquid thus drawn off can be replaced with the concentrate. Strontium yellow is useful in landscape painting, particularly for creating atmospheric effects for which cadmium

yellow (see *Cadmium Colors*) would be too strong and *Naples Yellow* too low in key.

Strontium yellow is used in both oil and watercolor painting. As a watercolor it provides a very clean transparent yellow with a slightly greenish cast.

STYLUS. A pencil-like instrument made of wood or metal that has a blunt point.

Stylus.

SULFURIC ACID is employed to refine *Linseed Oil.* It is also used as a pickling solution in *Enameling.*

SUNOCO SPIRITS. A petroleum solvent (see *Mineral Spirits*).

SUN-THICKENED OIL. When exposed in a flat container to the action of sun, *Linseed Oil* bleaches and becomes polymerized. As such its all-around properties are superior to that of raw linseed oil.

SUPPORT. The flexible or rigid surface upon which a painting is done, such as *Canvas, Panels,* and *Paper.*

SURFACE TENSION refers to the tendency of a liquid to contract into small, spherical droplets. In painting and in *Drawing* with inks, this is called *Crawling* and is likely to happen when liquid color is applied to a very smooth nonabsorbent surface.

SUSPENSION AGENT is a substance that allows the suspension of a solid in a liquid, such as the suspension of pigment in its vehicle.

SYNTHETIC PIGMENTS are products of chemical synthesis. These may be inorganic compounds of metals, such as *White Lead,* or complex organic compounds of coal tar, such as *Alizarin Crimson.*

SYNTHETIC RESINS are complex organic products known more specifically as acrylics and vinyl and alkyd resins.

TARLATAN is a stiff, gauze-like fabric used to ink the plate in *Etching.*

TEMPERA PAINTING. The term "tempera" has been loosely applied to almost all kinds of paints other than oils and water-colors. Strictly speaking, however, tempera refers only to pigment bound by an *Emulsion,* that is, by a *Vehicle* of oil and water in the presence of an emulsifying agent. This emulsion possesses properties that allow the paint to be diluted either with oil or water. Examples of tempera emulsions are *Egg Yolk* (probably the most perfect natural emulsion); whole egg; egg and water; egg, *Linseed Oil,* and water; egg, linseed oil, water, and a *Varnish;* and gum arabic, varnish, and water. Egg and *Gums* are emulsifying agents or catalysts; water and oil, or water and varnish, are the immiscible liquids to be emulsified.

Egg Tempera. Paint employing egg yolk alone as a binder for the pigment should be prepared in the following manner. The egg yolk should be separated from the white; the thin skin which encloses the yolk and all small threads or traces or membrane should be pinched off. Undiluted, yolk is too greasy for painting, so each yolk should be thoroughly mixed with 2 to 4 teaspoons of water. To prevent the mixture from decomposing, 3 to 5 drops of vinegar or 1% of a 10% *Phenol* solution should be added. This medium is then mixed with the pigments, which have been previously ground in water to a thick consistency and placed in wide-mouthed receptacles. If the receptacles are topped by a little water (so as to

221

retain moisture) and kept tightly closed, the pigment paste (without egg) will be usable for many months.

Tempera paint should be thin and limpid, so the pigment should receive a sufficient amount of binder. To achieve this, equal parts of the pigment paste and the water-diluted egg yolk should be rubbed together with a spatula. When the paint has been prepared in this way, a day's supply can be placed in the slots of a metal palette or in small cups.

A sample of the paint should be placed on a glass plate and allowed to dry for 24 hours. It should then be possible to scrape off the solidified cohesive paint film. If the film crumbles, not enough *Binder* (egg yolk in this case) was compounded with the pigment. Once the correct relationship between the amounts of pigment and binder has been established, as much water as needed to achieve easy brushability can be added. If the egg-tempera painting appears much lighter upon drying, this also means that the pigments have not received enough binder. The same fault accounts for egg-tempera paintings turning darker and spotty after varnishing. If the painting appears too shiny after it has dried, however, too much egg yolk went into its preparation. When dry, well-prepared tempera paint should show a slight gloss when it is polished with a soft cloth. If the paint remains dull, this may be a sign that the ground upon which it was painted was too absorbent (see *Priming*).

Correctly tempered paint should dry with a slight gloss when painted on properly prepared panels. Because the paint film lacks elasticity, only a gessoed *Panel* should be used as a support for tempera painting.

Egg-Tempera Technique. The colors cannot be blended like oil paints because egg tempera dries too quickly—it cannot be manipulated in the same way. Color transitions have to be carried out by linear rather than broad pictorial means, especially by *Hatching* and *Crosshatching,* executed with round sable brushes. Since the egg medium dries so fast, repeated overpaints can follow one another in quick succession. The material does not, however, lend itself to *Impasto* painting. The underpaintings should be kept in predominantly light colors. Once dry, the paint becomes water-insoluble and highly resistant even to strong paint *Solvents.* It can be varnished in the same way that oil paint is (see *Varnishing*).

Oil-Tempera Painting. As the name implies, this type of painting employs linseed oil in the painting medium in addition to egg, and usually a varnish as well. The egg serves as the emulsifying agent in the medium. The nature of the emulsion may vary in several ways. A water-in-oil emulsion—1 part egg yolk to 1 part stand oil, diluted with some turpentine—may be thinned with oil only; an oil-in-water emulsion—2 parts egg yolk, 3 parts water, 1 part stand oil—may be thinned with water.

Besides the formulas mentioned, the one most frequently used is composed of 1 part whole egg, ½ to 1 part stand oil, ½ to 1 part *Damar Solution Heavy,* 2 parts water. One whole egg should be beaten to a froth and mixed well with the stand oil. Next, the damar varnish should be added and shaken with the solution. Lastly, the water should be added drop by drop, with continuous stirring, until it is perfectly emulsified with the other ingredients. As a preservative for up to 1 pt. of the emulsion, 20 drops of vinegar or 20 drops of *Dowicide A* should be added. When stored in tightly closed bottles in a cool place, the emulsion will remain fresh for weeks or even months. The emulsion should be shaken vigorously before use; this divides the globules that form when the ingredients are allowed to settle.

The emulsion will serve as a vehicle for pigments as well as a painting medium. The dry pigments should be treated the same way as when painting with the egg medium alone—a brief rubbing with a spatula will disperse the pigment in the vehicle. If it is not going to be used very thinly, oil-tempera paint should be applied to a rigid panel that has been gessoed (see *Gesso*), never on an oil priming.

Oil-Tempera Technique. Compared to pure egg tempera, oil tempera is more like oil paint. The paint does not dry as rapidly, so there is more freedom to blend the colors. When the amount of oil in the emulsion becomes significantly increased, the vehicle will behave in much the same way as pure oil medium.

Tempera Underpainting. During the past decades, the fashion of underpainting in tempera and following up with an oil-paint glazing was based on the assumption that such a process insured greater permanence. The idea that this was the method followed by the van Eycks and other early Flemish masters has now been

223

refuted by the best-known authors on painting technique. Fifteen years ago micro-chemical tests on van Eyck's *Adoration of the Lamb,* conducted by Dr. Coremans in Brussels, resulted in conclusive evidence that several of van Eyck's underpaintings were executed in straight oil. Tempera medium was found only in areas where *Lapis Lazuli* was used, because this color becomes much darker when compounded with oil.

TERRA DI POZZUOLI. Originally prepared from the pigment mined in the village of Pozzuoli in southern Italy of the same name, terra di Pozzuoli is an *Iron Oxide Red* of low iron-oxide content. It is absolutely permanent, and its *Tinting Strength* and drying capacity are relatively good. It is not as opaque, however, as a pure iron oxide red, such as the one known as *Venetian Red.*

TERRA ROSA is a very light *Iron Oxide Red* of relatively slight *Tinting Strength.* For all practical purposes, this color is interchangeable with *Terra di Pozzuoli.*

TERRA VERDE, TERRE VERTE. The first term is Italian, the second French for *Green Earth,* an earth color of minimal tinting strength, great transparency, and poor drying quality when compounded in oil. It was not on the old master's palette as an oil color. When in *The Craftsman's Handbook* (1437) Cennini called it a ''valuable color,'' he was referring to green-earth tempera paint. In aqueous compounds green earth has none of the poor qualities inherent in the oil color.

TESTING PAINTS FOR ADULTERATION. The following tests can be carried out by the painter who does not have specialized training. The equipment needed includes a delicate balance, a beaker, test tubes, a blowpipe, a small piece of charcoal about 1'' thick, a Bunsen burner, filter paper, and a funnel. The chemicals required are caustic soda (2 tablespoonfuls of lye to one quart water), *Hydrochloric Acid, Nitric Acid, Aqua Regia,* ammonium hydroxide, and washing soda (soda crystals).

There are various kinds of adulteration. A color can be cut with *Fillers* that deprive it of its intrinsic strength, or it can be fortified with a *Dye.* When a filler is used, not only is the tint weakened,

224

but the oil absorption is altered. This changes the behavior of the paint, and its permanence is jeopardized. When a paint is made with or fortified by a precipitated dye, it may appear more powerful than that produced from the original *Pigment* alone, but it is not always permanent. (Only a few of the organic dyes are considered absolutely permanent.) Moreover, mixtures of paints containing dyes will differ from mixtures of paints of the same hues containing true pigments.

Tests for such adulterations can be made either by volumetric reduction or by chemical reaction. The first method is not always reliable, because a paint may contain a dye in addition to a filler. To detect the presence and approximate quantity of an insoluble filler (such as *Kaolin* and *Barium Sulfate*), the following method can be used. A small amount of paint should be weighed, then boiled with the caustic soda, and then the residue should be washed with water to remove the caustic. Next, the mixture should be boiled with aqua regia, diluted with distilled water 1:10, filtered, and dried. By weighing the residue, one can establish the percentage of the insoluble filler.

The presence of *Whiting* or calcium carbonate used as an adulterant will be revealed if the material effervesces and dissolves under the action of nitric or hydrochloric acid or aqua regia.

The presence of an organic dye (usually a coal-tar color) can be detected by extracting it from the paint. This is done by stirring the paint in a beaker with alcohol or benzene and then filtering it. If the liquid that filters through is colored, a dye is present. Colors containing a water-soluble dye should be first washed with benzene to deprive them of their binder, and then treated with water. Adulteration with carmine (*Cochineal*) can be detected by placing the pigment, moistened with concentrated ammonia, on blotting paper. If the dye is present, a red stain will appear on the paper.

Some colors may be submitted to a blowpipe test in the following manner. The paint should be placed in a small hollow made in a piece of charcoal; then the paint is burned by means of a blowpipe. After a few minutes, the organic dye will burn off, but the base, consisting of the white inert filler, remains unchanged. If *White Lead* (e.g., *Flake White*) is subjected to this test, it will be reduced entirely to metallic lead. If it contains any adulterants— even in the amount of 10%—it will not yield the metal but will

225

change to a whitish or yellowish substance. Pure *Naples Yellow* will yield tiny specks of metallic lead, interspersed in a blackish metallic mass of antimony. An imitation of this color will not be reduced in similar fashion; instead it will remain a yellowish mass. *Vermilion,* when subjected to the blowpipe test, should evaporate and leave no residue. *Cerulean Blue,* if first boiled with nitric acid, should leave a whitish residue of tin oxide that can be reduced by the blowpipe to metallic tin.

To detect the substitution of cadmium sulfides for cadmium-barium colors, mix 1 part pigment with 4 parts hydrochloric acid. If the solution retains its original color, the pigment is a cadmium-barium; if the solution becomes colorless, the pigment is a cadmium sulfide. Hydrogen sulfide gas will change the colorless solution back to its original color.

Cheap grades of such other colors as *Ultramarine Blue, Viridian Green, Chrome Oxide Green Opaque, Prussian Blue,* and *Phthalocyanine Blue and Green* will, most likely, be compounded with excessive aluminum stearate.

No conclusive chemical test can be carried out with the *Earth Colors.* Here, the difference in quality usually lies in the fineness and purity of the material and in the strength of its coloring matter.

All oil paints can be reduced to pigments by washing them repeatedly with benzene on filter paper. When all of the oil is extracted, the dry pigment will remain.

TESTING PAINTS FOR LIGHTFASTNESS. The light-fastness of paints may be tested as follows. The sample to be tested should be placed under glass, and part of the glass surface should be covered with metal foil. The glass should then be exposed to the sun for 600 hours. If at the end of this time the paint shows resistance to fading—revealed by comparing the covered and uncovered parts of the sample—the color is considered absolutely lightfast. This method is not quite conclusive, however, because the behavior of paint under the influence of direct sunlight is not always comparable to its behavior under normal light conditions.

226 TETRACHLORETANE. A powerful solvent for resins.

TEXACO SPIRITS. See *Mineral Spirits.*

THERMAL PROCESSING is processing with heat. See *Copal.*

THIOINDIGO VIOLET was available for many years as a *Dye,* but it has only recently been developed as a paint *Pigment.* Several different qualities of the pigment are presently manufactured, but not all are stable.

The pigment can be used for both oil and acrylic paint. Its red-violet hue is brilliant. As an oil color its transparency is considerable, its *Tinting Strength* moderate, and its drying capacity quite poor. Because of these properties, its usefulness is rather limited. A mixture of cadmium red and alizarin crimson can be used to approximate its hue.

THYMOL is a chemical used in a solution of up to 5% in alcohol for the destruction of mold (see *Restoration of Paintings*).

TINTING STRENGTH. The capacity of a color to impart its own hue to another color when the two are mixed.

TITANIUM OXIDE. See *Titanium White.*

TITANIUM WHITE that is obtained in tube form is a mixture of pure titanium oxide (about 30%), *Barium Sulfate,* and *Zinc White.* When pure (that is, unmixed with other white pigments), it is referred to as titanium oxide. Titanium oxide cannot be used as an oil color, however, because it becomes unbrushable when mixed with oil. Therefore the pigment must receive additions of zinc white, barium sulfate, or (as in the tube variety) both. In such mixtures it is labeled titanium white. Some manufacturers, however, differentiate the components; when titanium oxide is mixed with zinc white alone, the paint is labeled titanium-zinc white. The reason for the extension of the titanium oxide is its extraordinary *Tinting Strength* and *Hiding Power.* If it were used unadulterated it would radically reduce the hue of every color mixed with it. Moreover, since the drying quality of titanium oxide is poor and its dried film is soft, the addition of zinc white improves these qualities. The mixture absorbs twice as much oil as

Flake White, and if the paint appears to dry quickly, it is reasonable to assume that it contains dryers. Titanium white came into general use in the early 1920s.

In watercolor or acrylic painting, pure titanium oxide can be used. Regardless of its vehicle, this white is absolutely permanent.

TOLUENE is a coal-tar *Solvent* for oil paints and soft *Resins* (see *Restoration of Paintings*). Its penetration is stronger than the solvents of the *Mineral Spirits* group, and its evaporation slower than that of *Benzene.* It is also nontoxic.

TOLUOL is the name used for the commercial grade of *Toluene.*

TOOTH refers to the roughness or graininess of a painting or drawing surface, such as *Paper, Canvas,* or *Panels.*

TORTILLON. See *Stomp.*

TRANSFER PAPER. A paper used to transfer a drawing from one surface to another. When ready-made it is known as *Graphite Paper.* The carbon paper used for typing is not suitable for artwork; its marks will bleed through many layers of paint. Transfer paper can also be prepared by rubbing pigment into the surface of various papers. *Charcoal, Sanguine, Bistre,* dark-colored *Pastel,* or a dry pigment such as an *Iron Oxide Red* and *Umber* can be rubbed into the paper surface with a piece of rag. A paper thus prepared will serve for many tracings. A considerably darker transfer paper, such as that required for tracing on a canvas already covered by dry paint, can be obtained by mixing a dark dry pigment with a *Petroleum Derivative* and brushing it onto an absorbent paper like newsprint. If a transfer in white outlines is required, white chalk or pastel should be rubbed into the paper. White transfer paper can also be bought ready-made.

TRICKLING. See *Crawling.*

TROWEL. See *Spatula.*

228 **TUBES** for paints are made of tin (other materials might react

with a *Pigment* and or *Vehicle*), and come in a variety of sizes, the smallest measuring ½" in diameter and 2" in length. The standard tube for oil paints is ¾" in diameter and 4" long. White paint is normally put in 1 lb. tubes. Collapsible tubes appeared during the middle of the 19th century. Earlier, rigid metal tubes with pistons—into which color was put by the colorman—were used. Still earlier, paint was kept in pig bladders. Watercolors in tubes appeared commercially around the middle of the 19th century; until then, these colors were available in cakes or in pans. (For instructions on filling tubes with paint, see *Grinding Pigments in Aqueous Binders* and *Grinding Pigments in Oil*.)

TUBES: STORING PAINTS IN. See *Grinding Pigments in Oil; Grinding Pigments in Aqueous Binders; Tubes*.

TUNG OIL (China wood oil) is used in industrial paints. When subjected to *Polymerization,* it becomes highly resistant to moisture. It dries slowly, wrinkles easily, and yellows.

TURPENTINE is the *Solvent* most commonly used by the oil painter, and perhaps the oldest known. (Pliny described its crude distillation in the first century A.D.) It is obtained from the sap of pine trees and is produced in two generally standardized qualities: "gum spirits of turpentine" (usually labeled "redistilled" or "double-rectified turpentine" on bottles sold in artists' supply stores) and wood turpentine. Its boiling point ranges from 150°C. to 200°C. which, with the exception of *Kerosene,* is the lowest of all the solvents useful to the painter. Wood turpentine is a product of destructive (dry) distillation of wood pulp. It possesses the greater dissolving action and evaporation rate, but it is otherwise an inferior product, not recommended for use in making varnishes. It is used as an industrial paint thinner.

When exposed to air, turpentine oxidizes, becomes sticky, dries slowly, and forms *Rosin* (colophony)—as such it is worthless.

If turpentine is stored for prolonged periods of time, it should be kept in well-filled and tightly closed bottles.

TUSCHE is the German term for India and lithographic inks. See also *Lithographic Tusche; Silk Screen Printing.*

TYRIAN PURPLE, an ancient color that is now obsolete, was prepared from certain mollusks found on Mediterranean shores. A costly dye of deep purple hue, it was used for coloring cloth. It was first produced synthetically from coal tar in 1904. The hue can be approximated with mixtures of *Alizarin Crimson* and *Ultramarine Blue*.

ULTRAMARINE BLUE is an artificial color, resembling the ancient blue *Lapis Lazuli* in its chemical composition. The commercially produced oil color has a purplish cast, apparently because the manufacturers believe that the painter's preferences lie in this direction. However, a neutral-blue ultramarine can be obtained in dry pigment form which, when mixed with white, yields the identical tint we see in the paintings of the early masters. Ultramarine is a transparent color and cannot be used with *Impasto*, because it would lose its intrinsic clarity and appear blackish. Its drying capacity in oil paint is moderate, but it is seldom, if ever, used unmixed, so its drying time depends on the nature of the body color (see *Drying of Paints*). Ultramarine blue was first introduced in France and has been in use since about 1830. It is sometimes referred to as French ultramarine or permanent blue and is the basic blue in *Watercolor Painting* and other water-based mediums.

ULTRAMARINE GREEN is so weak in *Tinting Strength* that it is virtually useless for painting purposes. However, mixtures of *Ultramarine Blue* and *Viridian Green* produce a color closely resembling ultramarine green that has a much stronger tinting strength.

ULTRAMARINE VIOLET. A color developed from *Ultramarine Blue* in Germany at the end of the 19th century. It is a transparent, weak color possessing poor drying quality; hence its

231

use (except for fresco painting) is not justified. Its tint can be approximated by adding a little *Alizarin Crimson* to ultramarine blue.

UMBER. *Raw* and *Burnt Umber* are earth *Pigments*. In its natural state umber has a dull brown color, often grayish in tone, depending on its source of origin. (The best grades are mined in the island of Cyprus.) Although the composition of umber is similar to that of other earth colors, such as the ochres and sienas, in addition it contains amounts of *Manganese Dioxide,* varying from 8% to 16%. This accounts for its great drying capacity (see *Drying of Paints*), exceeding by far that of other Pigments. When added to the slow-drying colors, even in small amounts, it will accelerate their drying time enormously.

As with many of the earth colors, the shades of the pigment differ depending on its origin. For all practical purposes, the painter could limit his choice to the warm, reddish-brown *Burnt Umber.* The color of burnt umber is achieved by roasting the raw pigment to the desired depth of reddish-brown hue.

U.S.P. These letters indicate that the product conforms to the quality specifications of the United States Pharmacopoeia.

UNDERPAINTING. One or more layers of paint underlying the final paint application. All painting processes employed by the old masters (except the one known as *Alla Prima Painting*) used underpainting. See *Oil Painting.*

UTILITY BRUSH is a term which designates *Brushes* made of horse hair (and other material) that are used for house painting. These brushes come in various widths ranging from one inch up.

VALUE refers to the degree of lightness or darkness of a color.

VAN DYKE BROWN (Cassel earth) is an impermanent, semitransparent color of reddish-brown hue. It does not solidify in mixtures with oil, but is stable in varnish solutions. Extensively used during the 19th century in both oils and watercolors, it caused irreparable damage to many paintings.

The best approximation of this color can be obtained by mixing *Burnt Siena* and *Ivory Black* and then diluting the paint with medium to the consistency of a glaze.

VARNISHES are compounds of *Resins* in volatile solvents. The present-day varnishes fall into two groups: those made with hard resins and those manufactured with soft resins. In both cases, the diluent is *Turpentine* or *Mineral Spirits.* The best soft-resin varnish is *Damar;* Mastic is no longer considered its equal. The only commercially available hard-resin varnish is *Copal.* Other suitable hard resins, such as amber and the Zanzibar and Sierra Leone copals, are no longer readily available. Manila copal is not a true fossil (hard) resin.

Use of Varnishes. Varnish serves a dual purpose: to revamp a sunk-in color and to protect the paint surface from atmospheric impurities. If a pigment is compounded with a minimum of oil and does not receive enough painting medium or if it does not solidify quickly, but remains wet for a long period, the color will dry without luster. This flatness is particularly conspicuous in dark

colors. Further, if the substrata upon which the final paint film rests have not dried well, they will absorb the binder and the medium from the superimposed paint layer. This makes the top paint layer look flat and deprives it of its intrinsic color. An application of varnish, however, will at once reestablish the color.

Dirt accumulates slowly but tenaciously on a paint film. The impurities that settle on a painting eventually incorporate themselves into the paint itself. Cleaning may become quite difficult unless a solid film of varnish protects the paint. If the paint is varnished, it is the varnish that becomes soiled, and after its removal the original paint remains unscathed.

The belief that varnish protects a painting from atmospheric moisture is most often illusory. Several layers of *Copal Varnish* could partly accomplish this, but the concentration of *Resin* in the other varnishes is too light. A heavier oil-varnish mixture could offer protection from moisture, but it would be otherwise inappropriate as a picture varnish. For the best—although still not complete—protection from atmospheric moisture, a wax-resin varnish would be the best choice (see below).

Varnish Formulations. The thinnest and most easily removable varnish film is formed by so-called *Retouching Varnish.* Its resin concentration is minimal because it serves a merely temporary purpose. The thicker *Damar Picture Varnish* is formulated for use on well-dried paintings, at least one-year old. Depending on the thickness of the paint strata, as well as on climatic and environmental conditions, the varnish film can maintain its cohesion for a few years or for much longer. *Damar Solution Heavy* contains a great concentration of resin, which makes it suitable for use as a varnish in *Tempera Painting, Encaustic* work, and *Watercolor Painting* with self-prepared colors (see *Grinding Pigments in Aqueous Binders*). *Matt Picture Varnish,* as its name indicates, is designed to produce semiglossy surfaces.

Copal Varnish is the more resistant than any of the varnishes already mentioned, and thus it is best used in *Alla Prima Painting* and as a final picture varnish. The old doubts about the value of copal varnish were caused by a 19th-century oil-resin brew which contained a very large amount of lead dryers. This product was used for commercial purposes (varnishing coaches, etc.), and at times it also found its way into the painter's studio.

Acrylic Varnishes are prepared with a volatile solvent. These are considered reliable, although their substance is alien to the surface of oil paints. (Wherever Copal varnish is referred to, it is the product manufactured by Permanent Pigments of Cincinnati. Other materials on the market are not suitable for the purposes mentioned in the above text.)

VARNISHING. The painting should be placed either upright or, preferably, flat on a table and turned toward the source of light at an angle that permits control of the spreading varnish. Relatively fresh paintings should be varnished with a soft brush. The so-called *Utility Brush* is very useful for this purpose. Its elasticity can be increased by reducing its thickness; this can be done by cutting a portion of the hair at the neck of the ferrule. Older paintings can be varnished with cheesecloth.

Only a small part of the painting surface should be treated at one time, perhaps a 10" square; when one part of the surface is finished the adjoining portion is varnished, and so on. All the varnishes mentioned in the preceding entry are formulated to allow unhurried work; they do not dry so rapidly as to become unmanageable. Therefore, after a moderately proportioned picture has been completely covered with the varnish, it is still possible to thoroughly amalgamate the varnish film by using a circular rubbing motion with the side of the hand.

As a rule, a single varnishing will bring the desired result. However, a painting sometimes requires a second varnishing. When using retouching varnish or damar picture varnish, the second coat can be applied at once, since the initial film will be dissolved by the second application, no matter how old it may be. If copal varnish is used, it should be allowed to solidify for a few days. The second application will not dissolve the first, but rather will form an independent film, thus increasing the resistance of the varnish. The second varnish should be of the soft resin variety.

The effectiveness of varnishing—this is, bringing about a cohesive film of resin—depends largely on the nature of the paint surface. Paint that contains enough binder, medium, and particularly *Copal Concentrate* will require little varnishing. Well-executed *Alla Prima Paintings* need not be varnished at all; glazes will not change their appearance when varnished, because they

235

already possess a superabundance of oily and resinous ingredients. (Even when these ingredients are insufficient, varnishing will prove to be ineffective on a glazed surface.) Paintings executed on an absorbent ground or done with paint much diluted with turpentine, cannot be varnished successfully.

Occasionally, the surface of a painting as a whole will appear to be sufficiently varnished, but certain spots will remain flat, even when repeatedly covered with varnish. This will indicate loss of binder and medium in that particular area of the paint surface because of a break in the underlying paint strata, which has allowed the liquid substances to be absorbed by the fibers of the canvas. In such cases, *Copal Painting Medium* light should be used as a varnish. It is best to rub it into the particular spot with one's finger. Larger areas should be treated with a bristle brush, and then the medium should be rubbed firmly into the paint film with the side of one's hand using circular motions.

Sometimes varnish does not spread evenly on a surface, but contracts in droplets; in other words, it crawls or trickles. What causes this cannot always be explained, but the remedy is simple. Before the application of the varnish, a little turpentine should be lightly brushed onto the picture surface and then allowed to evaporate.

Wax-Resin Varnishing. Of all the varnishes already mentioned in the previous entry, the one that employs carnauba wax in combination with copal varnish offers maximum protection against dirt and atmospheric moisture (see *Waxes*). The mixture can be applied on top of a varnish film, preferably copal varnish, and then be polished with cheesecloth. The protective film thus produced is smooth and tough and allows safe dusting of the picture for a great many years. To avoid having the edges of the stretcher make an impression in the surface of the picture, the protective shield described in the *Canvas* entry should be used when the paste is applied.

Varnishing Acrylic Paintings. Works executed with acrylics do not require varnishing; they can be cleaned with soap and water. As a protection against physical wear, however, the acrylic medium can be used as a final varnish, only slightly increasing the original gloss of the paint film. If a flat surface is wanted, a matt

medium or *Matt Picture Varnish* can be used. A bristle, a utility brush or a pad of cheesecloth can be used for its application.

Varnishing Casein and Watercolor Paintings. The physical nature of these paintings does not favor varnishing in the same manner as oil paintings; they should remain matt. However, to increase their resistance to atmospheric moisture, they can be sprayed lightly with any of the synthetic-resin *Fixatives* sold in aerosol cans. These are volatile solutions of acrylic resins, sold as non-gloss fixatives under various trade names (Krylon, Acrolite, etc.).

Varnishing Tempera Paintings. Depending on the medium used, *Tempera Paintings* can be varnished in a few weeks—or few months—after their completion with any of the varnishes used for oil paintings.

VARNOLENE. A mild petrol solvent (see *Mineral Spirits*) used as a thinner in *Oil Painting.*

VENETIAN RED designates a nearly pure, bright *Iron Oxide Red.* The hue of this color, like that of other iron oxide reds (such as *Terra di Pozzuoli* and *Terra Rosa*) is a bright brick red. Unlike the other iron oxide reds, however, it is not composed of silica or alumina, but consists almost entirely of *Iron Oxide.* Therefore, its *Tinting Strength* and *Hiding Power* are far greater. Its drying capacity is however only moderate (see *Drying of Paints*). Venetian red is extremely permanent.

VENICE TURPENTINE is a *Balsam* (oleo-resin) obtained from certain coniferous trees of the larch group. The balsam is collected chiefly in the southern Tyrol and in the Lake Ontario region in Canada; the latter is called Canada Balsam. The substance is extremely viscous and highly aromatic.

It is undesirable as an ingredient in *Painting Mediums* and *Varnishes* because it forms a weak and brittle film. (The reports that it served in the medium used by Rubens must be discounted because the material is impermanent.) However, this material is quite useful as an additive to the gelatinous adhesives used in relining paintings because it imparts elasticity and delays drying,

237

thus facilitating the process of attaching the old to the new canvas (see *Restoration of Paintings*).

VERDIGRIS (copper acetate) is an ancient, obsolete green color, produced artificially. Its hue can be matched by mixing *Cobalt Blue* with *Viridian Green*.

VERMILION (cinnabar) is a red mercuric sulphide. It is found in natural deposits, principally in Almaden, Spain. It was also produced artificially early in history, and until the discovery of its modern equivalent, *Cadmium Red*, it was the most widely used brilliant, light red color. One of the heaviest pigments, it requires only a little oil to turn it to paint but has a strong tendency to separate from its *Vehicle* in the tube. Its body and its *Hiding Power* are stronger than those of cadmium red. See also *Testing Paints for Adulteration*.

VINE BLACK is a member of a group of impure forms of carbon made by calcining wood and other vegetable products. It is inferior to *Lamp Black* in *Tinting Strength* and *Hiding Power*. It should not be used in *Fresco* techniques because it contains water-soluble impurities.

VIRIDIAN GREEN (introduced around 1860) is a transparent hydrous oxide of chromium and the most useful green on the palette. It is a moderately strong glazing color and it possesses good drying capacity and permanence.

VISCOSITY. The thicker a liquid, the higher its viscosity, and hence the slower its flowing capacity. The volatile mediums (*Mineral Spirits, Turpentine, Alcohol,* etc.) have an extremely low viscosity and flow freely. In contrast, *Copal Concentrate,* the thickest liquid used by the painter, has to be scooped up from its container because of its excessive viscosity.

V.M. AND P. NAPHTHA (varnish makers' and painters' naphtha), also known as petroleum thinner, is a petroleum distillate that is used as a substitute for *Turpentine*. Its evaporation and solving properties are comparable to those of turpentine.

VOLATILE SOLVENTS. The term designates *Solvents* that evaporate rapidly. *Acetone,* for example, will evaporate as soon as it is placed on a glass slide and exposed to air. In contrast, *Turpentine* takes several minutes to evaporate from a nonabsorbent surface.

WALNUT OIL, obtained from walnuts, has a long history in painting, but this does not make it a reliable material. Recent tests revealed no valid reason for its use in place of standard-quality *Linseed Oil.* Like *Poppyseed Oil,* walnut oil becomes rancid with age and creates a weaker paint film than linseed oil does. According to some reports (not necessarily reliable), Leonardo da Vinci used this oil in sun-thickened form as a paint vehicle.

WASH. An application of transparent liquid color essential to the technique of *Watercolor Painting.*

WATERCOLOR PAINTING. As the word indicates, the medium used for painting is water; the pigments are bound by the highly water-soluble gum arabic (see *Gums*). The chief characteristic of a watercolor is its transparency; the white paper remains in evidence under the thin veils of color, and it remains untouched by paint in all the passages that are to remain white. In true watercolor, white paint is not mixed with other colors because it would render them more or less opaque. Opaque watercolor is referred to as *Gouache.*

Watercolor Materials. Watercolor paint is sold in three standard varieties: round hard cakes; semi-moist colors in small pans; and tube paint in semi-liquid form. The pigments are ground to a very fine consistency, which is important when work of great delicacy and precision are to be executed. Studio-made watercolors can be very easily prepared, (see *Grinding Pigments in Aqueous Binders*)

but their body will be more granular; in certain techniques aiming at broad and bold effects, this can be quite desirable.

Watercolor Paper. Because its character always remains in evidence, the watercolor paper (see *Paper*) must be chosen carefully. Its texture will strongly affect the manner of working. The three standard surfaces are available: rough, which is strongly textured; cold-pressed, with a more delicate texture; and hot-pressed, which is quite smooth. As a rule, the paper should be 100 % rag and not lighter than 72 lbs., or it will wrinkle if not stretched and held taut while working and while the painting is drying. An intermediate weight is 140 lbs. The heavier weights range from 300 to 400 lbs. Only the white or (on rare occasions) off-white paper can be used for transparent watercolor; colored papers are not suitable for this purpose, although they are acceptable for gouache. Loose sheets of paper come in sizes of 22" x 30" and 27" x 40". Pads are sold in much smaller sizes.

Stretching the Paper. As already mentioned, thin papers will cockle when wet. To prevent this, the paper can be attached to a drawing board or a Masonite panel by means of gummed paper tape, strong masking tape, or tacks. Oil-painting stretchers can also be used; the paper is cut so that it extends beyond the stretcher bard on all sides and is fastened to the bars with thumbtacks every 2" or 3". In either case—whether attached to a drawing board or stretchers—the paper should first be well moistened with a sponge after it has been stretched. Upon drying it will show no wrinkles.

Some papers may not accept the water readily, probably because the *Size* used in their preparation is water-repellent. To remedy this, sponge the surface before painting, or add a trace of detergent to the water to reduce the *Surface Tension*.

Watercolor Brushes. These are commonly made of sable hair and are the same as those used in oil painting, except that they must have a shorter handle. *Oxhair Brushes* and *Fitch Brushes* are less costly substitutes. Besides the round sable brushes, a flat brush made of sable or squirrel hair, about 1" wide, is important for applying washes and for wetting the paper. Occasionally, a bristle brush will be serviceable for creating *Drybrush Effects* and for washing out undesirable color passages (see *Brushes*). Certain

textural effects can be produced with a piece of sponge, and a toothbrush can be used to spatter by dipping its bristles in paint and then running the tip of one's finger across them or by flicking the whole brush with a sharp snap of the wrist. Blotting paper is also useful for blotting wet areas of the paper. If desired, a mottled effect can be created by pressing absorbent paper onto the wet color.

Watercolor Technique. The basic technique is the flat wash, a film of transparent color applied in a series of parallel strokes that overlap and run together. A graded wash is produced when more water or more color is added to successive strokes, so that the wash moves from dark to light or vice versa.

Detailed work requires a more or less accurate preliminary drawing. This must be delicate, and hence only well diluted paint, that is, a weak, almost neutral color, can be used for this purpose. The drawing can be executed with a small, round sable brush, a *Scriptliner,* or a medium soft (HB) pencil. Three or four washes at the most can be superimposed, always starting with the lightest color and ending with the darkest. Areas that are to appear white, especially small passages, are best left untouched by the wash, but a thin application of paint can sometimes be removed with a hard eraser, providing that the quality of the paper allows such an operation.

For bold pictorial treatment, a fairly smooth or an extra rough paper are equally suitable. The rougher the support, the more its texture will attract the attention of the beholder, and in extreme cases, the ''tooth'' of the painting surface will overwhelm the articulation of the brush. Heavy pure rag paper can be subjected to forceful treatment. Certain textural effects can be achieved by scraping into its surface with a sharp knife or razor blade, and undesired paint areas can be scraped away. The resulting roughness can be smoothed by rubbing the paper with a *Burnisher* or the back of a spoon. Rough paper is also well adapted to drybrush effects. These are produced by taking a little paint on the brush and dragging it lightly over the surface of the paper. The paint is deposited only on the top grain, and the interstices remain free from color.

Painting on wet paper produces effects that have a character all their own. Soft, blurred transitions of color and of line can be

achieved on paper that is wet, whether slightly moist or saturated. Depending on the thickness of the paper, it should be submerged in water for ten minutes to a few hours before painting. When the work is done on a small scale and rapid execution is planned, the surface of the paper can be merely sponged. The wet paper can be kept on top of wet blotting paper or be placed on top of tempered Masonite (which is more water resistant than the untempered variety to retard drying). As long as the paper is wet, it will cling to the board tenaciously. Linear definitions can be made with a pen rather than with a brush, since the brushmarks may not register sufficiently on a surface flooded with water. The limitation of this technique is that colors cannot be confined with any degree of accuracy to definite areas. When rice paper is used, blotting paper should be placed underneath to absorb the water that will quickly saturate its surface.

WATER-SOLUBLE INK refers to those inks that can be mixed freely with water and that remain soluble in water after drying. They are designated as "writing inks." Inks other than writing inks are not miscible in water (printer's inks) or only partially soluble in water (i.e., inks that are soluble only as long as they are still wet, such as India inks). Because of their tendency to fade when exposed to strong light, water-soluble inks are not recommended for artistic use.

WATER-SOLUBLE RESINS are synthetic resins used as *Vehicles* for pigments. See *Acrylic Resins.*

WAX CRAYONS. For artistic purposes, there seems to be only one technique in connection with which the employment of wax crayons is justified. A drawing made with wax crayon, then painted over with watercolor can be given intriguing textural and coloristic effects. This is because a wax substance repels water and the watercolor penetrates on the spots that remained unmarked by the crayon.

WAX PASTE is made from natural or synthetic wax suspended in a volatile dilutent.

WAX-RESIN is wax dissolved in a resin varnish. 243

WAXES are substances of animal (e.g., beeswax), mineral (petroleum wax), and vegetable (carnauba wax) origin.

Waxes differ from each other in their reactions to heat and atmospheric humidity. When solidified, their solubility in certain liquids also varies. Beeswax will soften very quickly under heat, and it can be redissolved in turpentine, petrol, and coal-tar liquids at any time, even after centuries. A carnauba wax-resin compound is extremely resistant to heat and atmospheric moisture. Once solidified, it becomes progressively more resistant to the action of solvents.

Beeswax. This wax is generally sold in small brown discs. Bleached white wax is also obtainable, but it is of no advantage to the artist. Although it is sometimes claimed that the brown color can be bleached by exposing it to sunlight for several hundred hours, when this was tried by the author no bleaching occurred. The now obsolete practice of adding beeswax to paints as a stabilizer (in the recommended amount of 2%), although effective at first, proved to be without merit in the long run.

Beeswax paste should be prepared by dissolving 3 oz. of wax (by weight) in 3 oz. of *Turpentine* or *Mineral Spirits* (by volume). First, the wax should be shredded in small chips and placed in an aluminum cup. Next, the turpentine or mineral spirits should be added. The cup is then placed in a larger vessel filled with water, the so-called *Double Boiler.* If heated slowly, the wax will melt in the turpentine. The mixture should be stirred until the wax dissolves completely, which takes place when the temperature of the turpentine reaches 149°F. The resulting soft paste will be ready for use. This wax paste can be made more resistant as a surface coating if the solvent is made up of equal parts of *Damar* or *Copal* varnish and turpentine or mineral spirits.

Beeswax paste has the following uses: (1) coloring wood surfaces in *Framing;* (2) preparing grounds for *Etching;* (3) protecting painted surfaces (see *Varnishing*); (4) preparing wax colors in *Encaustic* painting; (5) relining paintings (see *Restoration of Paintings*).

Carnauba Wax. Obtained from Brazilian palm leaves, this wax is sold in the form of thick discs. The best quality comes in a cream color; the inferior grades are brown. Of all the natural waxes,

carnauba when compounded with copal resin is the most resistant to abrasion, offering the best protection as a surface coating for paintings executed on rigid supports and for decorative objects. It also serves as a binder for metallic powders in gilding (see *Gilding and Silvering*).

Carnauba Wax-Resin Compound. Because of its hardness and brittleness, carnauba wax can be reduced by scraping it with a knife to small particles or dust. It is then melted in a tin cup over a hot plate. Upon liquefication, which takes place after the wax reaches 185°F., a few teaspoons of turpentine should be added to 3 oz. of liquid wax, and the melt should be well stirred. The balance of the solvent, 3 oz. of turpentine and 3 oz. of copal varnish (twice the quantity used to produce a workable beeswax paste), should be poured slowly into the container. Pour gradually to prevent the hot melt from rapidly congealing and forming an incomplete solution. The copal formula recommended for this purpose is that produced by Permanent Pigments of Cincinnati, Ohio.

Ozokerite (Earth Wax). A dazzling white substance known in its refined form as *Ceresin,* this wax is found underground in the neighborhood of petroleum deposits. Ozokerite is sometimes used as a flattening agent in a 5% solution of mineral spirits which is used as a varnish to produce a matte surface on oil paintings. The matte surface should not be buffed or it will become shiny.

Paraffin Wax. This bluish-white translucent material is obtained from the distillation of shale oil and petroleum. It cannot be used as a substitute for beeswax or carnauba wax.

WET-IN-WET. When wet paint is painted over or into an existing layer of wet paint, the technique is described as wet-in-wet. In oil painting, colors are, as a rule, mixed on the painting surface by this means. In watercolor paintings, fresh color is often floated into a wet wash of another color so that the two merge or blend in a technique that exploits ''controlled accidents.''

WETTING AGENT. This is a substance that lowers the tension between the molecules of different liquids, thereby relatively increasing the tension between liquid and solid. Ammonia and

detergents are such substances when used in connection with water (see *Surface Tension*). Alcohol is an agent for wetting *Pigments* that do not disperse readily in aqueous solutions. In grinding pigments a polymerized oil will possess greater wetting capacity than raw, unprocessed oil (see *Aluminum Stearate; Grinding Pigments in Oil*).

WETTING POWER is the capacity of a liquid to moisten a solid. The capacity of raw linseed oil to wet a pigment (that is to form with it a compound) is less than that of a thickened oil.

WHITE. See *Flake White, Lead White, Titanium White* and *Zinc White.*

WHITE BOLE is identical with kaolin and *China Clay.*

WHITE GLUE is a general term for various brand names of glues employing polyvinyl acetate emulsions and other *Synthetic Resins.*

WHITE SHELLAC. See *Shellac.*

WHITING is an artificially prepared calcium carbonate (*Chalk*). It is the whitest and purest of all pigments suitable for the preparation of *Gesso.* When mixed with oil, it entirely loses its opacity. Combined with colored pigments, it is the basis for the manufacture of most *Pastels.*

WOAD. See *Indigo.*

WOOD PANELS. If a wood *Panel* is chosen as a painting support, it must first be immobilized to prevent warping, regardless of whether the material is oak, pine, fir, poplar, linden, mahogany, chestnut, or walnut. However, the immobilization should not be complete; the panel should not be braced by means of a framework glued to the reverse side, since this would not allow for expansion and contraction of the highly *Hygroscopic* material and would be as likely to promote cracking as it would be to prevent it.

246 Traditionally, partial immobilization of a panel is accomplished

by means of a so-called *Cradle.* In this method, strips of slotted wood are glued parallel to the panel's grain; through the slots, an equal number of wooden strips are set flat against the panel. These cross-strips are not glued down, so that the panel may contract and expand as it reacts to atmospheric moisture. A panel cannot be cradled by the inexperienced. Only specialists should be entrusted with this work.

Gluing a fine fabric to the back of the panel (in addition to the cradling) is the most effective way of safeguarding its permanence. Such treatment can be found on many panels dating from the 15th to 17th centuries. When using laminated boards such as plywood (gum, birch, or oak), the precautions mentioned above are not necessary.

WOODCUT and WOOD ENGRAVING are techniques of relief printing in which the face of wooden plank or block is partially cut away so that the raised portions of the surface can be inked and printed while the cut-away portions remain uninked and will not print. (A *Linoleum Cut* is made by the same process.)

A woodcut can be differentiated from a wood engraving by the nature of the tools used, since the character of the lines produced is distinctly different in the two techniques. In woodcut, the general treatment of a design is broader and more painterly, while in wood engraving the treatment is strictly linear.

The tools used in engraving are gravers, which incise lines similar to the marks made by the burin in metal engraving (see *Etching*). Several types of gravers are available, but all should have slightly bent shafts. A set usually contains different sizes of round, flat-, and bevel-edged gravers, and a special knife. For woodcuts, a

Graver.

variety of hollow, rounded gouges and V-shaped so-called paring tools are used. These can be obtained in different sizes, ranging in 247

blade width from ⅛″ up to ½″, with more or less shallow cutting edges. All tools are sold well-sharpened, but they must be honed further before using them. It is absolutely essential to keep them in razor-sharp condition. When dull, they will tear and chip the wood surface, especially when cutting crossgrain. Stones made especially for sharpening gouges and curved cutting edges are available; they are known as India carving-tool slips.

Burins.

Wood carving tools.

The choice of a wood block is very important. For precise work like that of engraving, its grain must be very fine and regular. Boxwood is best for this purpose, and linden is a fair substitute for it. Lime, maple, and white pine are suitable for woodcuts. End-grain blocks and planks should be distinguished. On an end-grain, the gouge can operate in all directions without impediment; on the plank, it is easy to cut in the direction of the grain but more difficult to work against it.

When cutting into the wood, the artist subjects the block to considerable pressure; it must therefore be partially immobilized. This is done by means of a so-called bench-hook.

Wood block on bench hook.

A press is helpful but not essential to print from wood blocks. First, the block should be impregnated with *Linseed Oil* to make it nonabsorbent. This can be done with raw linseed oil, but boiled oil is better. To accelerate drying, *Cobalt Dryer* can be added to the oil in a relatively large amount. For printing, the same *Printer's Ink* that is used in etchings can be employed, but its viscosity must be reduced by thinning it with linseed oil to a looser consistency. The ink should not be liquid, however, or it will run over the edges of the lines. After receiving the addition of oil, the ink should be rolled out with a *Brayer* on a sheet of glass or other nonabsorbent surface. The well-mixed ink can then be rolled over the wood block.

Woodcuts and wood engravings are printed on thin papers. These may be either of domestic manufacture or be mulberry or rice papers produced by the Japanese. The sheet of paper is placed on the block and printing is done by simply rubbing it carefully with a spoon or a paper folder made of bone. In the course of printing the image should become visible on the reverse side of the thin paper. Should this not be the case, probably not enough ink has been used.

Just as in etching, a number of trial proofs will have to be pulled and additional cuttings made before the print is successful. If unintentional cuttings remove some salient part of the design, errors can be corrected by replacing the crucial missing part with *Acrylic Modeling Paste.* Adding some dry umber pigment to the paste will make it stiffer and allow more precise modeling. When thoroughly hardened, any imperfections can be scraped off with a sharp knife and further additions made as required. The dry surface of the replaced material can be cut in much the same way as the wood and then printed.

X-ACTO KNIFE. A convenient, multipurpose knife for intricate cutting operations. The cylindrical handle is designed to hold small blades of various shapes, which can be easily detached and replaced. See *Knives.*

XYLENE (xylol) is a *Solvent* derived from the destructive distillation of coal tar. It is nontoxic and less volatile than *Toluene,* and its dissolving action is just as good.

XYLOL. See *Xylene.*

YELLOW BOLE is white bole (see *China Clay*) that has been colored by iron oxide. It is traditionally used as foundation for silver leaf applications (see *Gilding and Silvering*).

YELLOW MEDIUM AZO; YELLOW ORANGE AZO. These newly introduced colors are only obtainable as *Acrylic Paints*. As such they share the general characteristics of all acrylics. They are permanent, opaque when used full strength, and can be reduced to the consistency of a glaze when sufficiently thinned with water or *Acrylic Polymer Emulsion*. The color value of yellow medium azo closely corresponds to that of cadmium yellow, but yellow orange azo does not possess the deep orange hue of cadmium orange (see *Cadmium Colors*).

YELLOW OCHRE, and its varieties golden or brown ochre, is a moderately fast-drying color in oil consisting of up to 80 % silica and clay tinted with *Iron Oxide.* With the exception of the golden variety, which is rather transparent, its covering capacity is good. The use of this *Earth Color* reaches back to prehistoric times. The pigment is widely distributed all over the world, but the best qualities come from France. It turns red when burned; as such, the color appears on some lists as red ochre.

Depending on the source of its origin, this pigment ranges in color from a bright yellow to brown-yellow and golden-yellow. Golden-yellow ochre is more transparent, warmer in hue, and weaker in *Tinting Strength* than yellow ochre. It is generally used

251

for glazing. The hue of brown ochre resembles that of *Raw Siena*, but the ochre is more opaque and warmer. All ochres possess great permanence.

YELLOW ORANGE AZO. See *Yellow Medium Azo.*

YELLOW OXIDE is a pigment identical to that used in the oil color known as Mars yellow (see *Mars Colors*). It is a pure hydrous *Iron Oxide.*

YELLOWING OF OIL PAINT. Its principal cause is the gradual chemical change that takes place in dried *Linseed Oil* (used both as a *Vehicle* for *Grinding Pigments in Oil* and a diluent for thinning oil paints during the process of painting). Although linseed oil is the most suitable oil-paint binder because of its all-around properties, it does have a considerable tendency to yellow, even when it is designated "bleached." (Bleached oil, although it appears colorless in the bottle, yellows upon exposure to air, i.e., by oxidation, just as much as the unbleached variety.) Raw cold-pressed oil behaves much better in this respect, as does the acid-extracted oil. When thermally processed in the absence of air, linseed oil is known as "stand oil." As such its yellowing is minimized to a point where the tendency becomes immaterial. In practical use the particular quality of stand oil becomes considerably enhanced when mixed with *Turpentine* and congo *Copal Resin.* This mixture is labeled "Copal Painting Medium."

Excessive use of metallic *Dryers* can also cause yellowing. However, a yellowed *Flake White* can usually be bleached by exposing it to strong artificial light for a number of weeks or to sunlight, which will accomplish the task in a much shorter time. To avoid overheating the surface, a painting exposed to sunlight should be placed at a slant. Yellowing due to inferior oil, or other causes cannot be remedied.

ZANZIBAR COPAL, the hardest quality of fossil *Resin,* is found in Zanzibar. It is distinguished by great hardness, conchoidal fraction, and a "goose skin" surface. Zanzibar resin is, however, no longer readily available.

ZINC WHITE is zinc oxide (labeled *Chinese White* as a watercolor). It has been in use since about 1830 and has been much prized in some quarters for its dazzling white color. In comparison with *Flake White,* its color produces cooler tints (particularly pronounced in mixtures with black), and its body is more "buttery" as an oil paint. Zinc white requires twice the amount of oil that flake white needs to make it brushable; its covering and drying capacity are inferior to the latter color, and the film is less elastic when dry. The generally held opinion that its color retention is superior to flake white is only true in cases where the white lead, and the diluting medium, is of low quality.

ZINC YELLOW, a zinc chromate, differs from all the other yellow colors on the palette in color value (it has the tendency to acquire a slightly greenish cast in time) and in consistency when mixed with oil (it readily forms *Long Paint* when mixed with polymerized oil, a condition that may be desirable in certain techniques). Although the color was produced commercially in 1850, it has come into use only recently.

ZINNOBER GREEN is a mixture of *Prussian Blue* and *Cadmium Yellow.* It is generally referred to as *Chrome Green.*

253

Edited by Heather Meredith-Owens
Designed by James Craig and Robert Fillie